"If you want to feel like a badass . . . but you're a neurotic, germaphobe Goody Two-shoes, then this is the book for you!"

—Mo Rocca, satirical commentator, CBS News'
Sunday Morning

"Okay, you have vices. But until you read this book, you can't be sure whether you are going about them the right way. I once was lost, but thanks to this book I have found myself. I'm not saying in which chapter." —Roy Blount Jr.

Beth Albrecht Sagal

About the Author

PETER SAGAL is the host of *Wait Wait . . . Don't Tell Me!*™,
the NPR™ news quiz. He is also an award-winning
playwright, an occasional screenwriter, a onetime extra in
a Michael Jackson music video, a former staff writer for a
motorcycle magazine, and a regular contributor to "The
Funny Pages" in the *New York Times Magazine*. Sagal lives
near Chicago with his wife and three daughters. This is
his first book.

THE
BOOK
of
VICE

itbooks

AN IMPRINT OF HARPERCOLLINS PUBLISHERS

THE
BOOK
of
VICE

VERY NAUGHTY THINGS
(AND HOW TO DO THEM)

Peter Sagal

itbooks

AN IMPRINT OF HARPERCOLLINS PUBLISHERS

FIRST HARPER PAPERBACK PUBLISHED 2008.

Designed by Janet M. Evans

Library of Congress Cataloging-in-Publication Data is available upon request.

ISBN 978-0-06-084383-0 (pbk.)

11 12 WBC/RRD 10 9 8 7 6 5

for Beth

—◆—

For letting me go,
and better yet,
for coming with me

CONTENTS

"Do you ever get the feeling that there's something going on that we don't know about?"

—*Fenwick (Kevin Bacon) to*
Boogie (Mickey Rourke), in Diner

This book was inspired, in great part, by Marv Albert, the sportscaster with the evocative voice and woolly toupee. As you may remember, Albert was at the center of a sexual scandal in 1997 in which his long-term mistress accused Mr. Albert of all kinds of ungentlemanly behavior, including attempting to bite her. She found this unseemly, and went public with her accusations, causing the temporary suspension of Mr. Albert's career.

I felt some sympathy for him. Not for his strange appetites—I can't even bring myself to bite ice cream, let alone a forty-two-year-old woman to whom I am not married—but for what I imagined was going on in his head. Albert, a short, athletically untalented Jewish guy, has spent his career not just in professional sports, but (mostly) in basketball, the sport in which tall, ebony demigods stride about in gold chains and drive luxury cars, enjoying a lifestyle of hedonism and indulgence that would

make Nero himself think he got the short stick. Wilt Chamberlain, one of the greatest players ever to lace up oversize sneakers, claimed to have "slept with twenty thousand women"—a phrase which, with its emphasis on magnitude and implications of time-management problems, points up the utter ridiculousness of that particular euphemism. The only way to "sleep with" twenty thousand women in the course of even a long lifetime is to dress up in convincing drag, commit a crime, and get yourself sentenced to a series of women's prisons.

Back to Albert: so there he was, following these players around, seeing them pick and choose from available women the way you or I pick a meal from one of those phone-book-sized Greek diner menus. Many NBA players—even the so-called role models, like Shaquille O'Neal—have children by multiple mothers, and countless other assignations which we presume they indulge in with at least the implicit assent of said mothers. On the infrequent occasion that these players are called to account, such as in the case of Kobe Bryant, they—not to put too fine a point on it—*get away with it,* their marriages, careers, and future prospects, professional and personal, intact.

This is as it ever was: in any society, those few who perch at the top of the pyramid of the moment get a break from the rules that restrain the rest of us. In ancient Egypt, the Pharaoh got to marry his own sister, after all, which doesn't *seem* like a consummation devoutly to be wished, but the point is, he could, and you can't.

It must have driven Marv crazy. There he was, well paid, just like the players were, and famous, just as they were. When he walked into a bar, people shouted his name and asked him to perform his catchphrase, "Yesssss! . . . And it counts!" in that famous voice of his. I would imagine he started to emulate the

players' reserve about their fame, the way they cruise, eyes narrowed, through crowds of admirers, accepting as their due the phenomenon of people thrilling to see them. But they don't deign to enjoy it. . . . No, their pleasures are more recherché.

So why not me? said Albert to himself. Why can't I engage in that same kind of polymorphous perversity that seems to be the birthright of the successful?

Because you're *Marv Albert,* said the world.

Because it doesn't matter how close you are to glory; you can't share it. Because it is the fate of a tiny percentage to be the Veritable Thing Itself, and the rest of us just get to watch. Even if we're watching from the broadcast table, courtside.

In that sense—the sense of being, in the end, an outsider looking in, and not in the sense of having a secret biting fetish—I am Marv Albert, and if you've read even this far, so, probably, are you. This book is for all of us who have picked up a newspaper, or seen a TV show, or listened to a public-radio news quiz which talks about the really strange things that Other People do to either get themselves in trouble, or have an awful amount of fun, or often both. We shake our heads and wonder not only at the stupidity or daring or brass of the offending individual, but also that such things are possible in the first place. We consider the case of—say—Judge Donald Thompson of Oklahoma, who was convicted in June 2006 of using a penis pump underneath his robe, during court sessions, and like Horatio, we realize that there are things undreamed of in our philosophy.

It is human nature to look for whatever satisfaction eludes us by going forward, and further—faster, harder, and deeper, if you will. All the people in this book decided that what they wanted lay beyond a boundary, sometimes society's, sometimes their own. And they plunged in.

When the same mood came upon me, when I struck the board and cried, "No more! I will abroad!," when I decided to Seek to Strive, and Not to Yield, I didn't engage in recreational polygamy, or scarification. I didn't even get an interesting tattoo, though I'm still thinking about it, something subtle and small on the upper bicep so it won't show most of the time. No, what I did is write this book. Which, truth to tell, was transgression enough, for the likes of me. I enjoyed it. Hope you do, too.

THE
BOOK
of
VICE

INTRODUCTION

or

KNIT SHIRTS AT THE
FETISH BALL

It's nearing midnight at the Power Exchange, San Francisco's, and maybe the world's, only open-to-the-public "mixed" (men and women and transvestites and transgendered) sex club, a nine-thousand-square-foot former Pacific Bell switching station now done up in Inexpensive Brothel Moderne. The various dungeons, theme rooms, cells, niches, and mattresses have emptied out, and the patrons—mostly clumps of silent, single men, who have paid up to $75 for the experience of pacing around the place, looking for something, or someone, to do—have now gathered on the top floor, usually the gay male playpen, but now, thanks to a wrestling ring turned into a crude stage, a showroom. The time has come for the Kinky Couples Contest.

Josh Powers, twenty-one, the shaven-headed son of Mike Powers, the club's owner, takes the stage. A former straight-A, Eagle Scout Mormon kid raised in the Central Valley of California, he came up to San Francisco two days after his eighteenth birthday to join his father's business. He hopes to be the Christie Hefner to his father's Hugh, creating a multimedia empire based on that elusive, pervasive dream: a place you can go, any time you like, and get laid.

Josh takes the mike, and it immediately becomes apparent

that the first rung on the ladder to fame and fortune will have to be: learning a little stage presence. "Uh, hey, everybody, welcome to the Power Exchange Fetish Ball Kinky Couples Contest!" Most of the people watching don't look like they're interested in fetishes. Some of them wear knit shirts or T-shirts; more of them wear club wear: silk jackets for the men, revealing dresses for the girls. All of them have a kind of wary, curious look on their faces.

"Uh, okay, uh . . . time to get started! It's going to be, uh, hot! People have signed up . . . to show their stuff, and uh, okay. Let's get started!"

He consults a piece of paper in his hand.

"Julie and Jim!"

Nothing. Silence. Crickets.

"Bobby and Terry!"

Nothing.

"Guy and Friend!"

Around the corners of the room, the club's attendants/security guards, wearing T-shirts that read "Sex Squad," watch Josh impassively.

"Darren and Ron?"

Everybody in the room looks at the empty stage, waiting for the fun to begin.

🪶 🪶 🪶

In the long war between Vice and Virtue, Virtue has been met on the battlefield, routed, defeated in detail, occupied, and re-educated in prison camps. When last seen, Virtue was working on the Strip in Las Vegas, handing out color flyers advertising in-room exotic dancers. She says she's happy, but she doesn't meet your eyes.

Consider, for example, the sad, strange case of William J. Bennett.

A onetime high-level government functionary, Bennett changed careers late in life to become a pious Tribune of Virtue; with bestselling books, innumerable media appearances, anthologies, specially licensed "Pin the Opprobrium on the Sinner" party games, you name it, he made quite a living for himself by constantly condemning wrongdoing in public life. Of course, these sins were almost always committed by supporters or members of one political party, but what the heck, it narrowed the scope of his research, and saved him valuable time.

And, worn out from the back strain caused by heaping shovelfuls of disdain on his various enemies, who had all failed to live up to the Highest Standards of Western Civilization, he, like all of us, needed to relax from time to time. Which, we eventually learned, he did by playing high-value slot machines at casinos in Las Vegas and Atlantic City. Repeatedly. For hours. And for big losses, if we can assume the laws of mathematical odds were not suspended on his behalf in much the same way as he was allowed, as a courtesy, to cut in line at the buffet.

Why in the world would he do something like this?

Why didn't he stop, at any of the innumerable chances he had to do so?

And why would anybody play slot machines anyway? Particularly the ones that cost $500 a pull? The only less enjoyable way to dispose of $500 is to have it taken from you at knifepoint, and even that provides a good story to tell later on.

As the host of a weekly news quiz, I have marveled at thousands of stories of people indulging appetites that should have gone ignored. In 2004, conservative Republican congressman Ed Schrock abruptly resigned after a website posted an audio

recording of this upstanding married family man asking for company, in strangely clinical terms, on a gay phone-sex line. In 2006, it was finally revealed that Representative Mark Foley, a Republican who spent his work hours on the sexual exploitation of children, devoted a considerable amount of his private time to that subject as well.

Sinning, of course, is not limited to the halls of power. In Delmont, Pennsylvania, you can drive up to the Climax Gentleman's Club, show your proof of age to an attendant, and then drive forward to a window where you can enjoy a private strip tease, from the comfort of your car, at the rate of $5 a minute. If you're a fan of alcohol but don't like pesky hangovers, why not try the AWOL (Alcohol Without Liquid) breathable alcohol system, which snoggers you via face mask? Clearly, the better angels of our nature have given up and flown off, saying they needed "to devote more time to their families." Of cherubim.

Two hundred and thirty-odd years ago, a progressive thinker of the eighteenth-century Enlightenment envisioned a utopia, and in America we have come near to perfecting it on earth. Wherever the Marquis de Sade is now, he must be proud. I imagine him wandering through the Power Exchange, eyeing the copious bowls of condoms and lube, the porn playing in continuous loops on monitors and the walls, and saying, "Truly, this is the paradise that I envisioned. . . . But why does everybody look so confused?"

🎋 🎋 🎋

The Power Exchange was founded in 1995 by Mike Powers, an ex-military bodybuilder and occasional recreational transvestite, who says that he worked as an escort for a while and came

across the idea for a genuine heterosexual sex club while look-
ing for a good place to take his clients. On the night of the Fe-
tish Ball, when I visited the club, he was wearing a sleeveless
muscle tee, camo pants, and black patent leather boots with an
alligator pattern. His long hair was feathered, like Farrah Faw-
cett's, and his fingernails were long and painted.

I sat in his office and listened as he spoke, rapid-fire, of his
life, his first two marriages and his impending third, his chil-
dren, the convoluted and sometimes bitter relations between
his large broken family, and his dreams for himself and his
club. They were big dreams, of course, ranging toward national
fame, perhaps a reality TV show, à la HBO's *Cathouse,* a docu-
mentary series about a Nevada brothel. While we spoke, he
constantly drank beers from his office bar, and showed occa-
sional signs of a volatile temper, especially when the subject of
his son and club manager, Josh, came up. It seemed that Josh,
in his father's eyes, could do nothing right, which might explain
why he found it so hard, as I observed him that evening, to do
anything right.

I asked Mike about the implicit promise of the Power Ex-
change, that is, a place where a single heterosexual man could
come and have the kind of no-holds-barred, anonymous sexual
encounter seen in porn films. He waved his beer and argued
that my view was too narrow; that—using one of the many ex-
tended metaphors he turned to during the course of the
evening—it was like wanting fast food, thinking you're going to
McDonald's but ending up at Taco Bell instead. You get what
you wanted, but you select it from a different menu.

"They need to expand their idea of a sexual experience," he
said of the men who were, even as we spoke, lining up outside
on Otis Street. "They may think, okay, a sexual experience is

with a girl . . . but then they come here and have an encounter with a transgender person . . . or watch a performance. So they've expanded their experience, they've widened their personal menu."

In other words, no, they're not going to get laid. But a boy can dream, can't he?

☙ ☙ ☙

Economists dating back to Adam Smith have told us that the driving force of human affairs is to improve one's own living standards, to acquire better food and healthier environments and longer life. But at some point in the early twentieth century (cultural historians argue about the date, but most agree that by the time Sally Rand did her fan dance at the 1936 world's fair, the movement was well under way), most of the Western world realized that living a healthy, well-fed life was awfully dull. Since then, a growing part of the economy, and news headlines, and even the largest questions of national and global politics, have become less about acquiring the resources to Feed the Hungry and Shelter the Exposed but rather to Hit the Fourteen Because Goddamn It the Dealer Is Showing an F'in Queen AGAIN. Thus, *The Wealth of Nations* is now obsolete; the times call for a new primer, something like *Scratching the Secret Itch of Nations*. Or because educational standards have lapsed since the eighteenth century, how about a *Book of Vice?*

But at the same time, one could argue that such a guide would now be redundant . . . a swimming lesson, as it were, held on the wreck of the *Titanic*, two miles down. In a world in which porn star Jenna Jameson is blown up twenty times life

size on billboards in Times Square, does anybody really need a guide to excessive misbehavior?

In a word, yes. Because the great tragedy of our times is what we might call the Vice Gap, the chasm between innocence and experience, between blue state excess and red state morality (or vice versa), between the lives of those described in *Us Weekly* and those reading it. Astonishingly, even in this age of excess, for most people indulging their inner demons means having a third beer, or staying up late to watch the soft-core nudie films on Cinemax. With the sound turned down, of course, so as not to wake up the wife. And yet, when they turn on the news, they see stories of people like Dennis Kozlowski, the former corporate CEO who spent $6,000 on a shower curtain, or Jack Ryan, the perfectly haired onetime Republican candidate for Senate in Illinois. Mr. Ryan had to drop out of the race in the spring of 2004 when a judge released papers filed in his divorce from *Star Trek: Voyager* star Jeri Ryan. In her divorce petition, Ms. Ryan accused her then-husband of forcing her to go to sex clubs in New York, New Orleans, and Paris, and demanding that she perform obscene acts upon him in public. Ryan denied the allegations, saying instead that on just one occasion, he had escorted her to what he referred to as an "avant-garde nightclub"—so called, we assume, because public fellatio is so much the *prochaine* big thing. He says they didn't like it, and left. Nonetheless, his campaign cratered, and with no other viable Republican candidates available to take his place, the Democratic nominee, an obscure state legislator named Barack Obama, all of a sudden seemed as if he might amount to something after all.

But the questions swirled: Where are these sex clubs? How

do you find them? Do you have to pay for admission, and is that admission inclusive of drinks? Or is it all à la carte? And how do you get to marry a starlet-model, anyway? What if they're all hanging out at the sex clubs, which we still don't know how to find? And while we're asking questions, what exactly does a $6,000 shower curtain do that the less expensive $4,000 model can't? Do the premium shower curtains neatly tuck themselves into the tub, or what?

But before all those questions come these: What is a vice? And why is it different than a sin?

Sins are things you do that are wrong in and of themselves, whether or not you enjoy them. They are committed, for the most part, out of necessity or compulsion. They include theft, lying, hitting people, and being mean to your little sister. Vices may or may not be wrong, but they differ from sins in that you commit them simply (okay, well not so simply . . . some of them are rather hard) for the pleasure they afford.

Can some actions be both a sin and a vice? Certainly. When Jean Valjean stole that load of bread to feed his family, he was committing, clearly, a sin. But if had continued in his life of crime, unlawfully acquiring a larger number and variety of bread products, until he was routinely skipping down to the local early-nineteenth-century equivalent of a 7-Eleven to boost some dinner rolls just before the guests came by, then clearly necessity had long since been left in the dust. In other words, as soon as sinning starts to be *fun*, it becomes a vice.

Although, as we shall see, the pleasure you derive from a vice often arises from the fact that you shouldn't be doing it; that is, your vice may not be a sin, but it's essential that you believe it to be one.

Consider again, in this particular light, the case of William

Bennett. When his gambling habit was exposed, one of his early lame excuses was that gambling was not among the sins he had explicitly condemned in his career-long jeremiad. Further, as he pointed out to those people getting tipsy on schadenfreude, he wasn't hurting anybody: it was his money, and having made millions scolding others for their misbehavior, he was certainly entitled to squander some fraction of that fortune on his own. (Well, okay, he didn't put it that way, but he might have.)

So, given that he broke no laws, and even allowing him a gimme on the hypocrisy issue, why, exactly, do we say that Mr. Bennett's continuing handshake with his One-Armed Co-conspirator constitutes a vice? Like a modern-day Linnaeus confronting the vast zoology of a permissive age, we shall describe the three essential elements of vices, as they have traditionally been described by me once I stopped to think about it a little while ago, and see how Mr. Bennett's activities clearly demonstrate each one of them.

ELEMENT ONE
Social Disapprobation

This is the aspect of vice that is often dismissed by the sophisticated would-be libertine, but it's the one most prized by the otherwise straitlaced narrow-road-walking occasional transgressor. Children, too, with their unschooled intuition, realize this is the best reason to do anything. They'll never admit it, but when asked to explain their latest act of cruel, random destructive stupidity, any child, of any age, will answer, in his or her tiny heart, "Because I wasn't supposed to." Is there any person on earth who, when confronted with any arbitrary line, would not wonder: What would it feel like to cross it?

This is deeply felt by those adults who, like Mr. Bennett, must foreswear any misbehavior. When he found himself (we conjecture) sitting on the right side of the velvet ropes at the high-stakes-slots area at the Trump Taj Mahal, down thirty large for the evening, and considering, in that way you know you're not really *considering,* but ramping up to *doing,* getting a line of credit for another ten Gs, one of the things he was thinking about, in that capacious part of his brain not required to manage the simple manipulation of the machine, was the people who might be walking over the parti-colored carpet behind him, clutching their buckets of proprietary tokens, glancing over at the slumped figure, and thinking, *Is that . . . could that be. . . ? What is he doing here?*

And Mr. Bennett smiled a little to himself: *Yeah, it's me. What* am *I doing here? Surprised you all, didn't I? Didn't I?*

It's a jailbreak, is what it is. It's a rattling of the cages.

<div align="center">

ELEMENT TWO

Actual Pleasure

</div>

Despite what various preachers and reformed vice hounds will tell you, vices are, in fact, a lot of fun. They are, however, of a particular kind of fun: that is, the kind you actually have, rather than convince yourself you're having. We illustrate the contrast with two examples: the lap dance, and the community half marathon.

THE LAP DANCE

During: You sit there while an incredible curvy and fine-smelling woman of apparently poor morals writhes in your lap. Your thoughts are filled with images so intensely biological that

you could profitably project your brain, PowerPoint-like, onto the screen in front of a second-year med-school lecture. Your inner monologue is "MMMMM. MMMMMM. MMMMMM. AHHHHHHHH. MMMM."

After: Shame, mild self-loathing, some disgust, pathetic self-inquiry as to whether she actually liked you, delusions as to reasons she probably did. "I bet at least I didn't smell as bad as some of the guys here. And I looked her in the eye, she liked that. I bet."

THE COMMUNITY HALF MARATHON

During: Pain, misery, agony. The first few miles were okay, you were settling in, a little bit like the three miles you run every other day or, okay, every third day, but this time you went faster because you are *naturally* a stud, no actual training required, and the day had come to let the world know. Especially Barbara Houlihan from down the street, who'll be standing near the finish line because her husband, Chuck, is also running, and you'll be happy to surprise her when you cruise on by at *least* a mile or so ahead of him at the finish, or so you promised yourself, with the enticement of visions of that tight children's size *Blue's Clues* halter top she likes to wear. But by mile four you were starting to feel it, and by mile six, your lungs were trying to crawl up and out of your throat and over to the curb so they, *the organs themselves,* could have a refreshing vomit. Your side cramp is bending you to the left like a rag doll, and the blister on your foot must be—*must be*—making little wet pus-footprints as you slog down the street. Mrs. Houlihan is forgotten, her husband miles ahead, probably already slipping his hand around to the bottom of her Old Navy jeans, and you couldn't care less, because all you want to do is die. Can you will your own death? You try. You try again.

After: Your strength gradually returning, you turn your attention
to deceiving yourself. The burning in your lungs has subsided,
although your legs are so shaky you might fall over. Mrs. Houli-
han is over there somewhere, and hope fights its way upward:
Maybe she'll find your posture, bent over and retching, oddly
attractive. Maybe it will bring out her nascent sense of pity.
Because, you know, it's easy if you're tall and fit like her hus-
band, but what if you're a slogger? A fighter? Like you? You be-
gin creating the embellishments you'll share with your friends
at work tomorrow: "The middle miles were a little hard, but I
got a kick there at the end. Endorphin rush. There's no better
feeling."

<p style="text-align:center">🌾 🌾 🌾</p>

We note in passing that as a useful field tool for identifying a
vice, one can always consider the anecdote told afterward.
According to the Law of Anecdotal Valuation:

*The intensity, quality, and general nastiness of any vice rises
in inverse proportion to the length and detail of the story told
about it afterward, with the exception of certain sexual vices, al-
though, frankly, if you're talking about it that much, it probably
didn't happen anyway.*

In other words, if the person talks about it a lot, then the vice
described really wasn't that much of a big deal . . . something
akin to getting through the twelve-items-or-less line with six-
teen items because you counted the ears of corn as just one. On
the other hand, if the subject of inquiry gives a guilty smile, and
even tells a story about the afternoon clearly contrived to be
dull, then she probably narrowly escaped arrest or physical in-
jury or both.

Did William Bennett enjoy his gambling? Absolutely. It's hard to tell from their slumped, sullen demeanor, but gamblers—even slots players—are happy as clams. As I shall explore in the chapter on gambling, games of chance are appeals made to the gods, and when they smile upon you, with their flashing lights and their ringing bells, they shine a warm bright light into the darkest folds of your brain. Which leaves just enough memory of pleasure to entice you to flow the three Gs you just won back into the machine and then another seventy-five hundred bucks after it. But guess which twenty seconds of a long afternoon ol' Bill will remember afterward. Even though he'll never talk about it.

Which brings us to our third and final element.

<div style="text-align:center">

ELEMENT THREE

Shame

</div>

Not only does shame naturally follow from the commission of a vice, it is an essential part of the vice experience. In much the same way we say, "No blood, no foul," we say, "No overwhelming sense of guilt, no vice." After all, the question of whether William Bennett did anything wrong with his gambling remained open . . . until he announced he'd stop doing it. Because, you see, it was wrong. Which is why he did it in the first place; see Element One.

But what, you might say, about the nameless millions who daily commit various unspeakable acts and gaily go about their business with not the slightest wisp of guilt or shame to interrupt their complacent feeling of a job well done? Am I saying that without shame, whatever act they committed, no matter how heinous, wasn't a vice?

Yes again. We can rely on the findings from sociology, namely, a principle loosely construed as "It's Nothing to Be Ashamed of If Margaret Mead Is Watching You Do It from Behind a Tree." Different societies have different cultural traditions; thus, while you, sitting in your cubicle, might feel bad if you had spent the prior night chewing khat and gambling away your children with the preserved bones of your enemies killed in ritual sacrifice, the denizens of the primitive culture I just pulled out of my ass wouldn't bat a richly tattooed eyelid. Conversely, they might feel really bad if they, say, had eaten their food with their left hand, and then they'd swear to themselves, secretly, for the fortieth time, that they really, really have to stop doing that, especially because Barb was sniffing at their left hand during the solstice feast the other night and they're sure she suspects.

But within the realm of recognizable, Western culture, which we will define herein as the stuff I know about, I would argue that this essential *shame* is actually an extension of the *pleasure* referred to in Element Two. Both flow from the essential *optional* nature of all vices.

It is also for this reason that in this book we will tread lightly on those behaviors that are commonly called vices—smoking, drinking, drug abuse—but are actually, for many people, physical addictions. We make this distinction primarily because, *pace* Foster Brooks, Dean Martin, and Cheech and Chong, substance abuse just isn't that funny. But mainly because, as said, vice involves a choice, and you can commit a vice only if there's an easy option to do otherwise: a parallel universe branching outward from the moment of truth: a universe in which you do not have that extra five pounds on your

hips, or that callus where you never thought it was possible to get one.

In fact, it's the active choosing to do wrong—that repeated trip down the Via Hedonista, with its stations of Places to Turn Back—that provides so much of the thrill of misbehavior. We part the beaded curtains, whisper the password to the implacable bouncer, ask for $10,000 in $500 slot machine tokens; we order our drink, we prepare our cover story. Each of these acts has within it, homunculus-like, the image of the more substantial thrill to come.

And then, later, as we ruefully rewalk that path and think of the ways in which we could have Done Right, we consider a world in which we didn't lose the money that was supposed to be for the baby formula, in which we didn't spend all night clicking through member's previews trying to find a picture that wasn't blurred out, and we feel that last leg of the tripod that holds up the Big Wide World of Vice:

You knew you shouldn't.
But . . .
You loved it.
And now . . .
You feel terrible.

🎋 🎋 🎋

The Fetish Ball's Kinky Couples Contest managed to stumble to fruition, with a few exhibitionist couples climbing up onto the stage and performing various bumps and grinds—and in one or two instances, considerably more—for the applauding

crowd, whose thought balloon reading "Finally!" was visible even in the dim light. The winner was a remarkably attractive woman who did a credible job of stripping off her bra and pants; I congratulated her afterward, and it turns out she was a stripper on her night off. A ringer.

After the contest, I wandered the club for a while, which is what everybody else seemed to be doing. The quiet crowd meandered from the Egyptian Room to the King Arthur Room, down to the Undersea Room, with its sad remaining glow-in-the-dark fish stuck to the walls. Some men exposed themselves, sitting on couches or chairs, while others pointedly did not look. Many of the women present were not biologically, or in some cases even very convincingly, women. Some true exhibitionists, including an enthusiastic foursome in the basement, took over an alcove and put on a sexual display, while a crowd of silent, heavily breathing men looked on. I spoke to one such man, a fiftyish fellow wearing an Izod shirt.

"Do you come here often?" I said, wincing. Hey, I really wanted to know.

"No, just about every other month," said Izod.

"Oh. So when was the last time you were here?"

"Last Thursday," he said.

We spoke briefly about what it was he usually did there: mostly watched, he said, but he always hoped to participate. In his telling, this seemed to occur when one of the women (or "women") putting on a sexual exhibition invited, or allowed, or tolerated, other men to touch them—from what I understood, that touch was often literal: just a hand, resting on a palpating thigh. Izod seemed to live for such moments. Certainly, if he had ever been a participant in the ideal, zipless porn-style encounter, he would have told me. I got the feeling he would have kept photographs in his wallet.

"Are you married?" I asked. He said he was. "Does your wife know you're here?" I asked. No, she did not.

"She wouldn't approve that you came here?"

"She wouldn't care."

<p style="text-align:center">�356; �356; �356;</p>

So: here were some true exhibitionists, performing for an audience of enthusiastic voyeurs. Over there, another such show-off, a naked man known only as Bram—a high-priced gynecologist in private life, I was told—happily submitted to the ministrations of a woman with a whip. As for the rest of us—that is, the vast majority of people—the customers I spoke to confirmed that, with rare exception, no single heterosexual man was going to get lucky here with anybody he did not bring with him. The Power Exchange was, for the most part, nine thousand square feet of tease.

Outside, at 3 A.M., waiting for my ride, I was chatting with Gina, Mike Powers's thirty-five-year-old fiancée, who had snuck outside for a smoke. She was dressed in a tight latex-and-leather jumpsuit, and was telling me about her previous life, living in the suburbs with her first husband. He had been injured on the job, and came home to lounge around the house all day while she worked, kept the house, took care of the kids—she told me about doing yard work with a baby on her hip while her husband sat inside and watched sports on TV.

"One day I came home with the groceries, and he gets off the couch, starts poking through the bags. I'm like, this is great, finally, he's going to put the groceries away. And he pulls out a pint of ice cream, looks at me, and says, 'I said butter brickle, bitch.' And I'm like, 'THAT'S IT!'"

Now she was engaged to a pansexual sex club owner, and a willing, if not particularly enthusiastic, member of the Sexual Underground. I asked her if, without Mike, she'd be hanging out in a place like this. She wrinkled her nose and shook her head. "It's fun, and it's interesting, and the people are, wow, but . . ."

A taxi pulled up, and out came three more single guys, dressed for a night of clubbing. They were slightly drunk, as were many of the people who came through the Power Exchange's door, and slightly wide-eyed as well. L.B., a senior member of the "Sex Squad," was working the door. He's a court bailiff by day, but hopes to quit that gig and work in the "entertainment industry" full-time. He cheerfully answered the guys' questions.

"This is a sex club. You go in, and if you find somebody you'd like to have sex with, you can have sex with them, using a condom."

The guys nodded, looked at the door, considered the $75 cover fee to get in. It's only $30 if you agree to take off your clothes and wear a towel.

"Yeah . . ." said one of them. "But is it for real?"

1

SWINGING

or

DINNER PARTIES
GONE HORRIBLY WRONG

It is a truth universally acknowledged that when a couple at a swingers club announce that they are there merely to observe, and not actually to swing, everybody loses interest in that couple pretty quickly.

"Research?" said one young woman, her enthusiasm for further conversation with Beth and me shrinking and disappearing like that little point of light on old vacuum-tube TVs. *"Research?"*

Well, uh, yeah. Beth and I had been assured by Ross and Rachel, owners of the Swingers' Shack,[1] a private, invitation-only

1 "Ross" and "Rachel" are not their real names, of course, nor is their club called something dumb like the "Swingers' Shack." In fact, Ross and Rachel are quite open about their lifestyle and their commitment to it. But with two

club for participants in what is called the Lifestyle, that it would be *just fine* if we wanted only to observe, to talk to people. "No pressure," we were told. "It's actually much better than a bar," said Ross,[2] because at a bar, you know, there was anxiety, there were expectations you didn't necessarily want to meet. Here, everything was cool, laid-back . . . we, the merely curious, could happily interface with the avidly active. Except the real difference between the Swingers' Shack and a bar is that at a bar somebody you meet *might* have come just for a drink or to watch a game on TV. Here, you had to bring your own liquor, on which you wrote your name with a Sharpie, and the only TV in the place was showing hard-core porn, adding a sometimes discomfiting bass note of grunts and moans to the peas-and-carrots babble going on around us. No: with apologies to Ross's nice spread of Hershey kisses and a $29.95 chocolate fountain, the only reason people came to the Swingers' Shack was to *get it on.*

Except for us, which we made clear as soon as we had to, which was pretty early in any conversation. And then our interlocutor's eyes would go vacant, and soon he or she would wan-

exceptions—"Joey" and "Monica"—none of the other people I met at the Shack knew that I would be writing about what happened there, and I'm determined to erase any clue that might help someone figure out who they might be. So: every name in this chapter is fictional, and I've changed and obscured other details as well.

2 I had decided to refer to the proprietors of the Shack as "Bob" and "Carol," a reference to the famous wife-swapping movie *Bob and Carol and Ted and Alice,* but Ross objected, on the grounds that those names "tend to conjure up images of swingers from the seventies—you know, the open-shirt, hairy-chested guys with gold chains hanging around their neck." Instead, he asked that he and the couple they're closest to—who were going to be "Ted" and "Alice"—be referred to by names from the TV series *Friends.* I'm not sure that it's appropriate, conjuring as it does unorthodox uses for that famous couch, but I thought it interesting that this is how "Ross" would like to be seen, so I'm happy to oblige.

der off to talk to somebody else. Or, once, a man indicated his boredom with us by idly reaching out and palpating his wife's breast.

I don't blame them: this April night was the last party at the Swingers' Shack, maybe for the summer, maybe for the year, maybe forever. There was no time to waste with people like me. But still: in a lifetime in which I've been to all kinds of sexual marketplaces—bars, parties—this was the first time that I was going to get ignored because I *wouldn't put out*.

🔆 🔆 🔆

I had contacted Ross through his website, asking for permission to come interview him, his friends, and his "guests" because of all the varieties of deviant behavior, the Lifestyle seemed the most wholesome. In it, we are told, consenting adult couples . . . well, *consent*. The events at the Shack, like at almost every other club within the swinging community, are for the most part couples only, for various obvious and subtle reasons. And these couples have agreed that each partner can have sex with other people, within whatever confines they've set for themselves, and in each other's presence. It offers all the pleasure, security, safety, trust, and stability of monogamy, without the monogamy.

In fact, it sounded perfect, a model of what most men, and many women, would want from their sex lives—not for nothing was Plato's Retreat, the swingers club of the seventies, named after the inventor of the Eternal Ideal. And of course, to my mind, it was utterly impossible. How could stable, happy marriages survive adultery as a hobby?

We are told, via their occasional interviews in the press, that

swingers or Lifestylers or whatever are no different from you and me . . . they meet up to socialize, talk, drink, and dance with their good friends, old and new. And then they have sex with them. Which makes me stop, and consider the various good friends my wife and I have, and then consider how it would be if one of our suburban dinner parties ended with us removing our clothes and performing sexual acts, and I have to put my head between my knees and take deep breaths.

Ross told me straight up that he had been the recipient of some bad press, and was a little nervous about opening his club to a writer. We agreed, eventually, that I would first come and interview him and Rachel at the club, which was also their home, and then, if everyone felt good about it, my wife and I (*Couples Only!*) would attend one of their parties.

I asked him via e-mail: "And it's all right if we're there merely to observe, and not to participate?"

"Absolutely," he replied. "We encourage that. Nobody has to do anything they don't want to. No pressure at all. Although I looked up your picture online. I don't think you've got anything to worry about."

Swinger humor.

<p style="text-align:center">🕊 🕊 🕊</p>

Ross is a lawyer with his own private practice; Rachel, his wife and partner in life and avocation, is an accountant. (It is a cliché, of course, but true nonetheless, that the people involved in the Lifestyle are "normal people," lawyers and accountants and teachers and cops. If you're a rock star, model, S&M enthusiast, or sex-crazed porn star, you don't *need* to go to invitation-only clubs to have sex with lots of other people, do you?)

Childless, in their early forties, Ross and Rachel had stumbled into swinging nine years before, when a young woman of distant acquaintance and bent morals propositioned the both of them, via a letter laying out various scenes and scenarios. (Did it have bullet points? I wonder. Did it end, "Sincerely yours"?) Ross, presumably with his heart racing a bit, showed it to Rachel, prepared, if she reacted negatively, to say something like, "Yeah, isn't that awful? Yeah, I'll rip it up. No, I'll burn it. Have a lighter?"

But she did not, and the idea went from blueprint to actuality. The Instigating Woman went off to other unexpected propositions, and nine years later, not only are Ross and Rachel actively swinging, but they've devoted their lives, their homes, and their public reputations to it. Their first version of the Swingers' Shack[3] was in a suburb (swingers clubs tend to be suburban . . . because that's where doctors, lawyers, teachers, and accountants tend to live) and was going along swimmingly, when a neighbor dropped the proverbial dime on them, and the cops arrived, searchlights blazing and, we presume, coplike square jaws agape. A media storm followed, but no charges of course, because, as Ross pointed out to anyone who asked— he's a lawyer, remember—there's no law against inviting close friends to your house to engage in activities as old as life itself with other consenting couples. Even if each couple paid $60 to cover expenses—haven't you asked your friends to bring a covered dish, or a six-pack of beer? And even if they had never met some of these close friends before they showed up with their $60. And even if the hosts had to do extensive background

3 Really, I wish I could tell you the actual name, because it's not bad, and I think Rachel and Ross would like the publicity.

checks on their guests to make sure they weren't bringing a paid escort posing as their wife, because, you know, people do. It's happened to most of us, I'm sure.

Free from any threat of jail or fine, Ross and Rachel still had had enough—they sold their suburban home and bought a two-story building along a major arterial street in the big city, where, they say, they've never been bothered by anyone. Here, nobody notices cars parked on the street every Saturday night, or loud music, or any other noises—in fact, they have a tenant in the upstairs apartment who's never noticed a thing. "He just thinks we're popular," assumes Rachel. And the only cops who show up, like the two I met the night we paid our sixty bucks, are also guests of the house. Their parties have over time become popular, and well known among the swinging community, with some of the thirty to forty couples attending each Saturday night coming from other cities and sometimes countries. In fact, Ross asserts, only half joking, with the airfare, hotel rooms, and taxi rides purchased by their guests, the Swingers' Shack is an asset to the local economy.

They had become sexual entrepreneurs through necessity, they explained. (Or, rather, Ross explained . . . maybe it was just their different styles, or the particular challenge of my tape recorder whirring in their faces, but Ross did most of the talking, and Rachel could hardly get a word in edgewise.) First, in those days immediately following that instigating incident, they had tried the typical method to find other partners in play:[4] the

4 "Play" and "playing" are just the most favored of many euphemisms for sex among the swingers I met. In fact, they don't even like saying "swinging," and they just hate "swapping," which for them is a term that implies ownership; you swap baseball cards, not people. (However, they do talk about

Internet, placing and answering ads on swingers' message boards. But that proved inefficient.

"The online thing," Ross said, his voice dripping with regret for those wasted hours, "you'd meet for drinks, and in the first five minutes, you'd be like, I can't stand this son of a bitch, and then you're stuck there!"

It was so common as assumed to be the rule that the "Hey, let's try swinging" thing was the man's idea; so many times you'd meet some nice couple in a hotel bar, and as soon as the idea of swapping more than restaurant recommendations came up, the woman would react with a kind of horror strangled in shock, because her husband, who had arranged an evening of drinks with "this interesting couple I met online," hadn't gotten around to mentioning exactly why he wanted to meet them in a *hotel* bar.

Rachel said, "You don't know if it's the guy—"

Ross, interrupting: "How it starts, for almost every couple out there: the man has a threesome fantasy with another woman. We're all studs. We can all please more than one woman."

In fact, Ross's objections to most of the guys they met this way seemed to arise from a sense that they were too much into making that fantasy real. As he put it, "I get the feeling that the guy's trying to become like Wilt Chamberlain. . . . Maybe Rachel doesn't pick up on it. If I get that sort of feeling . . . if I don't respect him . . . it's over."

"full swap," which is intercourse with a person not your spouse, and "soft swap," which is oral sex and other, more mild forms of sexual activity.) In general, for a community of people who are really, really interested in sex, they are rather prim about their language. It may have been an attempt to spare my feelings; it might have been that using the more familiar, profane terms for the activities they are so avidly interested in would make their interest seem vulgar. Or maybe they were just raised well.

I asked if it ever happened the other way: if, upon meeting a couple, the man met Ross's high standard for decency and honesty and non–Wilt Chamberlain-ness, but Rachel exercised a veto because she didn't care for the woman.

Ross answered for his wife: "I don't think that's ever happened."

Then I asked them if, in fact, jealousy ever came into it, if a swinging wife or husband might veto potential partners in play because their counterpart in the other couple *was*, in fact, Brad Pitt/Angelina Jolie, or if one's own partner was reacting as if they were.

"I guess," said Ross. "But if you have an issue with jealousy, stop! Get out! It's not a place for any sort of jealousy issues, or any sort of relationship issues."

"Yeah," said Rachel. "It's—"

"We counsel people: If you have any sort of issues whatever," said the man who opens his home one night a week to carefully vetted strangers so he and his wife can have sex with some, or perhaps even, eventually, all of them, "then this is not for you."

So: let's say you want to attend a party at the Swingers' Shack. First, you fill out a fairly elaborate application for Ross, with your name, your address, your occupation, your history in the Lifestyle, and the same for your partner or spouse. And he will check it out, very carefully, all the way to tracking down your online identity: he barred one hopeful couple because the "wife" sent an e-mail from an account used by a professional escort. His main purpose in his background checks isn't, surprisingly—given his history—to foil any attempts to infiltrate the club by vice squads. He did recently turn down the

application of two police officers who had pretended to be a small-business man and a grocery clerk, but not because they were cops: he blackballed them because they were both married to other people. There is no cheating allowed at the Swingers' Shack.

Ross wants guests who are heterosexual couples in long-term, stable, honest relationships. No first (or second, or third) dates at the Shack; no gay men; and most important, no single men using a friendly female acquaintance as a golden ticket to the bacchanal. In fact, as part of the application process, Rachel will insist on speaking to the woman, on the phone, just to make sure she's with the program.

Single women are allowed in the club, and everybody salivates on the relatively rare occasions when they show up. But single men are the kryptonite of the Lifestyle; everybody fears them and almost every club bars them. Partially, it's practicality: as my experience at the Power Exchange showed, since there are so many horny unattached heterosexual men, if you opened your doors to them they would overrun your place and eat all the candies and generally make a nuisance of themselves, like Tribbles with erections. But it's also, I think, one of many indications that despite many claims of this being a woman-centered scene, in the end, male preferences are the trump. Having a careful selection of polite, handsome, generous single men at an evening's party might make for a real treat for the women in attendance. But to the men, while an array of sexual choices is a wonderful thing, it kind of loses its zing when the choice is someone else.

I point out to Ross: he takes painstaking care to make sure that every couple he invites to his club is committed, loving,

open, and absolutely honest with each other, a true working marriage . . . so they can come here and have sex with other people.

"I don't see the irony," says Ross.

<center>🔥 🔥 🔥</center>

If you pass his muster, you and your significant other show up as the party starts at 9:30 P.M., an hour before the veteran guests begin to trickle in. Ross and Rachel take your sixty bucks—legally, a voluntary donation to help cover expenses—and invite you to hang up your coats and put your self-supplied liquor bottle on the table near the plates of supermarket-bought snacks and candies. They give you a tour of the Shack.

The main party room, which looks like either a downmarket cocktail bar (without an actual bar) or a suburban hedonists' basement circa 1975, with high round tables, a raised dancing floor with mirror ball and stripper pole, a card table for strip poker games that Ross always hopes will break out (but, we were told, almost never do), random framed posters, and dirty Sharpie graffiti on the wall.

Then, accessed via doors and short hallways from the foyer, the Rooms. Here's the so-called Orgy Room, with a trio of mattresses on the floor and only a curtain over the doorway. Anything that happens in this room, you're told, is for public consumption. This room, as it turns out, is surprisingly popular.

The Semipublic Room has an open doorway and two mattresses, enclosed and separated from each other by curtains. This is a place for "play" that might become public, might not. A couple could become a foursome by a simple sweep of an arm.

The Private Rooms have doors that firmly close, meaning, when they do, that the people inside have everything, and everyone, they need, thank you very much.

All the rooms have mattresses on the floor (Ross expressed regret at the lack of actual bedsteads, which might give the place less of a utilitarian vibe), genial if inexpensive attempts at decor—one room, for example, goes for an Oriental feel with black fans on the wall—and dishes of condoms. Not too many condoms, you'll note, certainly not enough for the "level of play" you have literally come to expect. Why not? Because people grab fistfuls of them and put them in their pockets. Background checks can't screen out opportunists, it seems.

And then there are the rules, which are printed on the liability release you signed when you handed over your sixty bucks. Chief among them is the Swingers' Motto, which is: "No means no." In an environment in which sexual interest is expected and encouraged, everybody is explicitly given the right of refusal, and commanded to immediately respect anybody else's invocation thereof. It's calculated both to keep people safe, and, in a bit of basic reverse psychology, to encourage participation: people are more likely to be open to New Things if they know they're not obliged.

But unwritten on the sheet, and unspoken unless, like me, you keep asking your hosts and their guests and their friends and their "partners in play" about how all this libidinous, chocolate-fountain-accompanied playing is possible without, eventually, somebody getting really mad or jealous or obsessed or just sad, is the Most Important Rule of All, the Swinger Prime Directive:

No Drama.

❧ ❧ ❧

When Beth and I show up at 9:30, like the newbies we are, Ross seems a lot more nervous than when we had met earlier. Maybe he had come to regret our arrangement. We had agreed that it would be fine for Beth and me to attend under the pose of a Curious Couple, just checking out the scene: as he said, it happens all the time. I was not allowed to mention that I would be writing about the evening, for fear that that would make people shriek and scream and go running out the door. In general, people at the club are protected by Mutually Assured Humiliation: you can't tell people you ran into somebody at a sex club unless you were there too, can you? But an outsider threatened the balance. Ross was particularly concerned that somebody might recognize me from my radio show and figure out I was a journalist, but I assured him, first, that I didn't think the NPR demographic tended toward open marriages, and second, that if anybody did recognize me at a swingers club, hell, I'd want them to tell the world. Take that, Click and Clack.

There are already about ten couples in the main room, some of them huddled by themselves, looking around bashfully, some of them already talking with old friends. As soon as we arrive, Ross, apologizing, turns the TV from a basketball game back to the porn channel, and everybody proceeds to ignore it. The couples here seem to be mostly over forty, some of them past fifty, with a few younger people already radiating a King of the Prom glow. They're dressed neatly and casually, though some of the men are wearing blazers and ties. Nobody is naked. Nobody is spraying whipped cream on one another. It's

not so much an orgy, at this point, as a Casual Friday postwork gathering of a small accounting firm. With porn on the TV.

Here are Joey and Monica, Ross and Rachel's closest friends, and guests of such duration that they've become de facto co-hosts. They're also the only people who know what we're really doing here. Monica gives me a hug and offers Beth a warm embrace.

Unlike Ross and Rachel, Joey and Monica are on the down-low. . . . Their friends outside the Lifestyle have no idea what they do on Saturday nights, nor do their three children, aged twenty, eighteen, and sixteen. Joey and Monica have been married twenty-one years, and swinging for the past five. Which brings up in my mind a pressing question: What do you tell the babysitter?

"That you're going to a party," says Monica. "And that you'll be back late."

Their story was similar to Ross and Rachel's: years of monogamy, with increasingly predictable sex, until one day an Inciting Incident, involving a fellow (male) student of Monica's, a late-night study session, some or lots of alcohol, and Monica finally getting to say the words, with some glee, "I think I'll slip into something more comfortable." Subsequent attempts to repeat the experience led them first to Hedonism II, the famous Lifestyle resort on Jamaica's Negril Beach, and then to the Swingers' Shack.

They are an odd, and oddly delightful, couple. Joey is tall, gangly, nearing sixty but with an earring and scraggly beard: an aging hippie with a flat midwestern accent. He says he's "always lived life on the edge, I mean physically, mentally. I did the Alaskan pipeline, I was a bounty hunter in Australia for rabbit pelts, I did tours of the Hawaiian islands. . . ." Monica, almost

twenty years younger than Joey, is bubbly, flirty, and cute, with a loud, charming, and frequent laugh.

Joey, like his friend Ross, is a talker, prone to lengthy disquisitions about Philosophy and Society, starting one typical monologue with the observation, "When *Playboy* came out, they didn't show pubic hair." But Joey is extremely deferential to his wife, who interrupts his disquisitions at will. In fact, Joey's focus is all Monica. He constantly praises her to me, in front of her, claiming that the scene they're in is all about the women: "I'm really just here to drive the car here and back." Everybody tells me this—that it's really All About the Woman!—but everybody else who says that has the air of a father explaining that he drags his kids to the dog track because they like animals. Only Joey really seems to mean it. It is most likely, I eventually decide, that Joey is one of those men whose particular fetish is seeing their wife sexually involved with other men.

In fact, early on in their swinging experience, one of those men caused a problem. It was their first real involvement in a full swapping situation, and the man in the couple "played" with them many times. Then one day, in what seemed to me to be an unavoidable development, the man confessed to them that he had fallen in love with Monica.

Joey, telling the story, was indignant. "We had had great times. We had *broken bread* together. And he says this thing to my wife! I'm like, you're lucky you're alive today."

Why? Because he had the temerity to develop emotional feelings for the woman he was constantly having sex with? Wasn't that inevitable?

"It's not inevitable!" Monica cried. No: what this was, was *Drama*. Which is defined as: having an emotional attachment to the people you're having sex with.

"Here's what I don't understand," I said. "You guys keep telling me that this is not just about sex. You actually don't like those people in your scene, who you call 'hard-core,' who are just about sex. You say you're into relationships, meeting people, liking them, connecting with them on a personal level, before you have sex with them. But at the same time, you're not allowed to actually have an intimate relationship with them."

"You're confusing intimacy with sex again, Peter!" interrupted Ross, with some irritation. Ross was of the mind that sexual pleasure is just a physical sensation, and the only reason I associate it with emotions is because of societal pressure. "Has your wife ever gotten a massage, Peter? I mean, how do you feel about that? What's the difference between getting rubbed in one place and getting rubbed in another? Huh?"

"Well, wait a minute," said Monica. "I'm a massage therapist."

"When I was a kid," began Joey, "I was Christian, and boy, was religion respected. Nowadays . . ."

This was a place balancing precariously on a complete paradox: It celebrated, induced, and cherished something that everybody had to pretend was completely unimportant. And the second you acted like it was important—or more important than your mate wanted you to think it was—you'd lose your chance to indulge. So everybody had to act as if it meant nothing.

Both Joey and Ross swore that despite their enthusiasm and dedication to the Lifestyle, they could quit, instantly, if their wives asked them to. *Instantly.* Though, Ross said upon reflection, that wouldn't happen. Or, more likely, he said, while she was standing next to him, Rachel would say that *she* didn't want to do it anymore, but that he could go ahead, if he wanted. Not that he would, though. Because *his marriage was more important than this.*

Eventually, frustrated that no one was dancing, Ross left us to our own devices and took over as DJ. He cranked up the Black Eyed Peas singing "My Humps," as well as "The Bad Touch," by the Bloodhound Gang, a song that, in pungent rhyming form, expresses the premise behind all this organized adultery: "You and me baby ain't nothin' but mammals / So let's do it like they do on the Discovery Channel."

�482 �482 �482

But are we, in fact, nothin' but mammals? Are we monogamous at heart, as we were taught, or is monogamy an ill-fitting social construct jammed, muzzlelike, over our true selves? Biologists and moralists have always searched for examples of animals that "Mate for Life," in a somewhat pathetic attempt to limn our own social mores with the approval of nature. I'm not sure why it's worth the bother—does this particular misery love company across species? Would a man or woman, finding him- or herself thinking it'd be more fun to watch a Jimmy Kimmel rerun rather than hop into the sack with the rerun snoring in the other room, take comfort in the fact that the trumpeter swan is also Faithful and True to its mate? Probably not, and it's irrelevant because, of course, the trumpeter swan, like just about everything else in nature, is a slut. Studies of every single animal species in which the male and female demonstrate monogamous behavior—mating and remaining together as a "social pair" in order to raise young—also show evidence of fooling around. Many of those noble, supposedly monogamous male trumpeter swans, famed in song and story and cheesy Hallmark cards, sometimes end up raising somebody else's young.

Psychologist David Barash, author of a cheerfully subversive

book called *The Myth of Monogamy,* writes of the early days in which researchers found themselves shocked by how much extracurricular feather nesting was going on in nature, resulting in tut-tutting papers like "Extra-Pair Copulations in the Mating System of the White Ibis." But then, as the cumulative results made themselves starkly clear, the scientists found themselves trying harder and harder to find a species where rampant beastie cheating *wasn't* the rule, publishing papers like "DNA Fingerprinting Reveals a Low Incidence of Extra-Pair Fertilizations in the Lesser Kestrel." Huzzah for the lesser kestrel, which only cheats on its mate *a little bit!* That's why it's called the lesser kestrel, of course. The greater kestrel is a horn dog like you wouldn't believe.

Olivia Judson, the ambiguously sexy British biologist (on the one hand, she's a babe who writes about sex; on the other, the sex she writes about often involves pedipalps and the violent death of the male), has documented the amazing variety of sexual behavior that obtains in the natural world, and compared to what's going on in your average hollow log, Melrose Place was a monastery. In dung beetles, for example, males can be either large or small. The large beetles attract females by their ability to dig out holes (in dung, natch) for nests. The small beetles wait for the moment when the Big Guy's back is turned, rush into the hole, copulate with the female, and scarper off before Big Guy turns around again. We presume then that the female dung beetle greets the larger male's suspicious gaze with an innocent "What?"

Ms. Judson shows in her work, through hundreds of examples, not only that the idea of lifelong mating and sexual monogamy is vanishingly rare in the natural world, but that evolution has designed almost all its creatures—both male and

female—to copulate as frequently as possible, with as many partners as possible, and *by any means necessary.* You may know of the praying mantis, one of the shockingly[5] numerous species of insects in which the male is eaten or otherwise killed by the female during mating. Studies have shown that male praying mantises actually copulate better with no head, which will surprise no woman who's ever attempted to talk to a man during foreplay, especially about the idea of maybe having some foreplay. But an even more stark example of nature's sexual morality is the male honeybee. When the male honeybee ejaculates, he explodes. And before female readers start weighing the pros and cons of this, consider that via this explosion, the honeybee separates himself from his genitalia, which he leaves lodged in the female, preventing any further canoodling. The bee goes to his death in his moment of ecstasy, his last thought probably being the honeybee equivalent of: "Hah!"[6]

None of this should be surprising. As zoologist Richard Dawkins points out, from the perspective of evolution, there is no such thing as morality, in the sense of some innate obligation toward another being. There is no "good of the species." There isn't even a "good of the individual." There is only, in his classic phrase, "the selfish gene," and all those little jerks care

5 Well, shockingly to men.
6 One effect of contemplating all this animalian, ichthyian, and insectoid sexuality is a real existential wooziness when it comes to thinking about one's own. You know, on an intellectual level, that the reason you're so interested in sex and sexual stimulus is a biological imperative to reproduce. And yet, realizing that you fantasize about spending the night with Carmen Electra for exactly the same reason that a male Caribbean reef squid dreams of placing a sperm packet on the head of a female can dull one's erotic reverie, plus it offers a different perspective on romances like, say, *Wuthering Heights.* "Oh, Catherine, do not reject my offer of a sperm packet!"

about is propagating themselves. They care no more for your morality, or your marriage, or your good behavior than a recently exploded honeybee. In fact, if a gene, through some freak mutation, caused its host animal to be a gentleman about the whole thing, and be True to His Only Love, that gene would not last a generation, spending its short, sad life leafing through the host's bookshelves, alone, while other genes were sneaking off together to the spare bedroom. Metaphorically speaking.

And yet, despite all this, scientists suggest that it's likely that humans are among the rare species that are not overwhelmingly genetically disposed toward infidelity. What proof do we have of this? Why do we suppose that humans might be among the tiny fraction of animal species not programmed to rut with anyone, at any time?

Because of our small testicles.

"Testicle size is usually associated with sperm competition," Dr. Judson writes, thrillingly. "Males that are at low risk of sperm competition—either because they are good at defending a harem or because they are paired with a faithful female—generally have testicles that are small in relation to their body size. Males that are at high risk of sperm competition—either because they pursue a strategy of seducing the partners of other males or because their females mate promiscuously—generally have enormous testicles in relation to their body size. . . . Human males have medium sized testicles, suggesting a low to moderate risk of sperm competition."

And, she wickedly suggests, that may vary from individual to individual, with matching behavioral predilections. So, ladies, if you're sizing up some potential date in a bar, say, or in a coffee shop, and you're wondering if he'll be steady, loyal, and

true, always remember, before committing yourself, to ask him to drop his pants.

The totality of evidence is inconclusive, but it tends toward indicating that monogamy—or at least, female monogamy—may be the norm for our species. Limited genetic testing on certain family lines shows a low incidence of "extra-pair copulations" over time, at least, those that result in offspring. This scientific result actually supports my own theory. Which is, in essence: Human beings tend not to cheat on their mates.[7]

<div align="center">🐜 🐜 🐜</div>

It was now 10 P.M. at the Swingers' Shack, and the party was slowly getting into gear. Beth and I mingled, always moving as a couple . . . separated couples give people the willies. I chatted with Mike, a fiftyish political consultant who had worked on national, or hopefully-national-but-the-guy-couldn't-get-the-money-together, campaigns, and had even run for office himself, despite his decade-long enthusiasm for organized adultery. He spoke with admiration about what he called the signal event in American politics: the press conference in which Arnold Schwarzenegger, then running in the recall election for California governor, addressed accusations that he had groped women—not with denials, not with abject, groveling apologies and a promise to enter rehab, but with, essentially, a shrug: "He just . . . admitted it. He said, 'It was on rowdy film sets, what do you want, I'm sorry if I offended anyone.' And then there was a pause, and after an instant, a ROAR went up from the crowd,

7 Wink, wink.

as everyone started applauding." Mike's eyes seemed to grow moist.

In the meantime, Beth was talking to his long-term girl-friend, Nancy, a cheerful Asian woman, about forty-five, dressed in a businesslike sweater and skirt. She said that she had met Mike some years before, and he had been very open about his enthusiasm for the Lifestyle and his insistence that she also be open to it. She agreed to give it a try, and found herself so taken with it—"Everyone was so nice!"—that she now regularly made the hundred-mile round-trip from her home to attend events at the Shack. I had to believe her—she was there, after all—but her prim manner, her string of pearls and sweater set, made her seem like a pretty unlikely hedonist. I would have found it eas-ier to believe that she had come to audit the place.

And what about us? she—and everybody else, eventually—asked. Oh, we were just interested in the scene . . . wanted to see what it was about. No, weren't sure if we wanted to partici-pate. Not tonight, probably, most definitely . . . just curious.

And then began the backing away.

More couples arrived. I chatted about long-distance running with Elaine, a very attractive woman in her twenties, who was there with her fiancé, Gary. Gary and Elaine were both high school teachers at the same school, and one day had read about another pair of high school teachers, in Florida, who had been fired from their jobs when the school discovered that they at-tended sex parties like this one. Elaine admitted that their reac-tion to this scandal was ironic: they said, in essence, "My God, that sounds like fun," and ended up here. Elaine told me that she and Gary only engaged in soft swap with other couples, because intercourse was "sacred." Maybe, if they were ever discovered, that would give them plausible deniability with the school board.

After the typical questions directed our way, and the by-now predictable response to our answers (Elaine was the one who scoffed, "Research?" which, frankly, I think was particularly unkind, coming from a teacher), they moved quickly on to another couple, who, along with them, were the youngest and most attractive in the room. Weird, I thought: even here, there's a pecking order, like a high school dance. No wonder Elaine and Gary seemed so comfortable, then!

The talk in the early part of the evening was all about the future, if any, of the Swingers' Shack. Ross and Rachel had let everybody know that they were going to shut it down for a while, maybe indefinitely, but nobody believed it. There was some conspiratorial calculating about their profit . . . thirty couples a party, paying $60 each, that's $900 a week, $3,600 a month! No way they spent all that on pizza, candy, and condoms! They needed the income! But maybe that wasn't it, Mike suggested. He looked at Ross, who had taken off his Hawaiian shirt, revealing an ample, hairless belly, and was now dancing on the stage with Mike's girlfriend, who had removed her prim sweater and was now wearing only a prim white bra. "No way he can give this up."

After a while, we had run out of new couples to talk to, or at least couples who seemed willing to talk. One Latino couple sat by themselves all night, nervous, never speaking to anyone, or as far as we could tell, leaving the main room. Another couple, known as the French Couple, were regulars, but never spoke to anyone. They would dance with each other, go to the Public Room, have sex on a mattress, come back, and dance some more.

We realized that the population of the main room was strangely depleting. We had noticed no assignations being as-

signed, no public propositions, certainly no gropings. The cans of whipped cream by the chocolate fountain remained undisturbed. People were just . . . gone. We wandered out into the darkened entrance foyer. There, in the Orgy Room, two couples were slowly copulating on the mattresses. We quickly backed out of the doorway, feeling, despite the circumstances, that we were prying. In the Semipublic Room, a single bare foot protruded from the curtain hiding one of the two beds. We heard groans and various other noises. I stared at it awhile, trying to figure out both the sex and the posture of the whole person by judging the part. But the foot did not move.

Back in the main room: some of the women, having partially disrobed, were putting on some pretty impressive displays with the chrome pole sticking up out of the dance floor. The pizza was cold. The Latino couple still sat there. An older woman, with dyed blond hair, brought over a tray of Jell-O shots in plastic cups. I tried one. Much to my surprise—like I said to everybody I met, I'm pretty vanilla—I discovered that Jell-O shots are much like really bad-tasting Jell-O.

People started to reenter the room, looking, well, a little tousled. Ross introduced us to a couple with a "different perspective," one he thought we'd enjoy hearing about. Turns out that Ricky and Lucy's perspective was unique in that they didn't come here to have sex with other people. An attractive young couple who lived together, they came here once every five weeks or so to dance, get stoned, and then go into the Public Room and have sex with each other, and just each other. They were exhibitionists only, and while welcoming other people to watch them, and enjoying watching other people, they did not seek or welcome anybody to join them.

"Yeah," I said. "We just poked our head in there, and saw

'some couples, but they didn't really seem to be 'swapping,' in the classic sense."

"That was us," said Lucy cheerfully.

I think I blushed.

Before coming here, I had sworn to Beth—absolutely truthfully—that I didn't have any interest in participating in the evening's activities. She had said the same thing, of course. But she wondered, of course, if I was telling the truth—or, even if I was speaking honestly in the moment, how I would react once we were there. I wondered the same thing myself. Would the presence of so much flesh and opportunity overwhelm my ironic distance? Would I look around at the mattresses on the floor and the sponge-stippled walls and the rationed condoms in plastic bowls and say to myself, "Finally, I am home!" And what about Beth? A swinger of my acquaintance told me of a well-worn tale in the scene: A husband drags the wife to a club, but, once within the sanctum, the reluctant debutante becomes the belle of the ball—leaving the husband to dine on his own kishkes for the remainder of the evening.

If there had in fact been some weird harmonic resonance between our hidden sexual selves and this banal bacchanal, by this point it would have been hard to hide it. The air was damp with newly emitted sweat. We had not witnessed any of the transactions leading to "play," because we weren't participating in them, but it seemed easy enough. We could approach any of the other couples in the room, cock an eyebrow, crook a finger. I looked at Beth; she at me. And we realized, as we gazed into each other's familiar faces, in this very unfamiliar place, with its exotic promises of sexual excess being fulfilled in thin-walled rooms all around us, not only that were

we the most *boring* people in the club, but that we were the most *bored*.

We are ultimately unknowable, especially to ourselves, and I don't want to say that my wife and I have explored all the rooms of our inner mansions. Perhaps, someday, we will wander into (say) a specialty store for falconers, see the leather hoods used to blind and calm the hunting birds, and strange and wonderful scenarios will come to mind. Perhaps a day will come when I will find myself dressed in my big feather suit with plastic beak, trying to land on Beth's gloved arm.

But after a few hours at the Shack we were certain that wherever our urges might lead us, it would not be to here. Some people—in fact, everybody else in this building—saw willing strangers of various shapes and hues and said, "Yum." We looked around and said to ourselves, "But where have they been?" And what in the world would you talk about afterward? Some people come here and have visions of clumps of human beings, arms and legs and moans emerging from every angle. I looked around and envisioned saying to somebody, "Uh, wow, account- ing . . . Pretty busy time of year for you, huh?" while pulling on my pants. Beth and I looked for some other way to pass the time. There was an unused backgammon set, but the only thing duller than not having sex at a sex party was playing backgam- mon at a sex party.

🐦 🐦 🐦

We waited until a decent hour, about 1 A.M., after others had already started to leave, and made our way to the door. But there in the foyer were Joey and Monica. Monica had changed

into a thong and negligee, and Joey was stark naked—although, endearingly, he seemed vaguely embarrassed about that, and moved himself to a PG-rated position behind his wife, before finally excusing himself to go get a drink.

Monica was tired. She told us that earlier in the evening, a woman she had never met before—a newcomer to the club but apparently not to the Lifestyle—had flat-out propositioned her, and even though that kind of direct approach was "not my scene," she had accepted, and had spent the last hour or so in a closed-door room with that woman and two others, with their men invited to watch. Later on, she said, she'd pick another room and "consummate" with Wayne. She and Beth had become quite friendly rather quickly, and it must have been that, plus the lateness and the alcohol and the postcoital looseness, but for whatever reason, she started talking about her future in the Lifestyle.

"Joey's so much older than me," she said, and naturally, she expected to outlive him. In which case, she might find herself, again quite naturally, in another relationship. In which case . . . "I don't think I could bring somebody else here, somebody I loved, I mean. How would you introduce him to these people? How would you tell him about it?"

Joey, he who so loved his wife that he would go to any lengths to arrange for her to have sex with other men, while he watched and/or participated, as long as none of those people expressed any real affection for her, returned, in all his naked glory, and we took our leave.

On the way out of the Swingers' Shack, on what may have been, for all anyone knew, the last night of its existence, we ran into Mike's girlfriend one more time. She had shed the bra, and

was now primly topless, but still in her businesslike skirt. She gave me a hug. "We must get together!" she said.

Oddly, I didn't think she meant anything by it.

Addendum: Due to popular demand—Ross says, "Too many of our guests pleaded with us to stay open, so we acquiesced"— the Shack stayed open and continues to host parties almost every Saturday night.

EATING

or

SODOM'S RESTAURANT

Our evening at Alinea, the Finest Restaurant in the Country, began with two shaven-headed waiters bringing us sprigs of rosemary. They were, without question, the finest sprigs of rosemary I'd ever seen: perfectly shaped, fragrant, each little evergreen needle at the same fractally reproduced angle. Beth and I admired them for a moment.

I whispered to her: "Should we eat them?"

She didn't know. Perhaps the silverware would be a clue; for example, if we had been given little saws, we could attack the rosemary sprigs like tiny lumberjacks. But there were no saws, nor any cutlery at all. Our square matte-black wooden table was bare, except for the napkins. We decided to sit tight and wait for instructions.

❧ ❧ ❧

When you think about it, eating as a leisure activity, or sensual pleasure, makes as much sense as, say, everybody getting together for a fabulous exclusive party in which guests are allowed to breathe the finest oxygen, from custom-made ceramic high-pressure bottles.[1] Consuming food is a biological imperative common to everything from amoebas to elephants, and while other animals have their amusements—the play of kittens, the poo-hurling of baboons—no other creature eats strictly for pleasure or status. Yes, animals have their food preferences— but no horse ever sent a lump of sugar back to the barn, then turned to its stall-mates and said, "That stuff was beet sugar, which I simply can't abide, and frankly, I would think it's beneath an establishment like this."[2]

Consulting the anthropologist who lives just below my left ear, where he whispers wild speculation about human behavior, we learn that eating became a luxury soon after humans organized themselves into working groups efficient enough to

1 I write this knowing that, in fact, in the late 1990s, "oxygen bars" were all the rage in nightclubs in Los Angeles, New York, and other cities. . . . I saw one myself in Las Vegas in 1999. And yet, it is a concept of such ripe ridiculousness that even reality cannot diminish it.

2 The very day I wrote this sentence I came across an article in the *New York Times* about a pair of pandas at the Atlanta Zoo that are such picky eaters that four employees must seek out food for them. And keep in mind, giant pandas have a diet consisting entirely of bamboo. Apparently, they are so picky that a perfectly good variety of wild-growing bamboo that was delicious on Thursday will lose its savor by Friday, and a different variety must be procured. Even allowing for the fact that these animals are caged, and cannot pursue their natural foraging patterns, they still seem really, really annoying.

produce excess food on a regular basis. Jared (*Guns, Germs, and Steel*) Diamond argues in a 1987 essay that moving from a hunter-gatherer lifestyle—although there are those who would argue it's not a lifestyle, it's an orientation—to agriculture was among the "Worst Mistake Humans Ever Made" because it led, quite directly, to every ill that besets our species and planet today: overpopulation, overwork, pollution, poverty, racism, sexism, class stratification, Jennifer Bidle breaking up with me in the ninth grade, etc. His theory is that once it became *possible* to consistently create a surplus of food, it became *necessary* to do so, and all of a sudden, instead of lounging about, picking at the bones of the giant sloth you and your buds had bagged last week, wondering if maybe it was time to pick up the ol' stone spear again and go find another one, you were up at the crack of dawn chopping holes in the sandy plains of Mesopotamia, looking forward to your only vacation, viz, your untimely demise from overwork at the age of twenty-eight.

But these methods produced a surplus of food relative to the population required to create it—if they hadn't, human populations would never have grown over the earth. And we can guess what happened with that surplus, or at least the best part of it: *dinner parties*. To an acquisitive mind, there is no point in having anything if everybody has it, and if the people who don't have it are literally *starving* for it, then you've got all the savory sauce you need. We imagine the priestly and kingly castes of ancient Ur, for example, one of the earliest human civilizations, reclining with their barley beer and saying things like, "This goes smashingly with the canary giblets, *n'est-ce pas?*"[3] And

3 Translated from the cuneiform.

then the guests would go home and say to their spouses or concubines or whoever was assigned the task, in that ancient and alien society, of indulging the master's desire to brag, "You wouldn't *believe* what King Sargon served tonight. Canary giblets, with a paired barley beer. Old Ashurbanipal asked the king for the recipe, and got disemboweled."

We know that the Romans, as was their wont, perfected the idea of luxury in this area as well. The Roman aristocratic enthusiasm for feasting is axiomatic, almost synonymous with the word "Roman"—for many years, to take but one example, high rollers at Caesars Palace in Las Vegas were feted at a restaurant designed to look and feel like a Roman banquet hall in all its decadence, except in Vegas, of course, the serving girls worked for tips, and, of course, you couldn't purchase them from the owner if they pleased you. Except for that one time with Frank Sinatra. The Roman author Petronius, writing soon after the reign of Nero, describes in his *Satyricon* a fictional feast that was either an accurate depiction of a typical Roman blowout, or a sly parody: the fact that it's hard to tell says a lot about the author and his subject:

> The next dish was not nearly as large as we expected, but its originality made it the center of attention. For it was a round dish with the twelve signs of the zodiac arranged in order, over each symbol was set a food appropriate to it: over Aries, ramshead chickpeas; over Taurus, a slice of beef; over Gemini, prairie oysters and kidneys and so on. . . .
>
> Then the top of the dish is removed and inside: fat fowls and sow's bellies and a hare decked out with wings like Pegasus. Four figures of Marsyas sprinkle

*sauce over fishes in the corners of the dish. A little
later a huge boar is brought in with buckets of dates
hanging from the tusks, and surrounded by confec-
tions in the shape of piglets, which were for the guests
to take home in their napkins. When the side of the
boar was pierced, thrushes flew out, only to be caught
at once by fowlers. Next an enormous pig is brought
in, which when cut open poured out sausages and
black puddings. Now comes a boiled calf, dressed up
in a helmet, to be attacked by one latter-day Ajax
gone mad.*

Such gourmandizing has continued, as circumstances have
allowed, until the present day, taking a short break for wide-
spread famine and poor table manners during the Dark Ages.
Records of blowout European feasts exist as far back as the
thirteenth century, when royalty started developing a taste for
"subtleties," or custom-made sculptural foodstuffs that repre-
sented scenes or vignettes: a stag that bled wine when you
pulled an arrow out of its flank, and (perhaps apocryphal) a
clever combination of cloth and wax and food that represented
a woman giving birth to the main course. Such devices were, in
effect, both dinner and a movie.

The Rennaissance, of course, consciously called for the res-
toration of classical standards, no less in gluttony than in archi-
tecture, so by the time we reach the Sun King at Versailles
we're talking about feasts that took months to plan and weeks
to prepare and probably a couple of hours to polish off, much to
the rueful amusement of the thousands of peasants and ser-
vants who had labored to prepare the meal, who chuckled and
shook their heads and went back to quietly dying of scurvy.

Nowadays, as with almost every other aspect of what used to be the Divine Right of Kings and Kings Alone, anybody can partake in these pleasures: aristocracy, like roof tar, seeps downward. But in a world in which just about anybody can indulge his or her appetite straight through adult-onset diabetes and on to morbid obesity, entirely through drive-through lanes, those who really want to stand out as gourmands have to go the extra mile. For example, just as readers in eighteenth-century London subscribed to novels that were to be published by Goldsmith or Johnson, American eaters can now subscribe to production runs of Spanish ham. I do not know if they travel to Jerez to pinch the little porker in the thigh, in the manner of the witch seeing how Hansel and Gretel are coming along, but I know they want to.

These days, the rage among foodies is for single-source foods. Following the model of single-malt scotches, a branding idea created when some unheralded genius realized that instead of going to the trouble of mixing up something to make it taste good, you could charge a huge premium for the raw ingredients. Single-malt scotches begat single-barrel bourbons, which begat single-source coffees, which in turn begat single-tree chocolate (the cacao beans, apparently, are happier when they're roasted, shelled, and ground in the company of their siblings) and single-bush peppercorns. Someday soon we shall custom-order our eggs from individual hens, with placards attached to the cartons describing the individual chicken and its mood on the day it laid: "Anabelle/Riverbend Farms/Cautiously Optimistic Yet Apprehensive That This Clutch, Too, Will Come to Nothing." Many restaurants offer information on where the various ingredients are raised or farmed, so we can be certain, as we dig into our pork tenderloin with the demi-apricot glacé,

that the meat comes from an animal whose throat was cut by someone it knew and trusted. There are those who say that the ironic betrayal adds piquancy to the flesh.

But none of this is enough. It's all too common: If you really want to count as a gourmand, it's not enough merely to shop at Whole Foods (hell, the proles have so clogged the aisles, you can't even jump into the express line with your organic tempeh); it's not enough merely to fly to Carry-le-Rouet, France, for the annual sea-urchin festival; it's not enough to smuggle non-pasteurized Gilgora Pag cheese in your toilet kit as you return from Croatia. It's insufficient even to serve your friends the prized Kopi Luwak coffee from Indonesia, explaining to them—as if any explanation were needed, in your circles!—that these beans attain their rare luster and flavor from being eaten and shat out by wild civet cats, from whose feces they are carefully harvested, then sterilized, then sold to discriminating consumers in the world's capital cities.[4]

And God *knows* it's not enough to shell out $9,399 for a Viking 48" 4 Burner, Griddle, and Grill Professional Series Sealed Burner Dual Fuel Range. The suburbs are lousy with those things, which generally serve to provide pleasing reflections, on their shiny brushed aluminum fronts, of the master and mistress of the house eating Thai takeout on their custom-made Corian kitchen counter. God knows this because He bought one too, back in 1991, when they first came out, and nowadays all He does with it is fry bacon, because it turns out, as in the old joke, it wasn't that Daniel Boulud thought he was God, it was God who thought He was Daniel Boulud, and both were wrong.

4 I feel obliged to say here that I am not making this up.

Nope: If you really want people to marvel at your gustatory feats, as they did thirty years ago when the *New York Times*'s food writer Craig Claiborne dropped $4,000 for dinner for two at the Paris restaurant Chez Denis, then you're going to have to do more than simply fly halfway around the world, or order the most arcane ingredient prepared by the most haughty chef—and you're going to have to spend more than four thousand bucks, which, these days, is exactly $200 shy of getting you a bottle of Grand Cru Domaine de la Romanee-Conti 2001 at Charlie Trotter's in Chicago. You're going to have to do something special.

And of course, you'll have to do it without getting fat. After a night of Olympic-level sex with strangers, you can stagger home, bleary, in your torn lingerie, and still be an object of envy. And everybody knows that drugs, whatever other problems they might bring, have a pleasant slimming effect. But those among us who want to indulge the most basic appetite, to the point of inducing wonder and envy among the less fortunate, have faced a paradox. How can you wallow in stratospheric gluttony without paying the price in pounds? The Romans, of course, simply strolled from their banquet halls into the *vomitorium*, gave it all back, and returned for sixth helpings. But their short life spans provided a crucial advantage: they were most likely to die of bacterial infection or barbarian invasion before their tooth enamel rotted away. We don't have that luxury.[5]

5 My intrepid research assistant, Ted, tells me that this may be a myth, based on a misunderstanding of the word *vomitorium*. It refers to a passage by which audience members could exit, or vomit forth, as it were, from a stadium. However, he tells me, Cicero remarks on Julius Caesar vomiting after heavy meals, often with the use of an emetic, so we can assume it was a habit indulged in by at least some of the Roman trendsetters.

For example: Diamond Jim Brady, the legendary conspicuous consumer of New York's late-nineteenth-century Gilded Age—a man who possessed not one but six gold-plated bicycles—was famous in song and story for his extraordinary gourmandizing. He may, in fact, be the man who made eating into a form of desirable excess in American culture, as his extraordinary festivals of ingestion were routinely written up and gossiped over in the press. Here's one account of a typical meal, well-circulated.

> *A typical day's menu began at breakfast, with hominy, eggs, corn bread, muffins, griddle cakes, chops, fried potatoes, a beefsteak, and a gallon of orange juice. Next came a late morning snack of two or three dozen clams and oysters, followed at 12:30 P.M. by lunch (clams, oysters, boiled lobsters, deviled crabs, a joint of beef, and a variety of pies). At afternoon tea, Jim would sit down to a heaping dish of seafood and copious drafts of lemon soda. Dinner, of course, was the major meal of the day, and Jim often supped at Rector's, a posh New York restaurant. The meal included two or three dozen Lynnhaven oysters, six crabs, several bowls of green turtle soup, six or seven lobsters, a pair of canvasback ducks, a double serving of terrapin, a sirloin steak, vegetables, and much orange juice. Generally, Jim would top off the meal with a piled-high platter of cakes and pies and a 2-lb. box of candy.*

Legend has it that Mr. Brady would end his meal only when his stomach, which he would position four inches from the table at the start of the meal, finally made contact. In the great and glorious age in which he lived, before film actors and ac-

tresses supplanted pirate capitalists as American royalty, he was one of the nation's most beloved celebrities, famed for his exploits at the shops and at the table. But today, he'd be pitied as being morbidly obese, and *Us Weekly* would run grainy photographs of him emerging from his Fifth Avenue mansion in a muumuu and flip-flops to fetch his paper, his rolls of fat pouring out, with headlines like DOCTORS SAY: BRADY MUST LOSE WEIGHT OR DIE, and then he'd make a deal to have his stomach-stapling surgery taped for a special on E!, and he'd end up, newly svelte, with his own line of frozen entrees, such as Diamond Jim's Gilded-Edge Low-Fat Oysters Casino.

Thus, in this day and age, the food hedonist has a problem: How can you truly indulge yourself, purchasing meals so expensive, so elaborate, that even Henry VIII would blanche at the effort involved and suggest that maybe we all should just run by White Castle instead—how can you do this while still maintaining your svelte, ready-for-hedonism physique?

Molecular gastronomy.

🐝 🐝 🐝

Beth and I swirl the liquid around in the glass. . . . Our eager, intense, shaven-headed sommelier has told us it is Lheraud Pineau des Charentes, a cognac that has spent fifteen years aging in oak barrels waiting for this moment. I always feel vaguely guilty consuming something this old; I imagine that it had been saving itself for something better.

Waiters carefully place in front of us: a square of Lucite, four inches by four inches by half an inch, standing on edge. On top of the square: a sliver of metal, holding what looks like a single yellow die on which the spots were applied by a blind

person with a tiny brush. This is, according to the menu, "Corn, with coconut, cayenne, and lime." It looks no more like Corn (or coconut, cayenne, or lime) than a Whopper looks like the Queen of Romania.

"Lift them by the planchet," says the waiter.

We do. We hold them up in the air for a minute, waiting for further guidance; then we realize that (a) it is food, and (b) it is intended to go in our mouths. We place the cubes therein. We close our mouths. Odd things happen. The yellow die is, in fact, a kind of frozen corn custard. The spots on it were the coconut, cayenne, and lime. The result is quite literally indescribable—as if somebody poked your brain with an electrode and all of a sudden you started tasting things nobody had invented words for.

"Do you get to eat this?" asks Beth of the waiter who comes to fetch our now empty planchets. He's the only waiter with hair, and it's beautiful, so in my mind he becomes Gorgeous George.

"Oh, absolutely," says Gorgeous George. "I had, like, a pound of them for lunch!"

Gorgeous George is our favorite waiter.

> We simply micro-plane fresh matsutakes mushrooms over the cracker and arrange various herbs throughout.
>
> —CHEF GRANT ACHATZ

The origins of "molecular gastronomy" are the subject of some debate, and may never be entirely resolved: some histories begin with the food-preservation techniques developed by NASA for space missions, but most agree that the movement's founding prophet is Feran Adria, whose restaurant near Barce-

lona, El Bulli, is closed six months of the year so that Adria can retire to the food lab—that's what he calls it, a food lab—to further refine and perfect his techniques.

You and I may look at a banana and see a banana. If forced to come up with something more inventive to do with it, perhaps we'd mash it up, or maybe we'd dip it in chocolate, and say, "What a good boy am I." But a molecular chef would look at a banana and see something to be frozen, microtomed, processed into foam or liquid, or maybe, through some magic bit of alchemy, turned into a meatball. Why would you turn a banana into a meatball? Maybe because you've realized that the fibrous structure of bananas has certain similarities with beef protein, and can be manipulated into a congruent texture. Maybe because it occurred to you that the bland sturdiness of semolina pasta would provide an interesting contrast for the sweetness of the banana. Maybe because you want to comment on the visual comfort of spaghetti-with-meatballs by invoking the shocking, familiar, yet somewhat exotic comfort of "banana-ness." Keep in mind that I'm just pulling all of this out of my ass. But you can't eat any of this food, as spectacularly good as it often is, without thinking, all along, that all these celebrated chefs are reaching up behind their perfectly tailored chef's jackets with their names embroidered on the breast and doing exactly the same thing. Except they get three stars from Michelin for it.

🐦 🐦 🐦

A petite waitress—not bald, thank God—brings the next course. It is: an elegant glass, holding within it not liquid but what looks like a swizzle stick designed by Dr. Seuss—bumpy,

brown and curved, with odd red splotches wrapped around it. It rests in a small puddle of brownish goo.

"This is frozen yuba—yuba is a by-product of the manufacture of tofu—with blood orange around it, in a miso emulsion," says Petite.

No one has yet brought any cutlery. We realize that we're supposed to just pick up the swizzle stick and eat it.

"Looks like a gummi worm," says Beth, once Petite has walked away.

I take a bite. It is—again—indescribably delicious. Chewy and salty and sweet. It's—yubarrific.

"This is the best fried yuba I've ever had," I say, quite serious.

"Much better than Long John Silver's," says Beth.

The waiters whisk away the glasses, and only now, as we approach course number three, do they provide us with a fork and knife. Our sommelier brings a new set of glasses and fills them with Naiades Verdejo, from Rueda, Spain, whose qualities he explains in the manner common to high-end sommeliers everywhere: he knows you don't have any idea what he's talking about, but he understands that you're paying a 300 percent markup because you want to be treated like you do. Then: the waiters present us with sculpturally pure white dishes, on the middle of which, placed with the same care and artifice with which Leonardo da Vinci dotted the eyes of the *Mona Lisa,* is a long red strip of something I can't immediately identify. On this strip, arranged in the manner of a police lineup in which the suspects are all tidbits, are a globe, a spiral, a cylinder, a lump, a sprig, a lump, and a leaf. Gorgeous George explains that it's an heirloom tomato, with a mozzarella balloon, studded with,

among other things, pickled cucumber, couscous, and dehydrated garlic sausage. He smiles, and walks away.

I examine this thing and realize that the red strip is what you would get if you were to cut a thick slice of tomato, cut through the ring, and then roll it out flat, removing the extra goopy bits as you went. Thus, what I am confronting is, in fact, the salad.[6]

I pick up my fork and poke the mozzarella balloon, and it pops, releasing onto the plate a reddish foam which tastes intensely of tomato. I think of the guy in the kitchen who has the job of inflating the mozzarella, and somehow filling it with foam. I think of the guy whose job it is to make the foam. I think of the person who makes the dehydrated garlic sausage, all so a centimeter-long sliver of it can be served to me, along with nineteen other labor-intensive items to make this single dish, itself one of twenty-four one- or two- or three-bite "courses" we'll be eating tonight.

I have that swirling, terrified sensation characters in horror movies get when the kindly old professor starts laughing for no reason, and then they turn and try the door and see that it's locked.

My host for the evening . . . *is insane.*

> Surface area exposure to flavonoids is increased in liquid state due to coverage, but dissipates faster due to dilution and consumption.
>
> —Grant Achatz

6 The "Tomato" dish at Alinea has become a subject of some media fascination; one authoritative count, in *Chicago* magazine, lists twenty different elements, including the tomato.

The kitchen at Alinea is open to the first floor of the restaurant and strangely quiet, even in the middle of the dinner service. There's none of the clattering of pans and shouting in foreign languages you'd expect from watching TV shows about restaurants; no chaos at all, controlled or otherwise. And, for the record, there are also no huge Van de Graaff generators sending out massive sparks as Willa Wonka–like machines transmogrify broccoli stems into edible paintbrushes.

Instead: two very long stainless-steel worktables in the middle of the room, with stovetops and other equipment lining the two walls. The room is populated by intense, pale people, most of them men, all of them seemingly under thirty. They each lean over pots or plates or equipment, reaching into bowls for prepped ingredients or using squeeze bottles to administer a filagree of sauce. It's 9 P.M. on a Wednesday, and they've been at this for eleven hours already, with four or five to go. Most of the day has been spent preparing the various ingredients, and now the staff is primarily involved with what the fine-dining industry calls "plating," but you or I would call "serving the food," an art here practiced at a level of precision that, say, Michelangelo would have thought weirdly obsessive.

Nobody chats, nobody jokes, nobody, of course, bitches about the long hours or the four-top that just walked in and wants to have the whole twenty-six-course "Tour," which means the four hours till closing just became five. When they speak, it's in a code: "Grape thirty!" says a man standing at the entrance to the kitchen, with slips of paper on which he marks the progress of each diner's meal. "Grape thirty!" responds a chef, and shortly, a waiter appears, grabs a tray, and brings two little works of sculptural art, presumably involving a grape, up to table 30.

I have the urge to shout, "Bowl of red with frog sticks on the side, cup of joe!" just to see what happens, but I refrain.

I could easily have stood for an hour before realizing exactly who was in charge. But then I began to notice that on occasion, a waiter returning empty plates from a diner's table would stop by one particular white-jacketed chef, occupying a middle place along one of the serving tables. That chef quickly examined the leavings, nodded, and let the dishes go to the washer. Every now and then he made a brief request—never, at least not in my hearing, a criticism or even a comment on another's work— just a simple "Corn on two, please," and the response was instant and general: a chorus of "Yes, Chef," or "Thank you, Chef." The hostess came in from the front of the house with news or a question; he'd step away to deal with it, then go back to his place, to bend over two plates and begin, once again, to painstakingly create a work of art destined, in moments, to be picked apart with forks.

Grant Achatz was thirty years old when Alinea opened in the spring of 2005, and if the fourteen-hour days, six days a week, and the intensity and focus of his work have aged him, the damage must be limited so far to the internal organs. He's about five feet eight inches tall, slight in build, with tousled hair. Even in a kitchen filled with intense, well-scrubbed young people under the age of thirty, he seems oddly boyish. For a moment I hallucinate that he actually has freckles—maybe it's just bits of cayenne pepper.

And by the way, he really doesn't like being called a mad scientist, which I knew going in but asked him about anyway. "This isn't a science lab, it's *not* molecular gastronomy," he says. "It's a kitchen. We do things you would do in a kitchen."

Well, by "you," he doesn't mean, well, you. You, for example,

don't have an Anti-Griddle, a device Achatz invented in collab-
oration with a medical equipment maker, which allows him to
cool anything down instantly to minus thirty degrees Fahren-
heit by placing it on a metal plate. It's what he uses to make,
among other things, the corn dice. And you don't have a rack of
dehydrators against the wall, and you don't have a canister of
carefully selected maple leaves, which, as we spoke, an execu-
tive chef was immolating with a blowtorch, before smothering
the flames and then capturing the smoke in a glass so as to
season a marshmallow-sized bite of rabbit.

Let us grant, though, that he's not really insane, although
anybody capable of spending two or three hours preparing a
simple plate of food would probably find a mild mental distur-
bance, something like OCD, a little useful. But still, what the
hell is he after? A dish like his "Tomato" represents hundreds of
man-hours, what with the development and experimentation,
and then the laborious preparation of each of the twenty ingre-
dients, the painstaking final assembly and plating, all so that
some boor like myself, who wouldn't know an heirloom tomato
from a can of V8, can demolish the thing in ninety seconds.

"If I'm Picasso," he says, "and I paint a painting, a master-
piece, every time I look at it, as the years go by . . . do I get the
great pleasure that I did when I put the last touch of paint on
the painting? I don't think so. But *I* get that every night. When
a customer comes to the kitchen, and says, 'That's the best
meal I've ever eaten,' I get goose bumps . . . and then, the next
day, I get to do it again, and again, and again."

But right before I give in to his obvious antsiness and allow
him to go back to work, he makes an admission: "The fantasy
for me would be not to serve *any* food. It sounds ludicrous. If
we didn't have to feed customers, I could spend sixteen hours a

day creating. People say to me, 'Oh would you like to take six months off, just create?' And I say, 'Six months? How about a *year*! How about *always*!' We could just think of stuff, come up with a whole catalog of dishes!"

I say, "You mean, you'd spend all day creating masterpieces of avant-garde cuisine, and then just stand around and watch them melt?"

"Huh," he says. "So I guess it doesn't really work."[7]

Beth and I are deep into the Tour, at that point where you know that it would be just as hard to retreat as it is to press forward. We've had the Mackerel, Hamachi, and Squab. We've had the Bacon, which was a strip of home-cured meat, wrapped in apple and butterscotch, hanging from a custom-made wire contraption. Beth said, "It's a bacon harp!" I poked the bacon, making it swing a bit, and faux-shouted, "Where's the rest of the pig? Talk, damn you!" After plucking off the bacon and eating it, I examined the wire holder, and my poking at it caused the spring to unhook and sent half of the contraption flying across the dining room. A waiter picked it up, with an indulgent smile.

We've had the Kobe Beef, which was three small cubes of the precious meat served with two other cubes of watermelon prepared and cut to look just like the beef—"Choose carefully, Mr. Bond, or she dies!" And we've had the Black Truffle Explo-

7 At that moment, I honestly thought that I had wrangled a remarkable confession from him . . . something along the lines of getting Mick Jagger, say, to admit he didn't really like playing rock and roll, and if it were up to him, he'd rather just sit alone in the studio and play the zither. But then I discovered that Achatz has said that to other interviewers. Not that he doesn't mean it; he's clearly pursuing something far, far above and beyond mere commerce. But he also knows, apparently, that this "admission" adds to his aura.

sion and something called Bee Balm with Poppyseed Milk. "How do you milk a poppyseed?" asked Beth. "Very carefully, with tiny bowls," answered Gorgeous George.

And then—the table is bare again. Gorgeous George brings out two weighted metal disks and places them on the table in front of us. In each disk is a hole, and into the hole he slides a wire, held upright by the weight of the disk. At the end of the wire, bobbing in front of our faces like a marshmallow on a stick, is a white cube. "Menthol mousse," says George. "Chef believes that this should be eaten hands-free."

Beth and I look at each other, then, hands held firmly in laps, we lean forward and try to bite the menthol marshmallow. The wire bends a bit, and we have to chase it with our mouths. We are bobbing for haute cuisine.

Chef Achatz is known for his sense of humor. His favorite kind of joke is to name a dish after some familiar quotidian favorite. At his previous restaurant, Trio, he would serve "Pizza." The name is in quotes because his version was a stamp-sized piece of vegetable cracker. His famous "PB&J" is a bunch of grapes, still on their stems, peeled, then dipped in a homemade peanut butter, wrapped with a thin sheet of bread. He says: "Guests are not in the restaurant because they are hungry. Who doesn't like to laugh?" He has a point, both about the laughter and the guests not being hungry. He often refers, with apparent disdain, to the fad for "comfort food" that was widespread during his rise over the last eight years, as if "comfort" were the single most boring thing you could ask food to do. If you want something to fill up your tank, there's a Jack in the Box down the block. He's interested in creating food so odd, so unexpected, it ceases to be food. It's "food." Like John Cage made "music."

The apotheosis of his technique might be his shrimp cock-tail, a sensation at Trio. It was served in an atomizer—the bulb-pumped sprayer rich ladies use to apply perfume in old movies. The waiter would instruct customers to pick the thing up and spray it into their mouths, at least five pumps. What would come out: a fine mist of shrimp consommé. You had just reached a kind of foodie nirvana—eating a dish of fine cuisine with no calories, no fat, no actual food at all. And you paid about twenty bucks for the privilege. Perfect.

<p style="text-align:center">🐦 🐦 🐦</p>

We had sat down to eat at 7:30. It is now past 11 P.M. The Menthol was nine courses ago. The past two hours have been a blur, of Lobster with vacherin, litchi, vanilla fragrance; Porcini with cherry, ham, toasted garlic. What is a porcini? I used to know. I can't remember now.

We have slurped foam from glasses. We have sucked food from a Lucite tube, like an emperor's own Pixie stick. We have been given small red spheres and told that they were made of smoked paprika; we put them in our mouths, dutifully, and bit down. Peach ensued. We have been given little white wax bowls, containing a teaspoon of broth, with a pin inserted through them holding up a dab of potato and truffle. When you remove the pin, the potato and truffle fall into the bowl. It is a food grenade.

But after all that, I couldn't tell you what it was that finally set me spinning off my axis, into a weird, Stendhal-syndrome-like miasma. Maybe it was the Lamb: a sizzling hot brick placed on the table. On the brick: three perfect rectangles of meat so perfect and unblemished it looked like they were lovingly excised

from the Lamb of God itself, which dutifully laid down Its holy life when It read the feature on Achatz in *Gourmet*. And then Gorgeous George and Petite, moving in perfect synchronicity, picked up the rosemary sprigs from where they had been sitting quietly in their holders since the beginning of the meal, and placed them into specially made holes on the heated bricks. The scent of rosemary filled the air. I swooned, and the room spun, and I gripped the edges of the table to keep myself upright, and I could think of only one thing:

A roast beef sandwich.

Not just any roast beef sandwich, but a particularly greasy, leathery open-face roast beef sandwich that I had eaten just the night before, at an outpost of a chain of faux British pubs that have been popping up around Chicago. The sandwich, part of a standardized chain menu, must have arrived at the restaurant in the form of shrink-wrapped meat and sauce packets manufactured in China, plus one of those pictograph assembly posters you can glimpse pinned up at the cook line at a McDonald's: in other words, the lousiest, most tasteless agglomeration of salt, preservatives, and gristle you can conjure. And at that moment, staring at the perfect cubes of lamb that were achieving their optimum heat and flavor just before my eyes, due to the careful calculation of Chef Achatz, I would have given anything—including each of the delicious seven courses that were to come, and the brilliant eighteen courses I had already eaten, and the money I had paid for them—in fact, I would have given all the money I had in the world—just for that *roast beef sandwich*.

I looked at Beth. "Do you feel it too?"

"Would they be mad if we sent out for a pizza?" she asked.

We weren't hungry—how could we be? We were over-whelmed. Chef had demanded too much of our poor senses,

too much of our brains. They had short-circuited. We could no longer discern, or taste, or judge.

We just wanted something to eat, to fill our bellies. Preferably while reading a newspaper, so we couldn't even quite remember eating it.

We held on. Seven more courses appeared, each more indescribable than the last. I remember one of them made a moaning noise, or maybe that was me.

The sommelier appeared, with a bottle of Toro Albala "Don PX" 1971 Gran Reserva, Montilla-Moriles.

"This one is terribly expensive," he said with a laugh. It was a thirty-five-year-old dessert wine. For the last three and a half decades, while we had grown up, finished our schooling, traveled, met, fallen in love, married, had children, established or left or changed our careers, aged, lost our hair (well, mine), this wine had been sitting in its bottle, waiting for us to become worthy of it. We hadn't really, but we still drank it.

It was *amazing*.

I paid the $750 bill and licked the glass.

🌱 🌱 🌱

Down in the kitchen, at the end of my visit, I stopped on the way out to take one last look around. The staff had been serving food for five hours, after preparing it for eleven, and would be working until the small hours of the morning. I realized that these people were "cooks" in the way that Catholic priests were "stand-up comedians." They may have been trying to please an audience, but they were serving a much higher calling.

Chef Achatz, having painted one of his ephemeral masterpieces onto two large custom-made plates and sent them on

their way upstairs, wiped his hands on his apron, walked over to the corner of the room, and opened a box. He rooted around inside it, picking out some samples, throwing others away. Then, picking up a silver set of clippers, he began pruning away the tiny branches of his selected rosemary sprigs. He made each of them perfect, holding them up to the light, spinning them around to check on their symmetry. Then, with a nod, he placed them carefully on a waiter's tray, which carried them up, up to a table, where a couple or foursome had just sat down at the Finest Restaurant in the Country, if not the world, which is truly a magnificent and extraordinary place, well worth the eye-popping expense—as long as you're not hungry.

Then I thanked everyone and left. It was late, but I hoped Jack in the Box would still be open.

3

STRIP CLUBS

or

SURE, THEY LIKE YOU. REALLY.

The taxi line in front of Caesars Palace is always long on Sunday evenings, as people head to the airport after a weekend of doing things they really *hope* will stay in Vegas, but the wait isn't so bad because you can amuse yourself by watching people clutch their heads and weep. This time, though, on a particular winter evening in 1996, everybody seemed strangely cheerful. Beth and I struck up a conversation with the guy standing next to us, who looked like a shorter version of Pat Reilly, the basketball coach. His hair glistened in the desert sun.

Vic, as he explained to us, was a former cop on the Philadelphia vice squad, who had to retire on disability because of an on-the-job injury—"my partner backed our patrol car over my foot." Looking around for a new career, he considered his skills—mainly interviewing people and filling out paperwork—and his

friends, who tended to be the inhabitants of what Obi-Wan Kenobi called "hives of scum and villainy." So, he explained cheerily, he became a journalist covering the adult entertainment industry.

"Strippers," he said. "Exotic dancers. They had their convention here at Caesars over the weekend, didn't you notice?"

We had. As we lounged by the pool, we would hear strange ripples of noise emanating from around us—the distinctive sound of multiple necks craning off of vinyl deck chair cushions. The plasticky popping would move in waves, around the pool, following the progress of these extraordinary . . . well, *people* isn't the right word, because it connotes an anatomical similarity to our species. These were strange caricatures of human beings, weirdly inflated, their breasts enormous spheres, held in place by string bikinis with cups the size of fourteen-meter yacht spinnakers. Their legs were elongated too, their toes pointed straight downward into high-heeled shoes steeper than double black-diamond ski runs. Their lips and eyes and hair all seemed doll-like, if dolls were designed by aliens who had never seen a live woman but had been fleetingly and incompletely briefed on feminine features by very drunk frat boys. So, yes, we had noticed.

Vic explained that every year, the cream of the stripper cohort, or "feature dancers," as they are called, came to Vegas to perform before club bookers from around the country. These are the headliners—Lexi Lamour, Texas Barbie, Kayla Kleevage—the women who barnstorm across America, removing their clothes—and doing exponentially more—for audiences who come in specifically to see them. Some of these women, apparently, have very elaborate routines: Sally Rand's fan dance as re-imagined by sex criminals. And each year, Vic came to the convention, talked to the girls, their managers, their bookers, and

wrote up the scene for the trade publication for which he was chief correspondent.

"Can anybody come to the convention?" I asked.

"Sure," said the guy on the other side of us, who had been listening to the conversation with real interest. His name, he said, was Chris, and he had spent the weekend enjoying an all-access pass, for which he had paid around $200. I was young, then, and a little agog that a man would spend that much money, plus hotel, airfare, meals, etc., just to spend an entire weekend goggling at strippers. I asked him why.

"It's my *hobby*," Chris said. "I'm a trucker, and whatever town I end up in, I just find the gentleman's club and go there. I feel at home, and the girls are always so nice."

"Of course they are," chimed in Vic. "You have money in your pocket."

If Chris heard Vic, he showed no sign. "People say the girls are sleazy, whatever," he said. "But they're not. I'm friends with a lot of them. . . . A lot of them, in some cities, they know my name, they're really happy to see me."

Vic: "I'm sure they are. All the girls care about is one thing, believe me. That is: how to get the money from your pocket into their garter. One dollar at a time."

Beth and I looked from one to another: it was like a real-life version of those angel-on-one-shoulder, demon-on-the-other debates that happen in cartoons.

"Sometimes I just like to talk to the girls," Chris said.

"If you want to talk, they'll talk. If you want to have them grind themselves into your lap, they'll do that," said Vic. "Whatever it takes to get the money."

"I'll tell you what," said Chris, who continued to act as if Vic were speaking a foreign language, and to someone else entirely.

"I'd rather go to a strip club, spend my money there, talk to the girls, then go to a real bar, talk to some of the women there."

"They're like psychiatrists," said Vic. "Except they get paid by the minute, and in crumpled dollar bills. They can make a thousand dollars a night from men like this."

Chris looked at Vic. If he had heard any of what Vic had to say, or taken any offense, he showed no sign. Then his face broke into a smile: he recognized Vic from his picture in the magazine. Turns out Chris was a subscriber.

The first strip club I ever entered was in the French Quarter of New Orleans. I was by myself, just a year out of college, and I had wandered up and down the streets of the Quarter for an hour, eyeing the neon signs and the curtained doors of the mysterious establishments advertising EXOTIC DANCERS and NUDE REVUE. Finally selecting one to enter, I tried to conjure the right attitude with which to walk through the door—should it be the quiet confidence of a man who knew his pleasures, and knew where they were to be found? Or the shame of someone who admitted the depth of his own degradation and had ceased to fight it? I settled for a combination of the two, and pushed the curtain aside with the world's first swaggering cringe.

Inside was a bar, running the length of the room. Facing the bar were wooden seats on risers, providing a view. Above the bar, a catwalk. And on it, the most bored woman I have ever seen in my life. She paced back and forth, wearing a bikini. She was slightly overweight. I have seen polar bears in the zoo, pacing relentlessly in their enclosure, so mechanically repetitious in their pacing that their paws have pressed depressions into the concrete faux ice, that had more animation and purpose in their movements than that woman.

As soon as the outer atoms of the denim of my jeans began

to interact with the atoms of the wooden chair, a waitress instantly appeared to take my order. I requested a beer. She appeared with it almost instantly, before the insanely bored polar bear woman could complete a single lap of the short catwalk. Fully half of the beer mug, from midpoint to the bottom, was solid glass—clearly a custom-made item. The demitasse-sized compartment remaining above was filled with a pale carbonated liquid that might have seemed yellow if you had looked at it with yellow-tinted glasses. "That'll be eight dollars," said the waitress, kindly.

Burning with shame—far more at the embarrassment of being a rube than at anything I was seeing—I paid, quickly drank the beer, or just licked what there was of it out of the glass, and got up to leave. About six minutes had passed since I walked into the Exotic Strip Club. The kindly waitress approached me as I shuffled toward the door and in a conspiratorial voice said, "The bathroom is in the back."

Aha! Finally! Whatever true appeal the place held, whatever illicit thrills were here, must be hidden back there, in what the insiders call "the bathroom." Ms. Polar Bear up above the bar and the $8-an-ounce near beer were merely a front, a charade we initiates had to go through before being admitted to the sanctum sanctorum.

"The bathroom, huh?" I said, trying to approximate a knowing tone.

"Yeah, hon," she said. "The bars on the street won't let you use the biffy without buyin' a beer, so you might as well go now."[1]

———————————

1 Roy Blount, who describes his own, equally unsatisfactory venture into a New Orleans strip club in his book *Feet on the Street: Rambles Around New Orleans* ("Is that the same lap the guy's children sit on?"), once accompanied

☙ ☙ ☙

It was more than ten years later, in 1999, when I tried again, this time as part of a gratifyingly stereotypical bachelor party in Las Vegas. I attended the wedding as a good friend of the bride, but had been invited to join the party along with the groom and some of his best friends, and happily made myself subject to their tastes. The best man had procured a minibus for the night, and it took us through the town on a Stations of the Cross tour of Standard Male Pleasures: first the bar for single malt, then the steak house, then the cigar bar, and then, finally, the strip club.

The Club Paradise is to the anonymous grind house on Bourbon Street as *Playboy* is to a Tijuana bible. This place was all glossed lipstick, expensive sound systems, computerized strobe lights, and nubbly upholstery. The beer was still $8, but at least you got to drink it out of a normal-sized-looking bottle, with a nice cocktail napkin wrapped around it.

And the women were no polar bears. They all seemed identical—about five feet six, with straight shiny hair, perfect figures, and round but not oversized breasts, each apparently equipped with its own miniaturized antigravity generator. As

me on a visit to a similar, if more honest, establishment in Portland, Oregon, called Mary's. We had been told that it was the oldest and most legendary of the many strip clubs in town, and was well worth a visit. We walked in to find a tiny bar with a jukebox and a stage no bigger than a refrigerator box lying on its side. The bar, apparently, had no dressing room, so, as we were to find out, the girls put a coin in the jukebox, got onstage, removed their clothes, and then, at the end of the song, simply climbed down and put them back on, in full view of the audience. That was what was happening as we walked into the bar. Roy took a look at the zaftig stripper snaking herself back into her spangled panties and said, "Maybe we came at a bad time."

each girl came on to one of the many stages around the room, the DJ breathed into the PA: "On the center stage, gentlemen, say hello to *Shannon, Shannon,* gentlemen," and the music would start, and we would appreciate Shannon as she quickly disposed of the tiny bra which she had worn onto the stage—I am not the first to notice that there is no more actual stripping in modern strip clubs than there is soap in soap operas. Shannon differed from Brianna who differed from Tianna only by hair color, and as such, the dancers reminded me of a fevered junior high fantasy version of Betty and Veronica.

After only a perfunctory dance on the stage, Shannon, Brianna, et al. quickly got down onto the floor and started mingling with the men. I drank my beer and observed some of my new friends, who were mostly highly paid professionals from Silicon Valley, start to behave in surprising ways. One of them approached a girl still on the stage and began a conversation with her, but what was weird about this conversation was that he kept bringing dollar bills out of his pocket and waving them at her, up near his own mouth, so that in order to take them she had to bend down to him, her mouth next to his. They spoke directly into each other's mouth, and all the while the dollars came up from the pocket, waved and waggled, and vanished into her hand and then into her garter. Neither of them looked at the dollars as they made this one-way journey. The flow of money was apparently impolite to notice, like gastrointestinal distress.

The best man was a partner in a Silicon Valley firm and a family guy like me. We stood and watched, and for some reason we became obsessed with an issue that at first seemed niggling but as the evening wore on and the beer bottles emptied became more and more of an impediment to our really enjoying

ourselves: *the women never took off their pants.* Granted, they
weren't much, those pants, but their stubborn persistence on
the buttocks of the Gorgeous Indistinguishable Figures danc-
ing and writhing in front of and on occasion on top of our
friends seemed scandalous, a travesty, an outrage. There we
were, soaking the $30 steaks in our stomachs with $8 longneck
beers and all we had to look at was stuff we could see on a
French beach, albeit not a French beach we had ever been to or
that even probably actually existed, but *still.* We were gentle-
men at a bachelor party in Las Vegas, for God's sake, and not to
put too fine a point on it, we demanded *both* $8 longnecks *and*
pudenda. Or pudendae; authorities differ.

This sentiment, it turns out, was widely shared by the rest
of the party, and with a sense of mission, we stumbled back
into the minibus and headed off to the legendary Palomino.

This place had the advantage of being in North Las Vegas,
outside the city limits and not subject to the same laws that
prevented full nudity in places where alcohol was served.[2] We
were far from the Strip, nowhere we would venture if we weren't
tipsy on beer and protein and cigars and eager for what seemed,
at that moment, like a true and honest consummation. The
host at the club, whom I remember looking like Tony Orlando

2 My friend James Reza, an authority on Vegas nightlife (more on him in a mo-
 ment), explains that due to the boys'-club nature of Clark County politics, the
 Palomino was given a "grandfather" exception when the county followed the
 city and made it illegal to serve alcohol at places with all-nude dancing. In
 fact, Reza explains, due to the vagaries of county and city laws, in Las Vegas,
 to be a patron or a performer in topless bars, which all serve alcohol (other-
 wise they'd all be bottomless, too), you have to be twenty-one. But eighteen-
 year-olds can both perform in and visit all-nude clubs, because there they
 will not be exposed to the intoxicating effects of likker. Thus, Las Vegas pro-
 tects our youth.

with his gut and his pompadour, immediately understood what kind of group we were and accommodated us instantly: we were sent upstairs and seated around a private stage, and one by one the performers emerged, rotating up from the main stage on the lower floor. These women, unlike the bronzed beauties of the Club Paradise, were easy to tell apart. They varied in age, height, weight, and figure. Either they couldn't afford cosmetic surgery or they objected to it on principle. They, too, came onstage in shiny bras, briefs, and a single garter around one thigh which acted as a de facto money clip, and quickly disposed of everything but the garter. They exposed their buttocks and the Mysteries Within to us in a manner that reminded me, a little dizzyingly, of mating displays I had seen on Mutual of Omaha's *Wild Kingdom*. Sometimes the women would throw one leg up on the pole and smile at us between their spread eagle, and I kept thinking outdated and inopportune thoughts, like, But, we hardly know each other.

After "dancing," and accepting our tips thrust into their garters, the women would bow and disappear; and as (say) Gretchen came out onstage to dance for us, Ellen, who had just finished, would reappear behind us, top and pants back on, to lay a hand gently on our shoulder and offer us a private dance. Some of my new friends nodded happily and went with her to a back room. I did not. Drunk, uncomfortable with these women I did not know, some of them displaying slight physical imperfections that made them staggeringly and uncomfortably human, I decided, in a besotted moment of inspiration, to find out the answer to a question that had burned within me for years.

"So, uh, Ellen," I said to Ellen, and Ellen hurled herself upon the pole, and then slid down it in a spiral. "I've got this

theory that a lot of you ladies come from the upper Midwest.[3] Where are you from?"

"Oh, I'm from Oregon," Ellen would say, in which case we'd talk about the people she knew from the upper Midwest, or maybe it *was* Michigan, in which case we'd agree that yes, I might be right, that a lot of young women come from there to seek their fortune in places and situations in which they can disrobe—"The winters are pretty harsh there, it's true"—and this conversation would happen in a perfectly kind and friendly and unsalacious way, the sort of chat you might have with a nice person you happened to meet while waiting for a bus. But as this particular friendly chat progressed Ellen, or Noreen, or whoever, would be entirely naked, and would be waggling her vulva at my new friends, who kept putting dollars in her garter.

As would I, of course. Which is why they were answering my questions, about anything. I thought about Vic, the former vice squad cop, and realized he was right: they'd be happy to be anything you wanted them to be. Even: dull.

🐦 🐦 🐦

The whole experience on that memorable night left me with a lot of questions: Who were these women? Where did they come from? What did they feel toward us—affection, contempt, anger? Was there a hierarchy of strip clubs, as there seemed to be, with the golden Shannons heading to the Club Paradise, and the more mottled, nonsiliconed Ellens doomed to display all their secrets down-market? And what went on in those back

3 See chapter 7.

rooms, anyway? And why in the world were any of us here in the first place? The nature of the transaction was unclear to me—what were we paying these women for, exactly? Their nudity? Their attention? Maybe Vic was right—these were psychotherapy sessions of some kind, but I couldn't tell at that point whether they were helping to solve our problems, or cause them.

<center>҈ ҈ ҈</center>

Recently, I decided to conduct some more-formal research. I returned to Las Vegas and, for my first field trip, chose the Library, a slightly grotty strip club on the east side of Vegas, far from the Strip. Frankly, I was suckered in by its name. I figured maybe it would feature girls coming out in schoolmarmish high-collared blouses, pleated skirts, and thick glasses . . . all of which would be gradually, and shyly, removed, as in a classic English major's fantasy, maybe to the strains of Joni Mitchell.

No such luck: the only nod to the library theme was a patently fake shelf of books in the entry foyer, and then once inside, it was the same round stage, silver poles, TVs, and loud music I'd seen before. The girls, to be brutally honest, didn't look like they had much higher education at all, and if so, they had probably not majored in comparative literature. My companion for the evening was the playwright K. C. Davis, now a professor at the University of Nevada at Las Vegas. He and I settled down in some seats far from the stage, and for a while we were completely ignored, possibly because of our Just Here for the Sociological Research Vibe, or possibly because we were the only patrons in the club, on a slow weekday night, who were not (a) wearing sports jerseys and ball caps and (b) loudly hooting.

Eventually, though, I was approached by a dancer, wearing a white bikini, with astonishing long painted fingernails that glowed purple under the blacklight bulbs on the ceiling. She looked no more like a librarian, or for that matter a person who might visit a library, than she looked like Estes Kefauver. She offered me a private dance, and I declined, instead asking for a conversation instead. She agreed, hesitantly, and awkwardly crouched next to me as she answered my questions.

Her name, she said, was Lia, and she had been performing— one way or another—since she was five, most recently in "musical theater." She had been going to school for accounting but ended up doing this instead. Also, she was studying to be a masseuse, which she was good at, but for which she was not yet accredited. During our ten-minute chat, she mentioned about four other things she was doing while not dancing, meaning either she was a genuine Renaissance stripper, or she was too bored to remember which lies she had told me just seconds before. She thought she'd be stripping for a while, not forever, maybe a year, maybe until she had enough money to buy a house. She was a Libra, she said. She said she was very "balanced."

Lia was not particularly excited about her work. She said that she enjoyed doing private dances more than stage dancing because "it's nice to work and not have to take your top off." She didn't have a lot of respect for the girls who preferred dancing onstage, because, she said, dancing on a pole "wasn't real talent." Just about that moment, another dancer did an amazing move on the pole: flinging herself on it and then spinning around it upside down, legs spread, like a toy whirlybird coming down a stick, until she landed gracefully in a somersault onto the floor.

"Oh," said Lia. "I haven't learned that one yet."

I asked Lia what advice she had for customers coming into the club—etiquette tips, if you will—and for the first time she showed some genuine feeling: "Keep your tongue in your mouth," she said.

I asked her what kind of customer she liked best.

"A good conversationalist," she said, thrillingly.

We were interrupted at that moment by the club's host, a large man in a dark blue suit. "Excuse me," he said, pointing at my notebook. "We don't allow people to have paper and pencils out in the club."

Down near the stage, men were whispering in the ears of seminude dancers, and the dancers were laughing, chuckling, smiling, whispering back. Why should I not be allowed to capture the whispered musings of *ma chérie* of the moment for later contemplation? But I chose not to make a big deal of it. I put my notebook and pen away, and asked Lia about the reason for the policy: she said it was a fear of prostitution: the club didn't want dancers giving customers phone numbers, and vice versa. That sounded ridiculous to me, but it seemed, again, pointless to argue. Lia might have something true and sincere to say, but she wasn't going to say it to me. Finding from her that a private dance usually cost $20, I gave her that much, telling her I had enjoyed our chat as much as any private dance. She thanked me and left, and I immediately indulged in the standard idiotic hallucination for these situations, that perhaps she had liked me a little more than the guys she usually runs into at the club. You know, 'cause I showed interest in her as *a person*.

A little while later, I saw her giving a lap dance to one of a group of frat boys on the other side of the room. With her top off. I felt a pang.

So: my first educational expedition into a strip club had gotten me nothing but a series of empty clichés from a bored stripper and an uneasy intervention from a bouncer. There was only one thing to do: try again, but this time bring along some female Ph.D.s in sociology.

<p style="text-align:center">❧ ❧ ❧</p>

Kate Hausbeck and Barb Brents, both on the faculty of UNLV and experts on the sex industry, suggested that we move my research to Olympic Gardens, one of the older and more established topless clubs in town. It was famous for, among other things, featuring both male and female strippers under the same roof. K. C. Davis joined us once again, and after I paid the cover charges, we all settled into a booth in the main room, adjoining one of the circular stages. Professor Kate and Professor Barb were the only women in the room—or, rather, the only women customers.

Kate and Barb had studied sex workers in Nevada extensively; had interviewed working girls of all sorts, from streetwalkers to call girls; had done sociological studies in brothels and written extensively about the underground economy of sex for money. They were particularly interested in the ways that the various aspects of sex work interconnected—strippers becoming escorts becoming brothel prostitutes—and the way in which certain rules of sex work applied across this lurid spectrum. I told them about my interview with Lia the previous night, and they laughed at the answers—*sure,* she was just a student, doing this until she could get back on her feet. *Sure,* she hoped to buy a house. There was no point in interviewing a

dancer in a club, they said. She was onstage, and anything she said would be just part of the performance.

What with all their experience in the hard-core sex trade, both aboveground in the legal Nevada brothels and underground in the illegal but thriving prostitution outfits in Vegas, Barb and Kate were kind of bored with Olympic Gardens. There, in what was becoming even to me a kind of numbing ritual, women would come out onstage wearing heels and a variant on a bikini, start writhing around a pole, then quickly, with little art or feigned coyness, remove the top of the bikini, wave their behinds in the air at us, then clamber down and start soliciting private dances. If they got a customer, they inquired about repeat performances. If successful in that, they took their clients into the "VIP Room" in back.

The professors explained to me why the dancers so quickly eschewed the stage and zeroed in on individual customers: contrary to my assumption, the dancers weren't employees of the club but were independent operators. Each of them paid the club for the privilege of dancing there on a given evening, and had to tip the DJ and other key employees out of her own earnings if she wanted to be allowed back in the next night. That's why the "dances" were so short . . . by gyrating for a mere couple of bucks stuck in her garter, each girl was in essence losing money. The dancers needed to get down off the stage, and into the laps of the customers, where the profit centers were. In addition, there was a tremendous amount of competition: Kate and Barb estimated there were about 2,500 dancers working in town at any given moment, with far more coming from out of town during big conventions and busy seasons. So a Las Vegas stripper had to be more attractive, energetic, and popular with

the clientele than other dancers who might want to dance at that club on any given night, because the club needed the strongest possible incentive for customers to pay the cover charge and sit around buying expensive drinks. But once inside, a stripper immediately had to convert those talents and assets into cash or risk losing money on the evening. Her professional balancing act was more difficult than anything she had to do on the pole: Too much public dancing, rather than private, and her income wouldn't be sufficient even to cover her expenses. But if she didn't put on enough of a show for the crowd—if she just vanished into the VIP Room with a particularly profitable client—then the club would complain that the girl wasn't doing enough to draw in customers. And further, if the girl was seen to really score off a single client, the club might demand a bigger cut of her take.

During this exegesis, I turned my head, and not four inches away, a dancer was rubbing her crotch, covered in fluorescent fabric. I turned my head back to Barb.

The professors have a tremendous respect for the dancers, who, they told me, were doing their best to maximize their economic status and take control over their financial/sociocultural destinies. "McDonald's, now *that's* a degrading job," said Barb.

All around us, men were hiring girls for lap dances. Each of the men, despite whatever boisterous glee he had been exhibiting while the girl in question was onstage, became quiet, almost reverent, as the girl straddled him. His hands gripped his chair arms tightly, as required by club rules. He stared up into the face of the girl who was gyrating over and onto his lap. Sometimes he closed his eyes. He was transported. He was scared. I think I might have seen a tear shed.

"It's funny," I said. "Everybody says that these kinds of clubs

are degrading to the women, but to me it seems the other way around." The man was frozen by his desire and the rules of engagement into his seat. The woman could slap his hand away, scold him, break it off, call a bouncer. But mostly, it seemed so because while the woman was clearly, consciously, and intentionally giving a performance, the man was lost in a sexual reverie, given over to physical sensation, helpless as a child who has to pee.

Barb and Kate agreed: the men seemed silly and strangely vulnerable. And, considering that they were giving up huge gouts of cash for a sexual experience located on the Axis of Erotic Thrills somewhere below a dry hump, they also seemed kind of stupid. As the professors knew well, there were about a thousand phone numbers in the Vegas phone book you could call to arrange for an evening of far more substantive, if illegal, pleasures for about the same amount of money these men were pressing into the lacquered hands of the dancers over the course of an evening. Certainly, there was a refreshing cut-and-dried nature to the exchange, which might be a relief to a man frustrated with the endless, pointless quadrille of bars and dates and courtship. But Olympic Gardens seemed to me just a purer form of that same sad ritual, except here, it was played out on a strictly cash basis. Where in a normal bar a man might hint at his wealth through any number of socially acceptable ways— "It's a shame Lutèce doesn't have a drive-through window, because I'm not the kind of man who's too fastidious to eat in his Bentley"—in here, he simply, and hopefully silently, opened his wallet and exposed his assets. And while any man in Olympic Gardens, no matter how homely or charmless, could get a beautiful woman's undivided attention, what he actually got in return for the crumpled twenties seemed to me to be paltry

recompense for the stark insult of the circumstance. What's
worse—to have a woman in a bar turn down your request for a
dance because you don't meet her unknown and arbitrary stan-
dards, or to have a stripper put her top back on and walk away
because you've run out of twenties? So even after many hours in
such places, I still wondered: Why in the world would a man,
being of sound mind and body (or, after a few drinks, maybe just
sound*ish*), come here?

The professors didn't know. They were intensely bright
women with Ph.D.s in sociology and experts on the economics
of the sex trade. However, understanding men left them just as
befuddled as anyone else. And, as it turned out, their under-
standing of the motivations of the women proved to be incom-
plete, as well."4

<p align="center">🦋 🦋 🦋</p>

"From the moment I heard about Jezebels, sitting in the church
pew, I wanted to *be* one," says Delilah.

4 We did, after a decent interval, go upstairs to see the male strippers. The
 scene couldn't have been more different—while the male customers down-
 stairs were clearly having very solitary (if public) interactions with the per-
 formers, the women, seemingly all together in a bachelorette party of some
 kind, were shrieking to each other, grabbing each other's arms, hooting and
 hollering as the muscular men writhed and flapped at them. They bought
 each other lap dances, and instead of staring at the "lucky" recipient through
 thick-lidded envious eyes, as the men downstairs did, they cheered and
 clapped and good-naturedly mocked each other, trying to induce blushes.
 The sociologists and I decided, in our wisdom, that sexual experiences of this
 variety bonded women, and isolated men. Then one of the dancers came over
 and asked the professors if they wanted a lap dance. If looks could char, that
 guy would have been nothing but rib tips and sauce.

Delilah wasn't Delilah, then, sitting in her midwestern church pew. She was a very dutiful, very religious daughter to very dutiful, very religious parents, and she says now that her strict upbringing had exactly the opposite of its intended effect. All that talk of sin and the terrible, terrible eternal punishments that awaited on either side of the razor-thin righteous path began to sound absolutely fascinating. "I got into a vicious cycle. I had this fascination with being a whore. This freedom that Mary Magdalene had: she poured the perfume on Jesus's feet! She flung her hair on them!"

Delilah is tall and strikingly attractive, the kind of woman you would think of as beautiful if she'd just help you out a little by thinking of herself that way. Instead, she comes off as a comedian: bright, a little loud, and very funny, often at her own expense. The story she's telling me is a decade old, and it's a story she's told before—sometimes, in fact, in comedy clubs. However, she still hasn't talked to her family about her adventures in the skin trade, and has asked me to refer to her by her stage name.

At eighteen, still dutiful, always very bright, she went off to an Ivy League college on the East Coast. Once she graduated, she got a job in upstate New York as an actress at a small repertory theater. At that time, she says, she had slept with only one man, a gentleman to whom she had been engaged. By the standards of the early nineties, that counts as virginity. But then something very important in her life happened: she stopped believing in hell. "All of sudden I was free to do all the things I had always wanted to do," she says, "and what I wanted was to be a whore."

Delilah wrote an account of how she realized her dream:

I called up the local strip club in Syracuse, New York, called Lookers and asked to audition.

I was told to come to the club that Friday night with a tape of the song I wanted to dance to. I tried to think of the sexiest, dirtiest song I knew. I came up with "Lola" by the Kinks. Somehow even though I knew all the words by heart, I missed the fact that Lola was a transvestite.

On Friday night, I drove to Lookers and met Dave, the manager, who wore a T-shirt with two big boobs drawn on it that bookended the statement: "Lookers. Girls you'd care to see naked." Dave took my tape and told me to put on my costume. I just assumed strippers wore their underwear so underneath my clothing I was wearing the sexiest bra and grandma panties I owned.

Dave said I should go onstage when I heard my song begin and then take off my top halfway through. I took a deep breath and said to myself, "Okay, just imagine you're Lola."

When the music began, I walked down the lighted runway as I imagined Lola would to the lyric: "She walked like a woman but talked like a man." I awkwardly unfastened the clasp on my bra while mouthing along with the lyric: "When she squeezed me tight she nearly broke my spine." A roomful of drunken sexually frustrated men stared back at me and I thought, "Oh, this is everything I hoped it would be."

Here's the punch line, though: *it really was.* She called herself Delilah and went about transforming herself into someone worthy of that name.

"I had all these little rules, which I then dropped, one by one," she told me. "First, I wouldn't do table dances. Then I would, but I wouldn't turn around, I'd only do it facing the guy. I wouldn't dance for a guy who had a wedding ring on. I would say, 'I just don't feel comfortable dancing for a married man.' I eventually dropped that. I decided: it's okay to dance for married guys because it keeps them from cheating.

"My big struggle when I was dancing," she went on, "was that the DJ kept referring to me as 'Lookers' Classiest Lady!' I *so* wanted to be like the other girls. I started smoking so my voice would go down lower. I had this whole journal, in which I wrote down little stick figures illustrating the moves: swivel hips, raise hands in air! I worked on that, and I worked on learning to talk. I wrote down dirty jokes that I could tell: *Two whorehouses! Teeth with two legs! Five disadvantages! Why are women born with foreheads?* I would write down examples of little comebacks. Guys at strip clubs will critique the girls' bodies to their faces. They'd say things like, 'Yeah, I'd love a dance, but I'll wait for someone who doesn't have a huge ass.' And the other girls would come back with, 'I can always lose weight but you'll always have a little dick.' Anytime things like that were said to *me*, I'd be like, 'That really hurts my feelings. . . .'

"It took me a long time to be accepted. Your trunks in the dressing room would be lined up in the order of popularity. The queen bee would be in the trunk in the corner, with a nook for doing cocaine. And I started off and my trunk was in the far corner, and by the time I finished there, after a year and half, I was finally close to the queen bee trunk."

She tried to adjust her behavior offstage, too. "I went home with one guy I met in the club because I purposely wanted to have sex with a guy whose name I didn't know. I remember the

next morning I was coming down the elevator, still didn't know his name. There were other people in the elevator, and they were looking at me because I was dressed all 'stripperly.' And I was like: *Fantastic! I've made it! I'm in an elevator, and I don't know the guy's name, and people are judging me!*"

She says that she knew the other girls had decided to accept her when she went backstage and somebody invited her to snort a line of coke. She quickly got addicted to coke, but that was okay: that was another of her ambitions.

Delilah absolutely believes that the strippers have absolute power over their customers, and, for many of her fellow dancers, that power engendered real contempt. The girls, she says, looked upon the men as weaklings to be manipulated, losers who could be convinced to give up hundreds of dollars or more if you just cooed at them and rubbed their faces in your breasts. There were a few dancers who took their role slightly more seriously—they thought of themselves as professionals, entertainers, who were paid good money for a job well done, and then went home to their real lives and real relationships. But none of them felt anything like affection for the men for whom they performed.

As for herself, she says, "I didn't need the money. And I didn't even work that hard. Sometimes a guy would give me money, and I would say, 'That's too much,' and give some back. I would buy guys drinks on their birthdays. It was unheard of! But the whole point was: I wasn't there for money. I wanted to change my personality. I wanted to be the girl who had Contempt for All of You. I got better and better at being that girl."

But she never quite made it. Everything came to an end, eventually, because of a pair of reddish dress shoes.

"So I was dancing onstage, and what you do, you look down

at their shoes, to see what kind of shoes a guy has, see how rich he is. And I looked down and saw expensive shoes. I looked up, and it was a very handsome guy. Now, if you're interested in a guy, you don't dance for him. You don't try to hustle a table dance. Because then you're saying my relationship to you is stripper/customer.

"I finish my act, and get dressed, and I find the guy with the oxblood shoes, that deep red shoe color. I went and sat down next to him at the bar, *without* asking him if he wanted a dance, and I put a cigarette in my mouth and silently waited for him to light it. And he leaned over, took a cigarette out of my pack, lit his own, put the lighter down, and looked away from me. How cool was this guy? I was finally like, 'Can you light my cigarette? Hello?'

"And we started talking and he was really funny. I was really attracted to him . . . and he didn't ask for my number. 'Listen,' he said, 'if you ever want to call me, I'm in the phone book.' And he walked out. He totally reversed the power thing. I had to go get a Binghamton phone book."

She ended up living with him, and she says the thrill of being in love replaced the thrill of performing. But mainly, there was the small matter of her now massively expensive coke habit. She got into a rehab program, and realized that if she wanted to stay away from coke, she had to stay away from the club, and thus ended Delilah's career. After her relationship with the Man with Two Red Shoes also ended, she moved to the West Coast to enter graduate school, and once again tried stripping, thinking she could easily supplement her income with her established skills. But it wasn't the same, she says, without anything further to prove, and "especially without the cocaine." Besides, her new boyfriend, soon to be her husband, didn't

much care for it. Though, she says, she still remains proud of
Delilah's career.

"I think it was an incredibly productive year and a half. I
went into it as an incredibly shy, reserved girl, who never made
a joke. . . . I wasn't funny, I was a serious boring Bible girl. And
it was like a personality workshop. I came out of it a lot more
confident. I was able to talk to men. I think I became a really
different person.

"I don't have anything bad to say about it."

🌿 🌿 🌿

"I wasn't a stripper, I was an *exotic dancer*," says Staci Linklater,
who doesn't have much bad to say about it either. "An exotic
dancer is a performer whose medium is the creation of a fan-
tasy. Strippers make five hundred dollars a night and have
nothing to show for it. They're like high school girls with a
really big allowance."

Staci earned the right to her contempt honestly, working for
more than a decade in the premium gentlemen's clubs of Vegas
as "Sapphire." In mufti, Staci doesn't look much like the comic-
book creatures who spin around the chrome poles: about five
feet five inches without a pair of her spectacular shoes, she has
a seemingly unaugmented figure but truly fantastic hair, dark
blond with twists and turns and subtle highlights, the kind of
hairstyle that befits a salon owner, which she now is. Staci is
married to James Reza, a Vegas native and an expert on the
city's nightlife, who's worked as a columnist for the *Las Vegas
Weekly* and other publications. Surprisingly, this clubhound
and stripper—excuse me, Staci, exotic dancer—have lived out
a Mickey-and-Judy schoolkid romance. They met when she was

fifteen and he was twenty-one, at a Saturday-night meeting of a club for Volkswagen owners. What a fifteen-year-old girl was doing (a) owning a car and (b) attending a car enthusiasts' club meeting is not explained.

Staci was thrown out of her home at the age of seventeen—rather gently, but firmly, in her telling—and took up dancing, full-time, two years later. Staci and James remained together throughout her decade-long career in the clubs, although they didn't get married until the night of her thirtieth-birthday party, when they surprised their guests by unveiling a clergyman they had secreted away until the clock struck midnight. There's no telling what really happened between them during those years, and further, there's no guessing what fraction of whatever actually happened they'd be willing to tell someone like me on early acquaintance, but I know few couples who've been together since adolescence, and of those couples, very, very few of them seem as happy and at ease with each other as James Reza and his ex-stripper wife. Ex–exotic dancer, excuse me again. Maybe it's something other couples should try: it's good exercise for the woman, and might maintain the man's interest. And unlike couples therapy, you get paid.

Which is another reason that James might not have minded, so much, his lovely young wife going out and behaving like a brazen, naked hussy for hundreds, cumulatively thousands, of strange men. Staci says she cleared $500 a night on average, sometimes more, after paying about $40 a night to the club, plus tips for the staff—that was back in 1990, she says; these days, girls have to pay anywhere from $65 to $100 to dance for the night. Staci's certain of the figures because unlike perhaps any other dancer, stripper, or sex worker in the history of the universe, she filed honest tax returns. That way, she says, she

was able to establish an income, which allowed them to get a loan to purchase their house, and eventually, open her business, the Globe Salon, a popular place for the Vegas native demimondaines to get their hair done. Her financial savvy gave her another precipice from which to look down on her former colleagues: "Strippers," she says, "are girls who take *taxis* to work."

Now that I've been to a couple of the strip clubs that dot the Vegas landscape, I've met James and Staci for a tour of the New Vegas Nightlife. First stop is Mix, the hot "ultralounge" of the moment, at the top of something called theHotel, a place with no gaming, a strange sense of typography, and apparently its own patented fragrance, with which it douses its foyer. "Smell that?" asked James as we walked across the marble floor toward Mix's dedicated elevator. I didn't smell a thing. It was early in the evening, just after nine, and the line hadn't started to form behind the velvet rope.

The express elevator let us out into a cool space decorated in slate grays and blacks and reds and glass, with a bar selling overpriced drinks served by the most beautiful cocktail waitresses it has ever been my knee-weakening privilege to see, each wearing a custom-made black dress with a tight bodice and a low neckline and slits up the side, the kind of plain but still astoundingly sexy outfit that might be worn by the lead actress in a movie for the scene in which the hero realizes she's the girl of his dreams.

I turned to James and asked, "What in the world are these beautiful woman doing working here?" He gave me a puzzled look, and said, "What should they be doing instead?" I don't know . . . breaking hearts, serving as muses, starting wars between Greece and Troy? I couldn't quite get my head around the

fact that our society, which so prizes physical beauty, would consign this particular kettle of cream to a mere bar.[5] I would have asked the women myself, but of course they ignored me. Instead, they attended to their main business: "bottle service." Bottle service is the lap dance of the ultralounge scene, and at the same time a particularly conspicuous way of consuming your tipple. Look—there in the corner of Mix: a group of men in their late thirties or early forties, lounging on the cushions around the table, like a GQ magazine version of a Passover seder. Each of them was casually dressed in slacks and a sport shirt that might have been purchased at Target for $15, except for the slightly different shade of color or sheen of texture that lets you know it actually cost about twenty times that amount. Some of the men had expertly tousled hair and carefully stubbled chins. They were successful entrepreneurs, independent contractors and consultants, producers with a deal on a lot, men with distribution deals, and they were out to enjoy themselves. Which they did by purchasing a full bottle of liquor for a 1,000 percent markup—say, $350 for a bottle of scotch—a price which included the dedicated attentions of one of the black-dressed sirens, who knelt, in the most provocative display of submission I have ever seen, to pour their precious liquor into rock-crystal tumblers.

And then, delicately, with tongs, put in the ice.

And then, carefully, with eyes downcast, placed the drink in front of the reclining man.

5 James tells me that the attractiveness of the staff has become such a selling point for new ultralounges that some of them have now contacted modeling agencies to do their hiring.

The men picked up their drinks, and eyed one another. A congratulatory toast was unnecessary.

Just like the men at Olympic Gardens, these masters of the universe were paying to enact a sexless fantasy predicated on sex. But in the stripper fantasy, the man was arrested, frozen in his seat, helpless in front of the powerful woman whom he could never truly have. Here, the guy wasn't obliged to even notice the girl. He could lounge, talk stocks and golf with his friends, while a clone of Marilyn Monroe, but in the hair color of his choice, hovered to the side, hoping everything was perfect.

Everything, finally, became clear.

I had been confused because the pseudosexual transactions I had been witnessing had no personal content; I had not seen how a man could enjoy the attentions of a woman when he knew, in his heart of hearts, that she couldn't give a damn about him, and, in fact, would ignore him completely if not for his wad of bills. I realized now that this callous anonymity was the entire point. I had been confused because I had assumed that other heterosexual men, like me, were uncomfortably dependent on the regard of women. Thus, I couldn't see the point of paying a woman to pretend to like you—a pointless charade which, to me anyway, only highlighted the need while guaranteeing it would not be actually met. But the men weren't, in fact, paying anyone to *like* them, or even pretend to. They were paying someone to ignore their real selves completely—to be oblivious and uncaring. In which case, the paying customer was free to return the favor. The woman you pay to serve you, whichever method of service you prefer, is a person whose opinions of you can be safely and happily, even joyfully, ignored. Vic and Chris, the quarreling angel/demon of the Cae-

sars taxi queue, were reconciled. Men in a strip club weren't there *despite* its being an empty, depersonalizing, dehumanizing experience. That was the *because.*

Watching this scene at Mix, these thoughts rolling through my head, I came up with a great idea for a true gentlemen's club: You pay your money and walk in to find a room full of astoundingly beautiful women, all of whom are delighted to see you, thrilled to talk to you, excited to be with you at last. They run up, and tug on your arm, and put their hands on the back of your neck, the way some forward women do. You endure their questioning, and their interest, for as long as you care to, and then you walk into the other room and watch sports on TV. For an extra $100, you can close the door right in their faces.[6]

🐾 🐾 🐾

Our final destination for the evening was Forty Deuce, the latest outpost of the New Burlesque empire created by impresario Ivan Kane. As we entered, I realized the club was a strange, black-lacquered updating of that long-ago anonymous rip-off joint in New Orleans. Seats and tables on risers, facing a bar: above and behind the bar, a catwalk stage. We were joined at our seats at the bar by a friend of James's named Dayvid Figler, who was, he told me, both a justice at the Clark County Superior Court and an amateur expert on the "sexual underground."

6 Before leaving Mix, James urged me to use the restroom—I had a weird flashback to my first time in a strip club, in New Orleans. But we went in, and I understood why. Each of the urinals was topped with a window looking out over the Vegas Strip from thirty stories up. It was truly remarkable—the only way to get a better vista while relieving yourself was to go up to the Grand Canyon at sunset and pee over the edge.

As we walked in, he high-fived a bouncer, who towered over him by a least a foot. "I went to his bar mitzvah," said Judge Dayvid.

We bought more drinks from the equally attractive bartenders—the women were just as gorgeous as they had been at Mix, but here there were also model-level men, so the back of the bar looked like an Abercrombie catalog as hallucinated by a dipsomaniac. Eventually, the lights dimmed, and the packed club roared in anticipation. A wall above the bar, emblazoned with the Forty Deuce logo, spun around to reveal a rotating dais, on which was a jazz trio playing saxophone-heavy bump-and-grind jazz. And then, emerging from stage left, wearing a full cocktail dress and gloves, came the dancer.

With the jazz pulsing and beating and the saxophone wailing in a way I thought didn't exist outside of fifties-era pulp fiction, that dancer proceeded to put on a show that had every single person in that bar, male and female, myself included, reduced to animal howls. She removed that dress, piece by piece. She swung from the beaded curtains, upside down. She did the splits—but demurely, her back to us, with a wink over her shoulder. With every garment she removed, she seemed more alive, larger—it was as if the clothing were some sort of restriction on her inner sexual demon.

Striptease wasn't the word—this wasn't a tease, this was the real thing, not some cheap simulacrum. It wasn't sex; it was rarer. Some asshole ran up to her—while she was doing an extremely difficult upside-down move, hanging from a railing six feet above the ground—and tried to put a dollar bill in her garter. The bouncers wrestled him away, and I would have gotten up to pummel the jerk if I hadn't been too busy hooting and shouting. She wasn't doing it for your *money*.

The dancer, reduced to pasties and panties—but still wearing pasties and panties—bowed, blew kisses, and disappeared. The band, with some last beats of a bass and wails from the sax, swung back into the distance. And for the next hour, until the next dancer commenced her act, the bar just burst with sexual joy. Women danced on tables. Men cheered and danced with them. I would have swung from a pole if I could have found one handy.

Thus, what strip clubs need to lift them above the grind house, make them more than just an expensive housing on a basic mechanism, truly worth the time and money:

Expertise.

Strippers of the world, hear me now: If you dance for money, we will pay you, but you will always be objects onto which we can project the contempt we feel for ourselves. If you want to control us, if you want to make us yelp and throw our bills onto the stage wrapped in our very hearts, you have to dance as if the money doesn't matter at all. We are but men, and we think with our souls. We are all helpless in the face of art.

4

or

THIS CHAPTER WILL CHANGE YOUR LIFE
AND MAKE YOU MILLIONS!

D ear sir: I write to you about an extraordinary opportunity, one that only someone of your wisdom and experience may seize. I am honored to inform you that you have magic powers. No, you do, really. You have a mystical power that can cause people to do your bidding, that can remove any obstacle, that can bring you riches, fame, and romance, or at least, get you laid. Once you become adept at its use, there are almost no limits to what you can do with it. While you won't be able to fly, you can convince people to pick you up and carry you around the room while you stick your arms out and hum the theme to *Superman*.

Oh, there's one little thing: like many other supernatural powers, after a while, the effects wear off.

To reveal the details of this remarkable technique, I shall require a small token of good faith, specifically, a donation of

$10,000 that will be returned to you a thousandfold by use of the techniques I am about to describe. Please slide the money into the back flap of this book and return it to the publisher. Then purchase another book, and read the rest of this chapter.

🌾 🌾 🌾

Once, many years ago, when I was just a few years out of college, I was fortunate enough to be befriended by a wonderful writer named Jo Carson. Jo came to Los Angeles to see a production of a play she had written, and on the day she was to fly home, we went out to lunch at a place on Venice Beach. Suddenly, Jo turned solemn, and told me that when she was starting out her career, she had been befriended by an older, more accomplished writer, and that one day this mentor had given her a gift of $100. Jo was to spend that money on anything that she desired if it would help her writing: research materials, a trip, a few bottles of good bourbon, whatever. The only condition was that once she had achieved some success, she was to find another young writer in need of encouragement and pass the gift on, with the same conditions attached.

And then she solemnly passed an envelope across the top of the beachfront café table. Inside it was a crisp $100 bill.

It was, and probably remains, the single most meaningful thing anyone's ever done for me. I was suitably grateful and impressed . . . not only was this the first time anyone had expressed real faith in my writing, but it was also the first $100 bill I'd ever owned that I hadn't made myself with construction paper and crayons.

I dropped off Jo at the airport, with many professions of gratitude and affection, and drove off, full of ideas for how I'd

use the money to start forging the uncreated conscience of my race in the smithy of my soul. A book on writing? Paper? I drove out of LAX on Century Boulevard toward the 405 Freeway, a distance of about two miles. As I drove up the northbound on-ramp, I saw an attractive young woman waving her arms frantically at me. I pulled over and rolled down the passenger-side window.

"My car's stuck on the freeway!" she cried. "And I called a tow truck, but I don't have enough money to pay them! I'm just twenty dollars short! And the cops told me that if my car's not gone in half an hour, they'll take it, and they'll fine me three hundred dollars! Please, oh, please can you help me? Please? I'll give you my watch, I'll give you my phone numbers, please!"

And then I found myself saying a remarkable thing. Something that I had never expected to say, in the whole course of my life, and certainly not in these particular circumstances. I said:

"All I have is a hundred-dollar bill."

She looked at me expectantly.

"I'll have to get change," I said.

"I'll wait," she said.

She cheerfully hopped into the passenger seat while I walked down to the bottom of the ramp, where a liquor store squatted next to a sickly yellow sign. It did not look like the kind of friendly establishment that might change a hundred so a stranger could help somebody he had met forty-five seconds before, so I needed to make a purchase. I pushed the precious symbol of an admired friend's confidence under the iron bars of the cashier's cage, and received, in return, four wrinkled twenties, a ten, a five, three ones, some change, and a diet soda.

When I returned to the car, she was rooting around in her

bag and had pulled out some grapefruit, of all things. They rested on the floor of the car. I noticed that she wasn't quite as attractive as I had first thought. Her hair was dirty, and so was the back of her neck. She smelled odd, not unpleasant, but as if she had dabbed a spot of fresh motor oil on her pulse points.

"You said twenty dollars. . . ."

She eyed the bills in my hand, and said, "Actually, I could use forty."

Of course, I knew she was lying. I had known she was lying as I stood in front of the metal cage of the liquor store cashier. I probably knew she was lying as soon as she got into my car. But by that point, it had become far easier to continue playing along than to call the whole thing off. She had worked so hard on her scheme, it seemed cruel to disappoint her. And of course, by suddenly expressing doubt, I would be admitting that I had been stupid enough to believe her to that point. Once having committed stupidity, it seemed preferable to remain consistently stupid until the bitter end. I would stick to my guns, even though they were pointed at my own head. I gave her $40.

She handed me a piece of paper with her name on it, her home phone number, and her work number, a restaurant in Huntington Beach.

"Call me, and I will absolutely pay you back," she said, and hopped out of the car. Instead of going back up the ramp, to where her car allegedly was, she walked down it, turned on Century Boulevard, and vanished under the underpass.

I went home, the previous five minutes replaying on the inside of my eyeballs like a traffic accident. I had been given a solemn gift, laden with trust and expectation, and I had—quite literally—not held on to it for ten minutes before I gave it to the first person who asked me for it.

I called Jo as soon as I could, of course, and bless her heart, she forgave me. She said she'd rather live in a world where you could trust people than have to start treating everybody who asked for help as a liar. I hope she didn't think what I was thinking—that if she wanted that money to go to a true creative artist, fate may have intervened to make sure it did.

I have always been a terrible liar. I get shifty and uncomfortable, I sweat from odd places, I spasmodically loosen my collar with a hooked index finger, even if I'm not actually wearing a collar: flop-sweat mime. If I wanted to impress people at a party, I could do a parlor trick: I could tell some trivial lie about something inconsequential, and invite everyone to watch as my pupils dilated to the size of JFK half-dollars.

Perhaps because of that, I've always admired people like my freeway maiden in distress, even as I've been abused by them. People are bound by certain rules of conduct, always unspoken, sometimes never even consciously enumerated. Among these rules is that everybody will, more or less, tell the truth, with generous allowances made for subjectivity. Anyone willing to break that unspoken compact has an immediate and powerful advantage, in the same way that anyone playing soccer would have a tremendous advantage if he were just to pick up the damn ball.

Let's say, for example, you're having an argument with your spouse about who's turn it is to do the dishes. You will each marshal facts to support your case and present them to your best advantage: "I did it last night," or "It makes my fingers wrinkle in an unattractive way." We know that there will be some bending of the truth, so, for example, you might reasonably expect your husband to say he's too tired, when you know he's going to go upstairs and play World of Warcraft for two hours. Or, similarly, he might expect you to say that your finger

still hurts from slamming it in the cupboard door two days ago, even though it doesn't really hurt that much anymore. This is to be expected. Neither of you, though, would expect the other to assert that he or she has been diagnosed with Huntington's disease, and is slowly losing voluntary control of his or her extremities. It's too bold, too uncaring, too raw an appeal for sympathy. If you were to lie about such a thing, maintaining the lie over the coming days and months would be daunting, and, when you were inevitably caught, the shattering of the trust between you and your beloved spouse would be irreparable.

But, on the other hand, you wouldn't have to do the dishes.

Consider the case of Jennifer Dibble, a Fort Worth, Texas, mother of five. In 2003, at the age of twenty-nine, she announced to her friends and family that she had been diagnosed with cancer. For the next year, she accepted sympathy, care, food, vacations (including a trip to Lourdes, to pray for her recovery, and Disney World, to go on Mr. Toad's Wild Ride), and a good deal of money while telling stories about the difficulty of chemotherapy and dialysis. Her friends began to get suspicious primarily simply because she looked so good. Would a cancer victim be so buff? Or tan? Well, yes, when instead of going to chemotherapy, she's going to the gym and the tanning salon. And Wal-Mart. She really liked to spend that "medical bill" money at Wal-Mart.

Her scam unraveled, eventually, with social ostracism and divorce and the loss of custody of her children following soon after. The question that haunts her former intimates though, of course, is: why? You expect con artists and liars to have a purpose that matches the enormity of their betrayal . . . some vast need for money, usually, or other desperate motive commensurate with the crime. But Dibble leveraged her lie into a lifestyle

that befit, well, a Texas mother of five, rather than some kind of international criminal. In essence, her interaction with her loved ones went this way:

DIBBLE: I want more time to work out.
LOVED ONES: Hey, we all do, but it's hard to find the time, isn't it?
DIBBLE: But I'm *going to die*.
LOVED ONES: Oh, my gosh. I'll watch your kids, okay?

She did it because it *worked*. Simply by intoning some magic words—"metastasize," "chemotherapy"—and putting some bandages on her torso, she was able to get everything she ever wanted, all the things any of us want: love, affection, care, indulgence, help with the kids, and nice abs.

Or: In 2001, Stacy Finley, twenty-eight, of Farmerville, Louisiana, let her friends and neighbors in on a remarkable secret. She was a CIA agent, she said. Deep under cover, for your eyes only, tell anyone and she'd have to kill you. Further, because of her status with the agency—or the "Company," as insiders call it—she had access to the supersecret CIA health-monitoring satellites that could scan anyone on earth to check for diseases. And further, in return for a small fee to help cover her expenses, she would arrange for CIA agents, acting on the information gleaned from the satellites, to enter the homes of said friends and neighbors and administer secret medicines that would ensure longevity and prevent any hereditary disease the person might be in for. Now, you might expect that having secret agents enter your home in the middle of the night to administer experimental unguents and injections would be fright-

ening, but not to worry: the agents would come only when the patients were asleep.

They gave her over $1 million, those good folks did. Some of them depleted their life savings, went into debt, mortgaged their homes. All so that they could be diagnosed by satellites they couldn't see, and then treated by agents they never sensed, and cured of diseases they didn't even have yet.

Why? Why? Maybe—apart from whatever considerable charm Stacy possessed—maybe because at a certain point—a very early point, as I discovered on the on-ramp—it's far easier to believe that shadowy secret agents are visiting you at night, to rub mysterious and unfelt salves on your skin, than it is to admit that you've been paying a twenty-eight-year-old huckster all the money you were saving for a boat in exchange for moonshine and bullshit.

The liars know this, of course. They know that we *want to believe,* they know that we *don't want to think such bad things about people,* and they know, most importantly, that *we don't want to admit that we were idiots.* There were men, brave and good and smart men, who went over the top of trenches at the Somme, to certain death, rather than be called a coward. And there are people, good smart people, who continued to give Stacy Finley money in exchange for mysterious CIA-approved medical treatment, rather than admit that they had been badly, and embarrassingly, fooled.

Stacy Finley, Jennifer Dibble, my brief freeway romance, all of them, of course, and uncounted others, of course, were partaking in a long and rich tradition of magical lying.

One of the great liars of history—his story enthralled me as youth—was the remarkable Shabbatai Zvi, a Jew who lived in

the city of Smyrna in the Ottoman Empire. In 1648, at the age
of twenty-two, he fulfilled the secret ambition of many a Jewish
boy (as well as mothers of Jewish boys) and announced to his
friends and associates that he was the Messiah. We assume
that he used this status to do things like always sleep in on
weekdays, and then always take the best figs at brunch, but
people allowed it, because what kind of sensible man would lie
about the imminent fulfillment of biblical prophecy? It's one
thing to promise that you'll bring a date for your best pal to his
dinner party next week, and another thing entirely to promise
to bring Yahweh.

He was believed, and widely so, because of his charm, his
good looks, his *sincerity,* and, I'm sure, because of the inability
among his friends and followers to believe that a man with
such gifts would lie about such momentous topics, just to be
able to sit at the end of the table all the time and not have any-
body interrupt his anecdotes. His influence and power spread,
in Eastern Europe and beyond, as whole communities of Jews
began literally packing their bags, waiting for the moment when
Shabbatai would lead them to Jerusalem and beyond. He be-
came the most famous and important Jew seen on the global
stage until the advent of Steven Spielberg. (There were other
benefits, of course: in addition to accepting the gifts and trib-
utes due to the Messiah, he also took as a wife a semilegendary
harlot by the name of Sarah, who had—it's complicated, don't
ask—been promised to the Messiah. It's odd, isn't it, how all of
God's messengers, post-Jesus, immediately whip out that godly
status like an AmEx Platinum Card in order to get laid. Joseph
Smith, founder of the Mormon church, received a message
from God naming the young girl He had selected to be the sec-

ond wife of Mr. Smith, and also calling out, by name, the first Mrs. Smith, very much alive and still married to Joseph, and suggesting she just chill about it.)

None of this is particularly unusual—even the Blues Brothers said they were on a mission from God. What's odd about Shabbatai Zvi was the denouement of his story: after achieving vast fame and influence, his intentions to begin his true earthly reign by overthrowing the Ottoman sultan were betrayed to said sultan, who had him arrested and put a simple choice to him: convert to Islam or die.

Now, it's difficult to imagine I would get into this situation, but if I did, I think that I, like most people, would feel an obligation to play it out, even at the cost of immediate and painful martyrdom. I would rather die than face somebody whose book I borrowed but never returned, so explaining myself to a continent full of Jews, who saw me as their only salvation from a life of repression, prejudice, and pogrom—*because that's what I told them I was*—would be a lot more difficult then just lowering my head, extending my neck, and trying not to wince when I felt the sting.

Shabbatai, though, converted on the spot.

I presume his thoughts, as he did so, were something along the lines of "No problem—I'll come up with something." He did, too, for a while, letting his friends in on the secret that this was, in part, God's plan for him, his new Islamic faith a short detour on the way to the Heavenly Kingdom. It didn't last, though, and he died in exile, alone and mostly reviled. Not so much, I would guess, because he told so many lies, but because he finally failed to come up with another, really good one. However, despite this, he has followers alive today, a sect known as

the Donmeh, or Shabbateans. I have no idea what they believe, particularly about that inconvenient conversion, but I would guess that at heart, their faith is this: "Come on, he couldn't have *just made that all up,* could he?"

Successful liars, like Zvi, are often charismatic, intelligent, and perceptive, the kind of people you want to believe because if you do, you bask in their presence. But the only real essential skill for a liar is purest chutzpah, and that alone will take you far. For example: Arthur Orton, known to history as the Tichbourne Claimant. In April 1854, a ship went down with all hands off the coast of South America. On it was Sir Roger Charles Doughty Tichbourne, an effete, French-speaking British aristocrat, aged twenty-six. His distraught mother, Lady Tichbourne, refused to believe her son was gone, and sent letters all over the world, seeking news of her son. Eventually, her prayers were answered . . . by Orton, a butcher from—of all places—Wagga Wagga, Australia, who had been put up to the task by unscrupulous friends, despite the fact that Orton looked nothing like Tichbourne, couldn't speak French, and was as aristocratic as a lamb shank.

Astonishingly, when face-to-face with this portly Australian butcher, who didn't know anything about her or, for that matter, about his putative self, "his" mother embraced him and claimed him as her own. Even more astonishingly, so did hundreds of the dead man's friends and relatives. It was only after the death of Lady Tichbourne, when the question of a vast inheritance came finally into play, that other family members challenged Orton, and the resulting dispute became the Trial of the (British, nineteenth) Century. Orton maintained his story to the last, despite a mountain of evidence against him, and was finally exposed. After a second trial for perjury, he spent

ten years in prison, and ultimately died as destiny meant him to die: as a poor, fat meat-cutter.

We think confidence games and hoaxes—see, for example, most any David Mamet movie—are sophisticated, elaborate schemes designed to slip by people's natural resistance to falsehood. But that's a mistake—we don't have such a faculty. A sucker isn't born every minute; a sucker is born every time someone is born. Orton said something so profoundly appealing—that Sir Roger was alive, not dead—that even those without a particular motive to do so were perfectly willing to accept the lie. Over a hundred people testified in his defense at his first trial, and many of those people had nothing to gain from Orton's inheriting the estate. Maybe they admired the way he had learned how to prepare a crown roast during his long period of exile.

To lie correctly, appropriately, and properly, *as* an individual, *to* an individual, it's necessary to keep several principles in mind:

First, like my friend Jo Carson, nobody wants to live in a world in which you have to distrust people constantly; everybody wants to believe. However, the question is: Believe *what*? A poor liar will make the mistake of telling somebody something he or she is inclined not to believe anyway, while a truly great liar remembers to appeal to humankind's deepest aspirations: namely, to get rich, and to get laid, and to help a former Nigerian dictator's widow retrieve his considerable fortune. It's amazing what people will swallow if they think they'll get something bright and shiny as a second course.

For example, let's say a friend gave you money to buy him a Nintendo Wii, and instead you blew it on scratch-off lotto tickets. The friend now wants to know where his Wii is. What do you tell him?

The Bad Liar: "Uh, I was coming back from Best Buy, with the

Wii in my arms, and I was jumped by a bunch of fat wheezing guys in their midthirties, who grabbed the box and shouted, 'Excelsior! We have one!' as they ran and jumped into what I think was their mother's Toyota minivan. No, I didn't get the plate number."

What are the problems here? First of all, this lie in no way reinforces anything positive about the person you're lying to. If true, it means he was unlucky and foolish to trust you, and that he will get nothing for his loss. Second, it's exactly the kind of lie he would expect a liar to tell. It is one small, pathetic step from "a dog ate my homework." Bad liars always invent outside agencies to explain or excuse. This makes them look weak and helpless, their own fortune contingent upon others. The person you're lying to will become suspicious, ask you for further details, demand repayment, treat you scornfully.

The Gifted Liar plays it differently, making himself seem powerful, lucky, successful, and offering a chance for the mark to get on for the ride:

"Dude! I got something better. A friend of mine showed me this insane new console, the Nintendo Woah. Instead of a thing you hold in your hand, it comes with an entire suit—you climb into it, and every movement you make is translated to the screen. Flap your arms, and you fly. I tried it out—it was incredible. There's a beta program, and anybody who gets in on the ground floor, puts down a deposit, gets to be one of the first play testers. In fact, they're thinking of recruiting the best testers to become a kind of traveling demo team. . . . You can end up getting paid thousands to play video games. I had to make the decision then, so of course I gave him the money. 'Cause I figured that's what you'd want."

The advantages of this tactic are obvious—you appeal simultaneously to your friend's hopes and dreams, and to his vanity. You are lucky, and now so is he—he'll get something no one else

gets. Further, he is gifted, and as such, will have a chance to become famous for his gifts. Your friend will not only forgive you the loss of the money, but he'll immediately go home, cover himself in Saran Wrap to simulate the close-fitting Lycra sensor-suit on the "Woah," and start flapping his arms in front of a mirror.

Of course, eventually he'll wonder where the "Woah" is, how soon he can try it out, etc. But don't worry: you'll think of something.

※ ※ ※

In the 2004 election season, John Kerry spent a lot of time shaking his long face slowly back and forth, wondering how in the world anybody could ever question the fact that he was a war hero. He was *there*, it had *happened*, there were *witnesses*. Nobody had ever cast a scintilla of doubt on the events for thirty-five years, and now he was being accused of faking it. The people lying about him wore ties, and looked calm on TV. They had theories, and spoke of dates and names, and pointed out inconsistencies. And every time Kerry or his supporters got mad, and red in the face, and defensive, and insistent, they looked untrustworthy. They looked like they were lying, and thus gave credence to those who were. They were handicapped by their own incredulity: *How could this be happening?*

Liars of all stripes have existed and thrived, but it seems that only in the late twentieth century did they begin to organize. In the mid-1990s, I researched and wrote a play about Holocaust deniers,[1] those people who convene fake scholarly

1 *Denial* premiered at the Long Wharf Theater in New Haven, Connecticut, in 1995, and is published by Dramatics Publishing.

conferences, write fake scholarly books, put on fake jackets and ties, and try to argue that the greatest single act of mechanized genocide in history, a vast criminal conspiracy that left behind reams of documents, hundreds of thousands of direct witnesses, and even a nice soupçon of confessions by the perpetrators themselves, never happened. I began researching the play primarily because I was interested in exploring why Holocaust deniers are so effective in achieving their goal—which is annoying Jews. You could make jokes about us controlling the world media or Hollywood, and we'll laugh and show you our World Zionist Conspiracy T-shirt. But cast any doubt on how we were almost all exterminated, and you'll hear from our lawyers.

That remains a mystery to me, but I became more and more interested, instead, in the techniques that the Holocaust deniers use to deny the obvious and historical truth. Almost immediately after the end of the war, various Nazi sympathizers tried to do a bit of ex post facto justification: to paraphrase Woody Allen, they pled guilty—with an explanation. Something like: concentration camps had been invented by the British, after all, and Germany was at war, and they needed labor, and certainly lots of people died, but look what happened to the Germans when the Russians invaded, etc. These apologists found some sympathetic ears, including those sticking out from under the helmet of George S. Patton.

But as the enormity of the crime became established in the years after the war, anybody who defended the Nazis would instantly be deemed a Nazi himself, which is about as bad as . . . actually, okay, that's about as bad as it gets. It's tough to defend your position when you start out as the modern embodiment of evil. By the 1970s, there were neo-Nazis, and still plenty of original Nazis as well, attending conventions and

reunions and cocktail mixers in Paraguay and Argentina, drinking caipirinhas and singing the "Horst Wessel Song," but they couldn't dream of coming out in polite society. The death camps were the most significant obstacle to presenting the National Socialists as a legitimate, if perhaps overly excitable, political party. Auschwitz needed to be explained away.

It's remarkable, given the frighteningly butch, Tom of Finland–like heroic fetishism of Nazi sympathizers, that the man who showed the way forward was a sallow professor of electrical engineering at Northwestern University named Arthur Butz. In the early 1970s, as soon as he had received tenure (and thus, of course, was safe from being fired for his extracurricular opinions), he took a sabbatical and, upon his return, published the fruits of his "research": *The Hoax of the Twentieth Century*. Written by an academic, it has the look of an academic text: organized into chapters, with footnotes, a bibliography, various citations, horrible smears of yellowish bile across the pages. No, I'm sorry, I just began to fantasize those were there after reading it for a while.

Butz created a framework for advancing a lie, a way to make it appear reasonable, and the rest of his associates instantly began to imitate it. Instead of Bunds and Klans, they organized themselves into Institutes and Centers. They traded the sad-looking fake jodhpurs they had wheedled out of their moms for tweedy off-the-rack suits, and bought secondhand Xerox machines to publish Journals and Newsletters. The most unreasonable hate-crazed fanatics outside of the end-zone seats of the Oakland Coliseum transformed themselves into what they hoped would look like reasonable people, and tried to keep the spittle to a minimum. Now instead of marching in the streets under home-made Nazi banners, they call for "open debate." They call for

schools to "teach the controversy." They make dark hints about the forces that prevent these reasonable things from happening.

Butz still teaches at Northwestern, scrupulous about never, never mentioning his hobby during his classes on circuits, systems, and signals. This is not out of any sense of propriety on his part: he knows full well that if he so much as says the word "Auschwitz" to a student, he will—as a succession of university administrators have promised, shaking their fists in the air—be kicked out so fast and hard he'll be only a distant splash out in Lake Michigan. Instead, he endures the derision, and the silent contempt, and the occasional campus protest. Then, during the summer and school breaks, he goes to gatherings in dingy halls in unpleasant countries, where he is hailed as a prophet and a hero. His most recent foray into the public eye was when he praised Iranian president Mahmoud Ahmadinejad's Holocaust denial conference in 2006. Butz probably imagined that all those Iranian chicks really dug him, underneath the burkas.

In 1998, three years after its premiere, my play was finally produced in the Chicago area, and I heard from friends at the theater that Butz himself had come to see it. This worried me; although I had never spoken to him, his work and life had inspired, in part, the central character of the play, a professor and Holocaust denier named Bernard Cooper. I had been careful to make sure I remained well within the rules of fair use, but was afraid that a person eager for publicity, and who enjoyed being Wronged, especially by Jews, might make some noise. I needn't have worried. He wrote a complete summary and review of the play for his website, noting the similarities between Cooper and himself, but his vanity overcame any sense of victimization: "Apart from the facts that Cooper is an engineering professor, has published a Holocaust revisionist

book, and uses some arguments inspired by my book, he has little resemblance to me. He is an organizer; I am not. He is devious; I am not."

🕊 🕊 🕊

After working on the play, and then considering other such organized falsehoods, I was able to create a tactical field guide for institutional liars. This isn't much use if you just need to explain lipstick on your collar. (How does lipstick get on your collar, anyway? Do philandering businessmen have a thing for overly made-up collar fetishists?) But it is the only way to go if you want to tell a really Big Lie . . . that the Holocaust never happened, that the moon landings were fake, that evolution is not true, that John Kerry was not a war hero.

Let's say, for example, that it is in your interest to convince the world that the state of Massachusetts does not exist. A daunting task, you say? Not at all, once you use these quick and easy steps!

ONE.

Affect a reasonable and neutral demeanor. Do not call your organization the Anti-Massachusetts League. No: you are the Committee for Inquiry into New England. Dress well, but not too well. A tweedy tie might help. You might want to print a newsletter, something like Journal of Inquiry into the Massachusetts Question. Remember to have footnotes. Footnotes make you look serious.[2]

2 See?

TWO.

Teach the controversy. There are two sides to the question you're addressing—that the second side is only something you just made up is irrelevant. Insist that all you want is a free and open debate on an issue that has perplexed many people for years, that is, whether there's anything between Rhode Island and New Hampshire. Certainly, you admit, there's evidence suggesting something might be there, but there's other evidence as well, and in a true and fair debate, both sides would be aired. I mean, why not? Why are the pro-Massachusetts forces so determined not to let you speak? Could they have something to hide?

THREE.

Project your motives and methods onto the other side. Now that you've established that there are two sides to the question, you're free to impugn the morals, methods, and intentions of the opposing side. Did you know that certain politicians and business interests make billions of dollars from the so-called state of Massachusetts? Did you know that these interests will do anything—anything—to make sure no one questions their assertions? Belief in Massachusetts is, in fact, an irrational dogma—and those who believe in it can't stand to have their precious diktats questioned. They organize secretly, communicating with one another behind the scenes, determined to hide their real motives and methods. There is evidence to suggest that they are some kind of evil cabal, who will do anything to protect their so-called Bay State . . . *from the truth!*

FOUR.

Your arguments are specific and seemingly verifiable; the opponents' are broad and assertive. You tell compelling stories

about how you were heading north on I-95 in Connecticut, and the next thing you knew, you were in Vermont. You point out how Sam Adams beer, supposedly "brewed in Boston," really is made by megabreweries in the Midwest. If "Harvard" is a real university, with a real football team, then why has it never shown up on national TV? In the meantime, while your opponents are sputtering, trying to answer each of these simple facts with elaborate and suspiciously complex-sounding explanations, you drive home the knife: "Pro-Massachusetts forces—Massachusettsists—assert the right to invent any state they choose, assign it ridiculous coastlines and towns with funny names, and simply expect the American people to follow their lead like sheep!"

Last, and most important,

FIVE.

Never give in. Ever. This is truly the key to a successful campaign of falsehood, large and small. Once you give ground, at all, everything falls down around you. Conversely, a serene confidence that you hold the key to the truth will attract followers—you'll certainly look more attractive and pleasant than those sputtering, increasingly crazed people who seem like they want to kill you. Remember, if they have the truth, why are they acting so defensively?

Thus:

MASSACHUSETTS BELIEVER: So, I was just in Boston.

MASSACHUSETTS SKEPTIC: Oh, really?

MASSACHUSETTS BELIEVER: What?

MASSACHUSETTS SKEPTIC: Did you see your pal Edward

Kennedy there? Did you go sailing in your yacht in the famous harbor?

MASSACHUSETTS BELIEVER: What are you getting at?

MASSACHUSETTS SKEPTIC: Everyone knows that Massachusetts is just a fictional place, invented by certain patrician New York families so that they could corner the market in haddock, and pretend to have nice cabins in the so-called Berkshire Mountains.

MASSACHUSETTS BELIEVER: That's insane. I was just there.

MASSACHUSETTS SKEPTIC: You might have thought you were. It's a trick of the light. . . . In certain weather, the sunlight reflecting off the water of northern Rhode Island looks like tall buildings, streets, and public parks.

MASSACHUSETTS BELIEVER: Honestly, are you high?

MASSACHUSETTS SKEPTIC: Typical. All you've got is personal invective. Why? Because there's no evidence of Massachusetts existing.

MASSACHUSETTS BELIEVER: [Slowly backs away, shaking his head.]

GULLIBLE ONLOOKER: Huh . . . maybe there's something to this.

Perhaps the single most famous lie told in recent decades was uttered at a press conference on education reform in Washington, D.C., on January 22, 1998. It remains, almost ten years later, a shorthand for lies, replacing such standards as "The check is in the mail" and "The dog ate my homework." As well it should, because simply looking at technique and style—it was a pretty good lie.

Contrary to popular belief, President Clinton was not a par-

ticularly accomplished liar. The primary source of awkwardness between him and the truth was his need to tell people what they wanted to hear; it was once said that, as president, he always agreed with the last person he had spoken to, but that's not true: he had merely *told* the last person who he had spoken to that he agreed with him or her. Which he also said to the person before that, and the person after that. When the time came to actually confirm or deny a fact, he showed a lawyer's precision with language and a formerly fat, fatherless boy's need to be liked.

For example, his odd and transparent 1991 declaration about his use of illegal drugs: "I've never broken any drug law." That, of course, was not exactly what he was asked, but it seemed conclusive enough: illegal drugs are, ipso facto, illegal, and thus if he had broken any law, well, then . . . Of course, he admitted shortly thereafter that he meant *state* law, and that he had tried marijuana in England, i.e., outside the jurisdiction of any state. And then he emitted one of the poorest, most pathetic evasions ever: "I didn't inhale." To lie like this, with a constant eye toward some future defense from the charge of lying, is like trying to pitch a baseball game from your knees. Thus, when the worst crisis of his presidency and life came upon him, it took him a while to stand up and do things correctly.

The Monica Lewinsky story had broken on January 21, 1998, just a few days after President Clinton had been asked about the young intern in an ambush set for him at the deposition in the Paula Jones lawsuit. The deposition, and Ken Starr's sudden launch of a perjury and obstruction-of-justice investigation, had been leaked to the press, and Clinton still seemed a little stunned when he sat down that day with Jim Lehrer, of *The Newshour* on PBS, for what he had supposed to be a standard

pre—State of the Union interview. He certainly wasn't in top form, liar-wise:

CLINTON: There is no improper relationship. And I intend to cooperate with this inquiry. But that is not true.
LEHRER: "No improper relationship"—define what you mean by that.
CLINTON: Well, I think you know what it means. It means that there is not a sexual relationship, an improper sexual relationship, or any other kind of improper relationship.

Lehrer, probably a little embarrassed to be asking these questions, didn't pick up on the repeated use of the present tense—"There *is* no improper relationship." When I asked Lehrer about it later, when he was a guest on *Wait Wait,* he said he just didn't notice it at the time, and regretted not following up. You know Clinton noticed it, though. By the time he was sitting down for another interview that day with my colleague Robert Siegel of NPR, he had shaken that scruple off, but still was slow to the plate:

SIEGEL: Is there any truth to the allegation of an affair between you and the young woman?
CLINTON: No, that's not true, either. And I have told people that I would cooperate in the investigation and I expect to cooperate with it. I don't know any more about it than I've told you, and any more about it really than you do, but I will cooperate. The charges are not true, and I haven't asked anybody to lie.

Still, it was pretty thin stuff, because as anybody knows, "I will cooperate with the investigation" means "I'm guiltier than

O. J." When Robert in turn was a guest on our show, I asked him, too, about what it was like to be one of the very first people Clinton tried to mislead about Monica Lewinsky. His response: "Let's talk about something else, please."

<center>❧ ❧ ❧</center>

The press just bayed louder for blood. The White House press corps' first opportunity to confront him en masse was at a joint appearance with Yasir Arafat, of all people, who, as he watched Clinton get assaulted, seemed even more befuddled and antsy than he usually did.

Q: Forgive us for raising this while you're dealing with important issues in the Middle East, but could you clarify for us, sir, exactly what your relationship was with Ms. Lewinsky, and whether the two of you talked by phone, including any messages you may have left?
A: Let me say, first of all, I want to reiterate what I said yesterday. The allegations are false and I would never ask anybody to do anything other than tell the truth. Let's get to the big issues there, about the nature of the relationship and whether I suggested anybody not tell the truth. That is false. Now, there are a lot of other questions that are, I think, very legitimate. You have a right to ask them; you and the American people have a right to get answers. We are working very hard to comply and get all the requests for information up here, and we will give you as many answers as we can, as soon as we can, at the appropriate time, consistent with our obligation to also cooperate with the investigations. And that's not a dodge, that's really why I've—I've talked with our

people. I want to do that. I'd like for you to have more rather than less, sooner rather than later. So we'll work through it as quickly as we can and get all those questions out there to you.

This was, again, just piss-poor, as if he had reverted under stress to the guilty, chubby schoolboy he had once been, caught in the back of the school playing doctor with Ardelia Mapp. First note the consistent weaseling about what it is he's denying: "Let's get to the big issues there, about the nature of the relationship and whether I suggested anybody not tell the truth. That is false." Note carefully, as many did at the time, that he says "that" is false, rather than "those" are false, and further, that he never says anything specific about "the nature of the relationship." During this crucial period of the developing falsehood, Clinton kept trying to shift the subject from his relationship with Ms. Lewinsky to whether he had asked her to lie in her own Jones deposition. For one thing, he knew that suborning her perjury would have been a criminal offense, while merely canoodling with her was not, although, as we found out, it was a gross violation of good taste. But shifting the topic to "asking people to lie" also got him on firmer ground: he never admitted, and it was never proved, that he had asked Lewinsky to lie.[3]

But with the subject shifting, and the classic dodge of "co-operating with the investigation," you can see Clinton realizing how weak that is, knowing that even as he says it, he fooled no one. Clinton had to elevate his game, and he did.

As Clinton puts it in his book, My Life, "The day before the

3 However, in his book Uncovering Clinton, Michael Isikoff, the reporter who played a central role in the drama, makes a strong case suggesting that Clinton did just that.

[State of the Union] speech, at the urging of Harold and Harry Thomason, who felt I had been too tentative in my public comments, I reluctantly appeared once more before the press to say, 'I did not have sexual relations' with Ms. Lewinsky."

Looking at the video of that press appearance—happily available forever on YouTube—he doesn't appear reluctant. He appears determined, fierce, ready to go. The occasion was an appearance on education reform, which also had been hijacked by the press back to the Lewinsky matter, as he had known it would be. This is what he said about the subject, in its entirety:

> Now, I have to go back to work on my State of the Union speech. And I worked on it until pretty late last night. But I want to say one thing to the American people. I want you to listen to me. I'm going to say this again. I did not have sexual relations with that woman, Miss Lewinsky. I never told anybody to lie, not a single time—never. These allegations are false. And I need to go back to work for the American people.

Finally, here, we see a master at work. First, notice the rhythm of the opening sentences, each with a thrumming downbeat: "Now . . . And . . . But"! Admire the setup sentence: "I want you to listen to me." He is signaling absolute sincerity. That's what people say when they're about to lay The Truth on your ass. That sentence is something you'd expect to be followed by This marriage is not working or The spaceship is on fire: something you need to pay attention to. Then—and this may be my favorite part—"I'm going to say this again." He hadn't really ever said it, which is why everybody was trying to pull down his pants. But by saying he was going to "say it again," all of a sudden, he made his

dodges and evasions over the past prior days a failure on *our* part: we just hadn't been listening carefully enough. We're sorry, Mr. Clinton! Please, tell us now, we're listening!

And then comes the famous lie: *"I did not have sexual relations with that woman, Miss Lewinsky."* In the legend that immediately sprang up about that moment, he's said to be *obviously* lying, emphasizing overmuch with his famous pointing finger. There were people who knew for a fact he was lying—Starr and his allies already had the tapes of Lewinsky talking about the affair with Linda Tripp—and they let their friends in the press know it as well, so Clinton was met with a continuing storm of skepticism and outrage. Thus, in hindsight, we think he fooled no one.

But look at the video. As he begins, he cocks his head, narrows his eyes. It's the demeanor of a father finally running out of patience with a recalcitrant child. "I'm going to say this *again*," he says, and raises that famous extended finger. He pauses for emphasis after almost every word:

"I did. . . . *not* . . . *have* . . . *sexual* . . . relations with that woman . . ."

He doesn't just wave the finger, he strikes the lectern in front of him audibly, a drumbeat of sincerity. Then he adds the name, "Miss Lewinsky." He knows her name. He's not going to pretend he doesn't know what you've been saying about him. Aren't you embarrassed?

Now he starts to shake his head, quickly, emphatically:

"I never told anybody to lie . . ."

Not ever, Mr. President?

"Not a single time."

Really? 'Cause I heard—

"Never."

Oh, okay.

He continues to pound the lectern as he finishes, sternly, angrily, magnificently:

"These allegations are *false*. And I need to go back to work for the American people."

As he says that last, he's already turning and walking away. A lesser liar would just seem as if he's fleeing the room. But Clinton, as an actor might say, motivates the exit. He's angry. He's unhappy, and aggrieved, just as you would be if scurrilous lies had been told about you. He's impatient, incredulous with the fact that he even has to stoop to this. But mainly, he's balls-out *saying* it. No more weasel words. He is making a bold statement in front of the world. Most of who could not conceive of facing those cameras and saying something so profoundly untrue. So we believed him. I believed him.

In fact, watching it again, after everything that happened after—the Starr Report, his guilty confessions, his begging for forgiveness—I *still* believe him. Whatever part of my brain it is that looks for signals of sincerity is completely satisfied. In fact, if he asked me for twenty bucks for the tow truck, I'd give it to him.

<p style="text-align:center">⚜ ⚜ ⚜</p>

A word on the current occupant of the White House. Mr. Bush has said an extraordinary amount of things that are factually untrue . . . the weapons of mass destruction, the uranium in Africa, the nature and purpose of his tax cuts and their effect on the deficit, "We are doing everything we can to avoid war in Iraq," and on and on; yet, despite all this, the meme of "Bush is a liar" has never caught on with his many detractors, even as others—"Bush is a miserable failure," "Bush is Hitler," "Bush is an idiot," "Bush

was spirited off to Proxima Centauri and has been replaced by
an alien saboteur"—have gotten wide circulation. Even the more
outré theories, such as "Bush has been infected by a brain para-
site which thrives in warm weather, and therefore causes its host
to advocate policies which increase global warming," have more
currency, late in the long dark winter of his second term, than
the simple contention that Bush fibs.

For some reason Bush's awkward and distant relationship
with reality has been treated indulgently by the press. It's hard
to blame them. When he says something that simply isn't true,
as he did on October 22, 2006, when he told George Stepha-
nopoulos, "We've never been 'stay the course,' George," despite
the fact that he himself had used that very phrase "stay the
course" at least half a dozen times in public (and videotaped)
forums; even then, of the various possibilities—he has a split-
personality syndrome, he's suffering from the same weird short-
term memory loss as that guy in *Memento*—the option that he
knew it wasn't true, and said it anyway, seems *least* likely. Al
Franken describes this attitude toward Bush as an indulgence
of a complicit press—"*He just doesn't know! Give him a break!*"—
but I think it's more than that.

Again, it has to do with the subtle signals people give off to
indicate that they are telling the truth: the direct eye contact,
the confident tone, the command of detail, and sympathy to
your natural skepticism. George W. Bush evinces *none* of them.
His speaking style is that of a little boy heatedly denying that
he's been setting raccoons on fire. "Yeah, I appreciate the ques-
tion. Look, I *understand* the raccoon is on fire. I appreciate
that. But the raccoon was set on fire by enemies of raccoons.
People who hate the *freedom* of raccoons. And my job is to *pro-
tect* the raccoons, and that's what I'm gonna do!"

He gets defensive, he gets angry, he gets impatient; in response to challenges to his broad claims, he makes even broader, less defensible ones. Sometimes, he just stops any pretense and falls back on simple assertions, as in this statement from a speech in October 2002: "There's a grave threat in Iraq. There just is." Nyah, nyah.

"The President's M.O. is to utter untruths with such nonchalance that no one could possibly believe he was deliberately lying," wrote David Greenberg, a scholar of the Nixon presidency, and therefore somebody who knows a little something about presidential lying. But even Nixon at least made some attempt at salesmanship—witness the Checkers speech. People saw through Nixon's deliberate falsehoods, but with Bush, there's a key element missing, here as in other of his endeavors: competence.

Former Bush speechwriter Michael Gerson once called his boss "a 'compulsive truth teller,' a man so guileless that he can't hide his boredom when making speeches he doesn't want to give." It's an interesting critique, and a revealing one. To make the case that the president is a "compulsive truth teller," Gerson doesn't offer, for example, some compulsive telling of a truth, something like "My fellow Americans, sometimes I suck down an entire six-pack of O'Doul's nonalcoholic brew just so I can feel the click." No; Gerson's proof is that Bush can't sell a speech if he doesn't feel it. It's not that he's a *compulsive truth teller,* it's that he's a *bad liar.* But just because you're bad at something doesn't mean you won't continue to do it, over and over again. Look at the Chicago Cubs.

We cannot say that President Bush is lying, because there is no evidence, none, that he believes anything but what he is saying, despite the contrary evidence provided by reality, his own

THE BOOK OF VICE

prior statements, the smoke and ruin of his policies wafting in through the window. Perhaps some insider account will emerge which depicts Bush, the moment after the national TV feed clicks off, slapping his knee, shaking head, and laughing, "Hey, Karl, I think they fell for it!" I doubt it, though. As he has said, he is the decider, and he makes those decisions not from anything such as evidence or facts or even informed opinions but from his "gut," the most momentous and consequential belly in world affairs since the reign of Baldric the Goutish and Peeved. Bush knows in his heart that he never said, "Stay the course," so he didn't, despite the fact that he did. In a strange way, the sheer audacity of the falsehoods, tumbling from his lips like chocolate pudding from the mouth of an old man trying to enjoy his dinner in a rest home, insulates him from the charge of deliberately misleading us. He believes what he's saying; thus, he can't be lying.

Perhaps the best thing that could happen to the state of national and international discourse would be for President Bush to learn to become a better and more convincing public speaker. No more squinting his eyes, no more smirks, no more impatient, rising anger with people who have the audacity to question. No more "Look, I *understand*," no more "In other words," no more "Because I said so." Instead, he would have to present evidence, with intensity, humility, appropriate rhetoric, and practiced gestures, just like Clinton.

Then we'd know he was lying.

5

GAMBLING

or

DICE, CARDS, WHEELS, AND OTHER
LETHAL WEAPONS

An old joke:

A guy goes bear hunting. He spots his quarry in a clearing, raises his rifle, and fires. But there's no bear corpse to be seen. Instead, there's a tap on his shoulder. It's the bear, with claws extended. The hunter's doomed, and he knows it. But the bear, saying it's in a forgiving mood, offers the hunter his freedom . . . in exchange for agreeing to perform a highly obscene interspecies sexual act. The hunter, despite his misgivings, agrees.

After limping home, the hunter gets mad. He buys himself a brand-new fully automatic AK-47, heads back into the woods, finds the bear in that same clearing, and blasts away, emptying the whole clip. The cordite clears, and . . . nothing. Once again, there's a tap on his shoulder, and once again the

smiling bear demands something even more obscene, and painful, in exchange for letting the hunter go.

After making up something to tell the emergency-room doctors, the hunter becomes obsessed with vengeance. With contacts in the black market, he acquires some fearsome munitions, and heads back into the woods. As soon as that bear shows its head in the clearing, the hunter launches his arsenal: rockets, grenades, cannon fire. Trees fall, birds die from the fright alone. When he's fired everything he brought with him, the hunter crawls up to the edge of the smoking crater. Nothing there. He closes his eyes, and isn't surprised by the tap on the shoulder when it finally comes.

"Well," says the bear, "clearly you're not in this for the hunting."

🦅 🦅 🦅

Next time you go to a casino, look around at all the people, screaming at the craps tables, sweating at the blackjack tables, staring sullenly at the slot machines.

None of them are in it for the hunting.

🦅 🦅 🦅

Back in high school, some friends and I jumped on one of those charter buses down to Atlantic City that give you coupons for rolls of quarters at whatever casino sponsors the bus. . . . In other words, the buses play the same role that conveyor belts do at a meat-processing plant. We arrived in Atlantic City, got our rolls of quarters, changed them quickly back into cash because we thought we were smart. We then took the money and played

blackjack, and lost it all within about four minutes, because that's how smart we really were. You can re-create my first experience with gambling like this:

Find a friend. Tell that friend to remove all indications of human warmth or kindness from her visage. Stand that friend behind a table.

Put down a $5 bill on the table.

Count to twenty, then have your friend remove the bill.

Repeat until you're out of $5 bills, which in my case was eighty seconds.

Now, you might say, where's the excitement, where's the possibility of gain? That's exactly what I was wondering at the time. *This* was gambling? This was the activity that James Bond got all dressed up for, that inevitably drew him into the orbit of supervillains, and got him laid? This was as exciting, and painful, as getting blood drawn. Most people say that their first sexual experience disappointed them, compared to the anticipation they felt before it. But imagine if you will, that first, long-hoped-for sexual partner saying, slyly, "Shall we?" and you nod eagerly, or shyly, and then you get socked in the jaw. Thus was the level of my disappointment, and for the next decade or more, I told anybody who asked that I just didn't care for gambling. Eventually, I learned to say that without my eyes shifting from side to side like Elisha Cook's.

I first visited Las Vegas, in 1992, as a research trip for a magazine article I was writing. It seemed like the veritable neon level of hell, Virgil's City of Dis with better lighting. I watched people stand in silence as vast sums of money gushed from their pockets and flooded downward into the drains on felt tables. I saw people bet, and lose, the amount of money I paid for rent every year, and then bet it again, and lose it again,

all the time without cracking even a smile. If they were enjoying themselves, they were doing it in a way unheard of in the annals of behavioral anthropology . . . replacing the traditional smiles, bright eyes, and occasional laughter with clammy skin, dull eyes, and trickles of sweat.

Men were gathered over there by a craps table, shouting and cheering or groaning and yelling, as dice and chips flew every which way. People sat silently in front of dealers at blackjack tables, staring, pointing, scraping, slapping their heads, looking into their wallets, muttering curses, getting increasingly angry at the implacable dealer. The other, odder table games made even less sense—what in the world was Let It Ride? Who rode what to where?

And so I studied, and learned, and even played a bit. I learned the rules to the games, and how they were designed, and what rewards they offered the serious player. I realized that those gamblers I had seen, on that first pilgrimage to Vegas, were not misguided or foolish. They were actually insane.

As is well known, if you flip a coin ten times, you might get, say, seven heads and three tails. You might even get ten heads in a row. But if you flip it a hundred times, a thousand times, ten thousand times, then you will begin to approach a fifty-fifty ratio between heads and tails. That's because there's a probability of exactly 50 percent of getting either heads or tails, and like the flaws in that remarkable person you spent the weekend with just a day after meeting him at the Viper Room, probability tends to reveal itself over time. This is known as either the law of averages or the law of large numbers, which is the basic principle of nature—not gravity, as you may have thought— that holds up the big walls at the Bellagio.

You might play a game ten times, and you can hope for, and sometimes even get, a run of luck equivalent to the ten heads in a row . . . ten points made in craps, ten winning hands in black-jack. But the casino, in effect, is playing millions of individual games a day, and is always listening for, and hearing, what Mr. Smith in *The Matrix* calls "the sound of inevitability." So all the games they offer have, built into them, a house edge . . . a small probability that the casino will win, eventually. If you happen to be near a casino roulette table while reading this book, you can actually walk up and touch that edge with your finger right now . . . it's the green 0 and 00 spaces at the wheel side of the felt. Bet black at roulette and you might think you have a 50 per-cent chance of winning . . . but it's actually about 47 percent, because of those two spaces that are neither red nor black. And those three points of difference, between a dead-even game and a game that favors the house by even a tiny margin, are why Steve Wynn has a private jet and you don't.

Guides to casino games will talk about good bets and bad bets, but it's all relative, in the same way that being struck on the head by a small sack of oranges is a good thing relative to being struck by a hammer. To find the house edge in any casino game, compare the odds expressing *what you win* versus the odds of actually *winning*. To take another example from roulette, the house usually pays what seems like a happily profitable thirty-five to one if you hit a single number. But a look at the wheel: with its thirty-eight spaces just sitting there waiting for someone smart enough to notice them, it reveals that the odds of actually hitting a single number are thirty-seven to one. Sucker.

This is true of every single bet in the casino, from a hand of blackjack to the most complicated proposition in *pai gow* . . . the

odds of the payoff are smaller than the odds against your bet winning.

So if anybody visiting the casino really wanted to make some money, he'd immediately turn around, exit the casino, invest in some blue-chip securities, and wait twenty years. So whatever it is that gamblers want, it isn't *money*.

Consider, for a final time, William Bennett. A Williams College graduate with a Ph.D. from the University of Texas and a law degree from Harvard, he is not, to put it mildly, a rube. He has served in positions of high power and, further, has made a lot of money, mainly through his books, including the bestseller *The Book of Virtues*, and through his lecture tours and radio show and other media that allow him to serve his demographic, i.e., people who like to listen to other people being scolded.

So when his decade-old high-stakes gambling habit was revealed in 2003 by *Newsweek* and the *Washington Monthly*, the question should not have been about hypocrisy, i.e., How could this man who had literally written the book on morals[1] have indulged in such a low, morally repugnant activity? *O where, Bill Bennett, is your devotion to the Right and True now?*

Who cares? The only person we can reasonably expect to actually live up to the moral standards he sets for other people is the pope, and even then we have to limit it to popes elected after, say, 1978 and before 2005. The real question for Bennett, and any other high-stakes gambler of his particular predilections, is: *Wouldn't it be simpler, and ultimately more beneficial, just to eat your money for the roughage?*

1 Well, one book. This is another one, I guess.

He played *slot machines*. Those high-stakes slot machines, $500 a pull, that are located behind velvet ropes or pebbled-glass doors—like restrooms!—at casinos, where, sometimes, tuxedoed hosts will escort you to your velour-covered throne, as if you were Ludwig of Bavaria himself, golden guilders clinking in your hand. And there, you sit down to confront your opponent . . . a computerized $500-a-pull slot machine, at heart just like the clacking, buzzing machines that the tourists down at Circus Circus are feeding by the thousands, but this one is gussied up with gold chrome plating and the same kind of fake wood veneer you find on a Lexus dashboard. Its winning payouts are programmed into it, and you couldn't beat it if you had all night long, perfect privacy, and a thirty-ounce Louisville Slugger. It is the ultimate sucker's game, as dumb a place to put your money as an open windowsill in a favela of Rio de Janeiro. Okay, maybe not quite that dumb: at the high-stakes slots, pretty girls bring you free drinks. Which, when amortized over a typical evening for Bill Bennett, work out to about $100,000 per scotch.

So: what's the motive?

The standard answer that he had an addiction or a gambling "problem" is utterly insufficient; it foists our conundrum onto his shoulders. We can't explain it, so we merely pity him for behaving in an inexplicable way. This will not do.

Perhaps, you could say, he thrived on risk, the thrill of victory over long odds. Nonsense. There are thousands of more efficient and rewarding ways to gamble outside of a casino. Once, a few years ago, a man was giving me a ride from Vegas to the Grand Canyon, and I asked him if he liked to gamble. He laughed. "I've spent the last year day-trading, buying and selling hundreds of thousand dollars' worth of stocks in the space of ten minutes, so playing fifty-dollar blackjack doesn't

really have a lot of thrills for me." I should note that he was giving me this ride in his own plane.

Well, maybe Bill liked the competition. There are all kinds of studies citing the rise of testosterone levels in successful athletes and even their fans, and anyone as good at Trivial Pursuit as I am knows, firsthand, the physical thrill you get from vanquishing your rivals. And even Bill Bennett, who has triumphed repeatedly over the public's tendency to get bored with shrill moralizers, needs new worlds to conquer. So why not visit an accommodating casino, where he can joust with Fate while drinking his Chivas and making eyes at the attractive barmaid who—

Oh, please. If he wanted to have actual competition against actual people, he could go down to the poker room at the end of the hall, or challenge the cocktail waitress to an arm-wrestling match, or try to catch a housefly with his bare hands. Any of those would involve more actual competition than playing slots, which is to an actual game what an IV drip is to dinner at Le Cirque.

So then: *what*? Why does a single person ever play a casino game, anywhere? I figured I'd return to Las Vegas and ask.

🜚 🜚 🜚

Anthony Curtis does not, as I think he would agree, look like a professional gambler. He has neither a black waistcoat nor a goatee, nor, insofar as I could tell, was he packing a derringer. At forty-seven, wearing a perfectly ironed shirt and slacks, he looks like he spends far more time in the gym than in dank card rooms. Either that, or he's got a portrait in his attic at home that looks just terrible.

His blow-dried professional appearance may be due to the fact that he quit playing blackjack for a living some years ago, and now owns and operates a Las Vegas–based publishing house, specializing in books on visiting Las Vegas and gambling. His newsletter, the *Las Vegas Advisor,* with its related publishing arm and website, operates out of a one-story industrial building west of the Strip, in the shadow of the Rio Hotel and Casino. It could, with a little gussying up, pass for an adult bookstore. The *LVA,* as it's called by its many readers, deals in tourist tips and hints, ways to save money and stretch a dollar during a visit to Sin City. Thus, a man who once made his living—and a very nice living, by his account—beating the dealer is now selling free buffet coupons to day-trippers from San Bernardino.

Was it a woman who set him straight? Did he look over the pile of winnings one day, get caught up in a semiotic haze because of the chips-to-cash-to-chips meaninglessness of it all, and decide to go make something of himself, and find redemption as a publisher of coupons?

"I can't gamble, because they don't let me," he explained to me. It takes two people to make a wager, and if the casino—or every single frickin' one—doesn't want to take your bet, there is nothing you can do about it. The funny thing, though, was that he doesn't seem that broken up about it. In Curtis's telling, playing blackjack for a living was about as exciting as data entry, without the glamour and sex appeal associated with the data-entry profession.

"You do it surreptitiously," he said. "If you're a tremendous blackjack player, you have to perform clandestinely, you can't let people know what you're doing. You have to take abuse from people. If somebody at your table has just chastised you,

you can't stand up and say, 'Listen, you moron, do you under-
stand what I just did? Do you know the makeup of this deck,
the count of the cards, how many aces?' You can't do that. You
have to sit there. It's brutal, it's lonely, it's tedious, it's monoto-
nous."

Curtis said that in "a vacuum" he could play blackjack in
such a manner as to give him a 1.5 percent edge. But of course,
in a vacuum, he'd quickly pass out from the lack of oxygen, as
his eyeball bulged out and then splattered all over the felt, so
instead he had to play in casinos. There, passing up showy op-
portunities to make a real killing, he actually played at a level,
he says, that earned him a 0.75 percent edge. And that, he said,
was enough to earn a nice living.

How could that be? Because, he said, he was able to churn
the money constantly, gambling, earning the return, "rein-
vesting" it back at the table, over and over again in the course
of a day. It's the law of large numbers again, but this time
working in his favor. He said that he once revealed this truth
to Penn Jillette on an airplane, and Jillette said, "Oh, my
goodness."

So for Anthony Curtis, and the relatively few people with
his knowledge and skill set, the urge to gamble is simple: profit.
But what about us, the helpless mooks without that skill, or the
smarts to avoid sucker's games like craps, slot machines, and
roulette?

"I think people are bored. Bored with themselves. Bored
with their lives, bored and disappointed with themselves. They
come here, to let it all out, to be different and reckless. It's a
spigot they can turn on and off.

"They're budgeting the stupid."

❧ ❧ ❧

From the modest one-story industrial building where Anthony Curtis works, I got in my rental car, drove west to the Strip, parked behind the New York, New York casino (for free, of course), and then walked into MGM Grand.[2] It's the largest hotel, in terms of number of rooms, in the world, and one of the largest and most profitable casinos as well. And every single square inch of carpet imprinted with the MGM logo, every bell and whistle (literally—there are bells and whistles), every pet lion in a cage, every shimmering cocktail waitress skirt, is paid for with a tiny fraction of the cash made from people who believe that they have a Sno-Kone's chance in a blast furnace playing casino games.

Years ago, we are told, Vegas was run by Characters, the Old-School Boys, who ran the town with flair and daring and skimmed profits, until they retired to shallow graves in mid-western cornfields. Nowadays, it's run by people like Alan Feldman. He started out doing PR for Steve Wynn, back in the days when the impresario was remaking Vegas with his tripartite casinos fronted by hotels and pirate ships, and now handles public relations for the massive MGM Mirage conglomerate of properties, which is basically any building on the Strip that doesn't have a big sign advertising SOUVENIRS or WEDDINGS in

2 Years back, you used to enter the MGM Grand through the legs of a gigantic golden lion, but apparently Asian gamblers, who revere lions, thought that was undignified and unlucky. The importance of Asian gamblers' superstition is evidenced by the fact that somebody threw away a four-story-high golden lion just to please them.

five-foot-high letters. He's short, incredibly articulate and well read. No more Robert De Niro, looming in his office looking over the gaming floor; Vegas is now run by David Paymer.

Alan's own professional history of selling Las Vegas has encompassed several eras, from Steve Wynn's reinvention/revival of Haute Vegas with the Mirage in 1989; through the weird abortive Family Vegas Era of the 1990s (a misunderstanding, he says . . . their message was that Vegas was a place where *you* could act like a kid, not that you should bring your kids); through the What Happens in Vegas, Stays in Vegas retro–Rat Pack period; and into the contemporary Vegas Lifestyle phase, in which Vegas—specifically, the unreal environment of the Strip—is now a place where people actually wish to live.

In the early days of his PR career, Feldman says, gambling was perceived as a dirty but open secret. Steve Wynn and his corporate copycats were trying to build a new world on the shifty bedrock of Sin, and, Alan admits now, there was a period of trying to brush all that gambling under the table. Back in the nineties, he says, his job was to get the press to write about the fine dining, entertainment options, and other amenities of the new Vegas: "That's what we thought was important then. We thought the public's reaction to gambling was inherently negative. But we knew that everybody would gamble when they were here."

And that, it turns out, is a bedrock of the Faith over which his company presides as a Vatican with better signage: *Everybody gambles.* "Go stand in the casino—and feel free to make it one of ours," he suggests. "And find a slot machine, and find a person sitting there putting coins in it. And watch him for a while, half an hour, an hour, and then walk up and say, 'Hi, my name is Peter, and I'm writing a book about gambling, and I'd like to talk to you.' And he'll say, 'Oh, I'm not a gambler.' You say, 'No

offense, but I've been standing here for an hour, and you've hardly blinked your eyes.' And he says, 'Oh, well, I put in twenty bucks, forty bucks . . . but I'm not a *gambler*.'

"That's a very common belief. We hear it a lot. We hear people say, 'Oh, I go to Vegas four times a year, but I don't gamble. . . . Oh, sure, I put maybe a hundred dollars on the table, but I don't gamble.'"

These days, with Sin back in vogue, gambling is openly celebrated, one of the many vices Vegas offers buffet-style. I ask Feldman why he thinks people do it, given that, as he readily assures me, every single casino game provides the house with a significant edge, because if it didn't, "Our shareholders would be very upset with us."

He contemplates the topic. "Gambling is life-affirming risk taking. You know risk is hard. Risk scares people. . . . You hear it all the time. . . . 'I'm risk averse, I don't want to take any chances, I'm afraid to change my job, I'm afraid to go back to school.' But here, you can take a chance, be done with it, right here, right now, know the outcome. In a way that's not going to cause any long-term harm."

By the way, Alan doesn't gamble. Told me so himself.

🐾 🐾 🐾

I leave the Strip and head downtown, via that horrifically depressing portion of the Strip north of the Stratosphere, a morbid line of liquor stores, wedding chapels, and pawnshops. . . . What happens in *this* part of Las Vegas stays here on the street until it starts to smell. My next destination is the Golden Gate Casino, the oldest continuously operating casino hotel in Vegas, and an anchor of what used to be Fremont Street and is now called "the

Fremont Street Experience," which is a marketing technique that hasn't, thankfully, spread very far. One doesn't want to go to, say, a podiatrist, and instead have to endure the Podiatrist Experience, with holograms.

The Golden Gate has a number of things to recommend it: it's small, it's friendly, it introduced the discount shrimp cocktail to Vegas, and still serves a very nice one for only 99 cents, a bargain Anthony Curtis continually points out to the subscribers to his newsletter. It's owned and operated by Mark Brandenberg, whose stepfather operated the place back in the Rat Pack days. He's sort of like Steve Wynn without the Ozymandias complex. Or the billion dollars.

I sat and had lunch with him and his general manager, Gary Smith, a true throwback, a thirty-year veteran of the Vegas (and Reno, and Tahoe, and Stateline, etc.) gambling saloons. He's worked everywhere, seen everything, and is bothered by nothing. Of course, I ordered the shrimp cocktail—but was told to ask for the more expensive $2.99 version. In return for putting more money on the table, I'd get larger shrimp. It's the kind of balls-to-the-wall quick decision making we Vegas hands make all the time.

Why do people gamble? I ask Mark and Gary. They respond with the usual reasons: Adrenaline. The urge to compete. It's a macho thing, Gary says: Back in the day, his day, gambling was what a man did, along with drinking, chasing women, and wearing Sansabelt slacks.

How about the rational explanation? Is it possible to make a living at casino gambling? Specifically, playing blackjack? We talk a bit about Anthony Curtis, and the other well-known card counters, such as the infamous MIT card-counting team, which supposedly beat the casinos for millions. Does Gary employ the

video surveillance, the private eyes, the sophisticated counter-
ing techniques, to protect his company's investment from the
rapacious professionals?

Gary shakes his head and breaks it down: "Card counting
had a huge following during the eighties and nineties, as a way
to beat the casinos. Now, if there are ten thousand people who
tell you that they are card counters, nine thousand of them are
lying to you up front. They don't know the math, they don't
have the discipline, and they have enough personality flaws so
that when they sit at the table, they've already lost.

"You've got a thousand left," he continues. "Of those, all but
about ten don't have the cash or the patience to beat you. Now
you have ten, who have the cash and skills. Of those, maybe
only five actually make a living at it. The other five decide to
retire to write books." Or, I mention, publish newsletters. "An-
thony Curtis started his publishing company on the typewriter
in my office," Brandenberg says proudly.

Do Mark and Gary themselves gamble? Brandenberg, who
came to his business relatively late in life, doesn't really have a
taste for it. He tells stories of how he came to Vegas as a young
man with his friends, to party and have fun, and ended up los-
ing far more money than he had intended, leaving him with a
woozy, angry feeling that tastes bitter to this day. Gary gambles,
but not in a casino. He likes to bet on sports, and will stop at a
sports book on his way home, outside Vegas, after the end of
his shift—at four or five in the morning—to put a bet on that
day's game, whatever it is. Why?

Gary shrugs. It's fun. It's interesting. It's something to get
excited about. He tells an Old Vegas story:

"It may have been when Jimmy the Greek was running a
sports book here, downtown. And a bum, what we'd call today

a street person, who slept out of doors just as much as indoors, whatever he earned, virtually all of it he'd spend at the sports book. And he would bet two dollars, and come in, and watch the TV, and scream and yell, and all the other gamblers, who may have had a hundred dollars on the game, would just sit there as this guy raised holy hell. . . . And this went on for a number of months. Finally, Jimmy the Greek called him over, and said, 'Hey, Charlie, you sit there, and you scream and yell and cuss that TV out, you've got a lousy ten dollars on the game. Show a little self-control.' Charlie says, 'Have you ever bet *everything you have* on a game?'"

In telling the story, Gary sounds a little jealous, as if he would like to be that guy, betting every dime on a single game. In fact, he says, as a casino manager, the only gamblers he worries about are the crazy ones. "The guys who are trying to come up with some complicated formula . . . go up so many units if you win, go down so many units if you lose . . . they're dead in the water. What I'm afraid of is the guy with just a little money, and he's not afraid of letting it ride. One guy who is absolutely fearless, and if one of those winning streaks happens, he'll cripple you."

That's who the casinos are afraid of: not the systems players, not the high rollers with their big bankrolls and years of experience. They're afraid of the crazy ones. It turns out being insane isn't merely a symptom of regular gamblers: it's actually an advantage.

❧ ❧ ❧

Still, nobody had answered my question to my satisfaction. Other than those five out of a thousand that Gary mentioned who really do have the brains and smarts to beat the dealer,

why would anybody gamble? In fact, one could argue that those five out of a thousand aren't really gambling, because, by definition, they have the system beat to where it isn't riskier than any other investment.

Enlightenment came, as it usually does, from an unexpected source, and, as it turns out, it came based entirely on a misapprehension. But hey, we live in an age which prizes Innovative Thinking rather than factual justification. Call the following story the "weapons of mass destruction" for which I "invaded" a conceptual "Iraq."

I was walking through the gaming floor at the New York, New York casino, on my way to some assignation or party which, no doubt, would in no way come within a parsec of looking like those assignations or parties pictured in the ads for the New York, New York casino. And I saw a very lonely-looking, quiet woman standing behind a table.

"Casino War!" the placard in front of the silent woman said. "You pick a card, the dealer picks a card. High card wins!" I immediately started looking for the catch. In gambling, there is always a catch . . . but not here. As far as I could tell, those were the rules. You get the high card, you win the amount of your bet. You get the low card, you lose.

Three things struck me at once: Given what we've established about the law of large numbers, first, it was impossible that this game should be here, as it seemed to offer even money (one to one) for an even-money-proposition bet. Thus, it was, without question, absolutely the best game to play in the casino. It should have had a $1,000 minimum bet, and still, there should have been a line out the door to the MGM Grand and back to play it. And, third, nobody was playing it at all. The Asian woman stared at me. I stared back.

That table, the lonely woman behind it, and the utter absence of people in front of it represented the whole secret of gambling: why people, otherwise smart and capable, insist on losing their money on games of chance they can't win. A mystery of human behavior, laid bare by a quiet Asian woman. She was my bodhi tree, the place where I received enlightenment. I finally understood. I smiled at her. She smiled at me. I went on my way. I wasn't going to play the damn thing, either.

And as it turns out, I was, of course, entirely wrong. Casinos are too smart to offer a real even-money game. If I had read the rules more carefully, I would have seen that yes, in fact, whoever has the high card wins even money. But if it's a tie, you go to "war," just like back in the second grade. But here, in the case of a "war," the player is required to double his bet. Casino does too, but that's just a show. If you lose, you lose your doubled bet. If you win, you win *only the amount of your original bet.* That's it. That's the edge right there, around 2.8 percent advantage to the house. But, you know, the enlightenment still counts, doesn't it?

🔱 🔱 🔱

Another old joke:

An old man goes to the synagogue (it's a Jewish joke, natch) and prays, every day, thusly: "God, let me win the lottery. Please, just one big win. I'll give money to the poor, and live a righteous life. . . . Please, let me win the lottery!"

For years, he comes to the synagogue, and the same prayer goes up: "Let me win the lottery! Please, Lord, won't you show your grace, and let me win the lottery!"

Finally, one day, after fifteen years of this, as the man mutters, "The lottery, Lord, let me win the lottery . . . ," a golden light suffuses the sanctuary, and a chorus of angels singing a major C chord is heard. The man looks up, tears in his blinded eyes, and says, "Lord . . . ?"

And a deep resonant voice rings out, "Please . . . *would you please just BUY A TICKET already?*"

That's why we gamble. *So God can answer our prayers.*

<p align="center">⚜ ⚜ ⚜</p>

Here are the essential elements of any true casino gambling game:

It must be at its heart completely random. Cards, dice, slot reels, computer chips, whatever. The final result must be up to God.

This essential randomness must be hidden by a series of arcane rules, propositions, strictures, taboos, and boundaries. Minimum bets, doubling down, horn bets, point spreads, laying odds versus giving them, splits, insurance, virgins throwing the dice, dealer must hit on sixteen, play one line or five, bank must draw on nine or less, and the Big 8 and Big 6—the last, of course, just for the tourists.

All of these rules allow the player a chance to believe that he or she has expertise, a way to differentiate him- or herself from the poor shlubs who sit on either side. They, suckers all, don't know that the surefire way to win is to place bets on six and eight, except when the point is six or eight, in which case . . . Blackjack players, as we have seen, are particularly enamored of this illusion: that there is a particular expertise

available to certain people that allows them, in the words of a famous book on the topic, to "Beat the Dealer."[3]

Gambling aficionados like to pretend that they can achieve enlightenment through wisdom: one of my favorite lines in all of gambling literature is this one, from Edwin Silberstang's *Winner's Guide to Casino Gambling*, in his chapter on blackjack: "Some experts suggest that a soft 19 be doubled down against a dealer's 6, but this is too skillful a play and might draw heat from casino personnel, so I don't suggest it be made." That's right, friends: don't display your superpowers so brightly: someone might notice.[4]

This combination of random fortune hidden behind rigorous, yet complex and sometimes ambiguous, rules for proper behavior will remind you of something—that's right: *splanchnomancy*, or

3 As counterevidence, I point out that every casino in America has blackjack tables.
4 This charming and readable book, which I constantly take down and leaf through, is one of the best-selling general gambling guides ever; it's prominently featured in most Las Vegas hotel and airport bookstores. And Silberstang provides lots of colorful anecdotes about his own exploits (successful) and those of others (not), but most of the book is a very honest, and therefore discouraging, description of the odds involved in casino games. His entire chapter on roulette, for example, twenty-four pages of tiny mass-market paperback print, could be boiled down to one word: "Don't." Has there ever been another area of human endeavor in which the most popular how-to guide generally, and at length, advises devotees simply to hang it up? Another great thing about the book—as a stylistic quirk, he titles his chapters with pithy descriptions of each game: "Blackjack—Advantage to the Player"; "Craps—the Fastest Game"; "Baccarat: The Glamorous Game"; "Roulette: The Quiet Game" (you can sense his desperation growing with that one). So what does he do when he gets to Caribbean Stud Poker, a complete dog of a proprietary fabricated rip-off that involves pictures of palm trees on the hucksterish rules placards that must offend every iota of his old-school, downtown Vegas, card-counting, steak-eating soul? He calls it "The Tropical Game."

the divination of the future via the examination of a freshly slaughtered goat's innards. Or, if you don't want to mess with goats, how about *alphitomancy* (divination by barley), *bletonism* (divination by movements of water), *margaritomancy* (bouncing pearls tell the future), or *scatomancy,* about which no more.

Each and all of these mystical practices were executed by adepts, wise men or priestesses schooled in the mysterious arts. It wasn't enough merely to grab a goat, excise its liver, and open it up as if it were the *Daily Racing Form;* no, these things had to be done right. The priestess needed to dress the part. The incense had to be just right, not too much sandalwood, not too little jasmine. The lighting had to make the jewels in the head-dress glisten just so. And, of course, you had to tip the waitress when she brought you your mead.

I have always credited myself with being the first to notice that gambling, and gambling halls, have more than a passing acquaintance to religious rituals, but Jackson Lears of Rutgers, a man of wide knowledge and far better research skills than I, wrote a whole book about it, called *Something for Nothing: Luck in America.* In it, he lays out a cultural history of the Great Divide in American society: between the belief that all good things come to those who work hard, play by the rules, and ceaselessly strive to improve themselves, and, opposing this faith in hard work and rational reward, a reliance on Providence, Chance, Fortune. America believes it is blessed with all kinds of good things—natural resources, a Protestant work ethic—but it also believes it is *blessed.* As Lears puts it, "Fortunate people always wanted to believe that they deserved their good fortune, but fortunate Americans were in especially urgent need of reassurance."

In Lears's telling, over the centuries, there have always been

religious and rationalist reformers, determined to stamp out this belief in the pagan goddess Fortuna, and its implicit disdain for hard work and earned desserts. Their primary target, of course, was gambling, which promises reward without work. Here's William Safire, as quoted by Lears: "The truth is that nothing is for nothing. Hard work, talent, merit will win you something. Reliance on luck, playing the sucker, will make you a loser of your life." Tell that to Chris Moneymaker, Bill.

Or tell it to John Winthrop, Puritan founder of Boston. Because, as Lears demonstrates, the history of America is a history of people who believed that, in the end, what happened was not up to them, but to Divine Providence, and that their success was a sign that God favored their endeavors. That belief, that some are blessed, and some are not; and that success, be it money, fame, a winning touchdown catch, is not a natural outcome of work and merit, but a sign of divine favor, is as American as the gated community and luxury skyboxes. And success in an essentially random, even meaningless symbolic endeavor is a divine centrifuge for separating the elect from the damned.

Consider sports stars, who seem, almost without exception, to make obeisance to the sky whenever they catch the winning touchdown or hit a home run. In any other field of endeavor, this would be recognized for the delusional self-aggrandizement that it is: "I landed the 'Depends' account yesterday, and of course it's all due to Jesus Christ, who wants me to glorify Him . . . and adult diapers." And of course nobody, but nobody, has ever excused a loss by blaming it on God: "The ball was hit dead solid perfect for the hole, but at the last minute, the Holy Ghost intervened to push it off line. That scamp." Or, as one agnostic pitcher once said of his prayerful teammates, "*Jesus* didn't hang that curve." God only rewards us; a loss is a

sign merely that we need to try again and give God another chance.

Or consider the Gambler himself, as icon and character. Time was, he was an attempt at Moral Instruction, with his black vest and shiny boots, his waxed goatee and mustache, his concealed derringer (real men wear their guns where we can see 'em), who lived a rootless and amoral life until he was redeemed in the end by a selfless, and sometimes self-destructive, act. But it was obvious that this reprobate was actually kind of cool, as all reprobates are, and in the years since the movie *Stagecoach*, among others, imprinted him on the public mind, he quickly went from antihero to hero to Kenny Rogers, at which point the forces of evil rolled their eyes and went out to find some other icon of menace.

There has never been, in the history of American culture, an evil character who truly lives by luck. No: the bad guys are always the casino bosses, the industrialists, the cheaters and criminals, the men who trust nothing to luck. At the end of the 1994 Mel Gibson movie *Maverick*, the incredibly resourceful title character, a professional gambler who can lie, cheat, scam, and finagle with the best of them, defeats his enemies by trusting to fortune, and in the Big Game, turns over the single card that allows him to win. (Then he shoots the bad guy, because bad guys never respect the decisions of Fortune, and have to pay for it.) In 2003's *The Cooler*, one of the recent spate of movies set in the new Las Vegas, the entire story pivots on a change in luck. The sad-sack "cooler" of the title, played by William H. Macy, has luck so bad that the amoral casino boss uses him to ruin the fortunes of gamblers by simply touching them. Then, as Macy discovers True Love and an inner well of courage, his luck changes, and he pays his debts and redeems his fortunes . . . *by winning*

thousands at the craps table. His fortune doesn't change his behavior; his behavior, quite literally, changes his fortune. And then he walks outside and a hurricane picks him up and puts him down on Larry Ellison's yacht just as the billionaire has said, "God, I'll leave my fortune to the next man I see." Oh, wait: that's the sequel.

That's what we expect. It is the Gambler's Religion. We make obeisance before the gods, and if they favor us, we will beat the odds. We will roll for hours without sevening out. We will Beat the Dealer. The mortal, mathematical impossibility is an essential condition. If we do right, if we appease the gods through whatever dance they require, they will reward us with fortune that we didn't *earn,* but *deserve.* And the casinos of Las Vegas, Atlantic City, Tunica, and every Indian reservation larger than a postage stamp are the temples built to celebrate this faith.

Not Monte Carlo, though. That exists to allow James Bond to meet supervillains, and get laid.

❧ ❧ ❧

My own moment on the Road to Damascus began with a wonderful and memorable night playing very-low-stakes blackjack at one of the cheaper casinos on the Strip, a place that sold $2 drinks at the bar, and where the advertised special in the coffee shop was fried mozzarella sticks. At the end of three hours of play, I had won $157, and that money seemed to absolutely glow. Each penny of that $157 throbbed with a reflection of my own worth. Since then, just like every other mook who's walked the trademarked carpet pattern of a casino, I've lost that amount twenty or thirty or forty times over, in a vain pursuit of that same moment of felt-table Buddha nature. But I don't remem-

ber any of that. But have I told you about the time I won $157 playing blackjack?[5]

These days, though, my favored game is craps, so after my visits to the various sages of Vegas I decided to spend a little time indulging. Craps, despite the mystifying lingo, is much simpler than blackjack—you don't have to memorize tables of "correct plays" for every situational variation. But the best thing about it, of course, is that you get to say you're a craps player. I like the dice. Love to roll them bones. Why, give me a car with fuzzy dice hanging from the rearview mirror, I'm inclined to flip that car over, just to see if I can make my point.

It's the one game at the casino where talking is encouraged, if not required, and I'm a bit of a talker. And a yelper. And, okay, I squeal sometimes, too, and they just don't dig that at the baccarat tables. Second, it's a manly game—there are women players, but by far the vast majority of players, and dealers, are men. For somebody like me, who splits his time between working in public radio and tending to a wife and three daughters, it's a necessary shot of testosterone. And last, and perhaps most important, it provides a terrific opportunity to feel superior to other people. Because a good four-fifths of the people around a craps table, particularly the stripe-shirted frat boys who play over at the Hard Rock, are absolute morons, or at least they act like them.

For example: On this particular occasion, I walk over to a $5-minimum-bet craps table and break a $100 bill. The action and excitement at this table are all centering around an African

5 One of the advantages of being nervous and crabbed around money is that it doesn't take a lot of cash to generate the requisite adrenaline or thrill when I win. For a mere $100 bankroll, I can enjoy the same heart-stopping terror that other people would have to spend thousands to achieve.

American man of about fifty years old who's wearing a cowboy
hat, cowboy boots, and heavy gold chains. In his hand is a drink,
which, I discover when he orders another one from the cocktail
waitress, is an "appletini." He's got lots of chips on the rail in front
of him, and he throws them out onto the table in the manner of a
man spreading grass seed. "Four hard way!" he shouts, and puts
his money down on an utterly miserable sucker's bet: that a pair
of twos will be thrown before a seven or a three and a one.

"Yo!" he yells.

"Yo!" yells the stickman, putting his money on an even
dumber bet, that the next roll will total eleven.

"Another appletini!" the Cowboy says to the waitress. This
was probably also a dumb move, because at a low-end casino
like this one, an "appletini" is most likely a shot of no-name gin
with an apple-flavored gummi worm dissolved in it.

Dice are rolled. A two and a two! Four the hard way! The
table whoops and hollers! A huge pile of chips is pushed over to
the Cowboy, who laughs and chuckles and orders yet *another*
appletini, and then throws more chips onto the table, shouting
out more proposition bets, as they are called, all those interest-
ing bets in the middle of the table that pay off at vasty amounts,
seven to one, thirty to one. Those odds are, of course, well be-
low the odds of each proposition actually happening—for ex-
ample, the odds against rolling a "hard four" before any other
four, or a seven, are eight to one. The bet pays at seven to one.
Which is why the Appletini Cowboy's pile of chips is steadily
vanishing, despite the occasional cries and shouts of glee.

I made some bets, won some, lost some, and then the dice
came around to me. I put down $20, and rolled a four. I now
had to roll another four before I rolled a seven. The odds against
this happening are two to one. Now, as all sophisticated craps

players know—sophisticated craps players like *me*—it just so happens that you are allowed to make an additional bet, called an "odds bet," that will be paid off *at exactly those odds*. It's the only bet in the entire casino that actually pays off at the same ratio as the probability of its happening. The casino doesn't advertise that fact. It's not written on the felt. You just have to know. And I knew. Because I am an adept.

I put $40 in chips, the odds bet, behind my original chips. Now: I started throwing the dice. A four would mean a win, glory, victory, that God loved me. A seven: disaster and death. I hurled the dice. A six. Other people's money changed hands, but it meant nothing to me. I hurled the dice again. A nine. People were cheering as their bets were paid off. But my fate was still up in the air. The Appletini Cowboy put a huge bet, again, on the hard four.

He turned to me, his breath sweet with gin and sugar: "Make that four!" he said.

I tell you now, dear reader, that I have never made any statement, not the "I do" I announced at my wedding, not even "Here" when my name was called in third-grade attendance, with the same adamantine certainty, the absolute confidence, the faith, with which I said the following words to the Appletini Cowboy:

"Okay," I said. "I *will*."

I casually tossed the dice down the table. Two dots on one die, two on the other. A hard four. I had made the point, and won the Cowboy's bet at the same time. A hundred dollars in profit came back to me across the table. The Cowboy got a huge pile of chips neither of us cared enough to count.

We gave each other a high five. "You got the juju!" he said. "You got the juju!"

Damn straight I do, partner. *Damn straight.*

6

CONSUMPTION

or

HOW TO KEEP UP WITH THE JONESES
WHEN THE JONESES ARE INSANE

Amy the flight attendant approached my in-laws on bended knee. At least: she was crouching, and walking forward, in a sup-plicantlike posture. It may have been because the roof of the Gulfstream cabin was so low. But if the phrase "on bended knee" means anything, it must mean this: a crabbed walk, as if the person doing it can't stop bowing long enough to actually move, so instead combines the two motions into a subservient shuffle.

"Mr. and Mrs. Albrecht," she said, "we had some discus-sions as to what to present you with, in honor of this trip, and since we haven't met you before we didn't know your prefer-ences. But we knew you live in Minnesota, so we decided to go for a North Woods theme." She presented them with a lovely gift basket, carefully hand wrapped. It had some wild rice in it, and some smoked salmon. My mother-in-law looked at it, and

tried to thank Amy for her thoughtfulness. But she acted as confused as I felt: my in-laws had paid tens of thousands of dollars for a private jet to take us from an equally expensive vacation in Jamaica back home. We were now in that jet, so Amy would have as clear an idea of this fact as anyone. My in-laws were people who could afford a private jet—the jet we were currently sitting in. Clearly, the last thing in the world such people needed was some free lox.

And yet: we were tyros at this level of luxury. My father-in-law, who had grown up on a dairy farm in central Wisconsin, had acquired his wealth through decades of hard work. Further, he had done it in a small Minnesota community that frowned on ostentatious displays of wealth. For years, despite his dreams of Mercedes-Benzes and Lexuses, he had been limited to driving the nicest Cadillac he could find on the local dealer's lot. I mean, the dealer bought ads in my father-in-law's newspaper. They saw each other around town. What's he going to do, turn up in some kind of foreign car? But in semiretirement, he felt he could start to enjoy himself, and did. First, he traded in the Cadillac and got himself a silver Mercedes S-500 with pneumatic and heated everything. Then he found out about fractional jet ownership. And thus, they found themselves forty thousand feet over the Caribbean, trying to effuse over a $30 gift basket.

Everybody breathed a sigh of relief when Amy retreated to the pilots' compartment. In a strange kind of midwestern reserve, we all felt we would be more comfortable in this luxury sixteen-passenger Gulfstream jet with a crew of three, including two highly trained pilots and a pleasantly obsequious and attractive flight attendant, if we were able to pour our own drinks. It would give us a sense of self-reliance.

But I kept thinking about that gift basket, now sitting on the floor, where my mother-in-law had tried to hide it. Amy dealt with wealthy people every working day, as well as with the occasional movie star or other celebrity. These people expected, and received, excellent service, not to mention a selection of single-malt scotches and faux-mahogany toilet seats. But why in the world would they expect a present? Yet they did, clearly . . . otherwise Amy would never be so bold to offer it. Clearly, she had some insight into the psychology of the ultrawealthy. As much as they buy, they don't want to think they have what they own just because of their money. They want a little token, just a package of wild rice, to indicate that they're *liked*.

🐦 🐦 🐦

Thorstein Veblen, a curmudgeonly midwesterner himself, conceived of the theory of "conspicuous consumption," one of those phrases that describe behavior that, like "passive aggressive whining," is something we readily see in others but never ascribe to ourselves. Veblen, a serious and respected economist, was reacting to the disparity between classical Adam Smithian economic theory, which holds that people act strictly in their own best interest (and thusly, collectively, in society's), and the Gilded Age society in which he found himself, in which a small but visible minority behaved in ways which, if they became widespread, would destroy Western civilization.

He observed men like—to take but one of a thousand available examples—"Commodore" Ned Green, the one-legged, debauched son of the infamous Hetty Green, one of the most parsimonious and wealthy misers who ever lived. The Commodore had a different view of economic theory than his mother,

who wore severe black suits for years until they fell apart—perhaps because they were bought secondhand in the first place. The Commodore, by contrast, liked to keep his own blimp at his estate near Buzzards Bay. Deciding at one point that he would like to own the world's largest yacht, he tried to have it built, but the shipyards were busy with World War I. Frustrated, he then tried to purchase suitable vessels from the Morgan and Astor families, but they weren't selling. So he purchased a Great Lakes steamer, the 225-foot-long *United States*, had it sawed in half, and ordered 40 feet of deck length added to it. The finished yacht, which was either the largest in the world or formidable enough to sink any rival by ramming, sported nine master suites, each with its own bathroom, and had a crew of seventy-three officers and seamen. Soon after the finished vessel was delivered to Buzzards Bay, it sank in 15 feet of water, and lay there, askew and useless, like the detached detumescent penis of a bored giant.

Not only that, but Commodore Green also owned what may have been the world's only diamond-encrusted chamber pot, which, in re his innate attitude toward the nature and source of his wealth, would send any Freudian into fits of ecstasy.

Now, Veblen observed men like Green—and Diamond Jim Brady, and Commodore Cornelius Vanderbilt, and John "Bet a Million" Gates, and James Gordon Bennett, who, among many other exploits, built the Newport (Rhode Island) Casino Club just to spite another club in town that had refused him membership. Bennett, it is estimated by chronicler Lucius Beebe, squandered more than $40 million in his long life, for which he got nothing more material in return than a "bad hangover."

So Veblen asked: If economic theory predicts that everyone acts for his or her own benefit, purchasing goods at the best

possible price and conserving resources as much as possible, then why in the world would anybody purchase a diamond-encrusted chamber pot?[1] His answer was to ascribe a *social* benefit to such purchases, rather than an economic one, although, in his view, social and economic benefits were intertwined: if you eat with the big dogs, you get better kibble.

Specifically, Veblen surmised that in premodern times, human castes were divided by labor duties into a hierarchy, with the lower castes doing more-menial yet essential labors, and the higher castes doing such things as hunting and fighting wars. The upper caste was marked by ritual and costume, often pertaining or relating to those martial occupations, and vestiges of that remained to Veblen's day: the aristocratic foxhunt, the wealthy landowner with his armies of uniformed servants. Nineteenth-century aristocrats often indulged in building new "ruins" of temples on their lands, as if to make literal the connection to a distant divine, ritualistic origin. But mainly, in order to maintain position at the top of the economic pile, people had to demonstrate their wealth by purchasing things that served no actual purpose. In other words, in order to prove you had money, and thus reap the caste benefits of the wealthy, you had to visibly waste money. To this day, an object that serves no purpose except to show that the owner could afford its ostentatious price is known as a "Veblen good."

But Veblen, we now believe, was only partially right. He was

1 His actual, classic example was the proverbial silver spoon, in that a utensil made of silver had no measurable advantage over a tin spoon in transporting soup to mouth, but I think he would have gone with the diamond chamber pot had he (a) known about it and (b) been slightly less stuffy. Besides, as any metallurgist could have told him, silver spoons do have a utility: silver being nonreactive, it doesn't affect the taste of the food. Nyah, nyah.

correct in that the purchase of such frippery as diamond chamber pots or, to take a more current example, anything at all sold by the Sharper Image, has value only as a display of wealth; but he might have been shortsighted in assuming this behavior arose from strictly human, social mores. There's evidence that displays of excess wealth go back far, far beyond the Neolithic age—and also that such wasteful behavior has more value than merely impressing the Joneses (or, in Neolithic times, the URggghFLGHHHs, I guess).

Richard Conniff, in his book *The Natural History of the Rich,* applies recent discoveries and developing theories of evolutionary biology to his personal observations of the wealthy. Evolutionary biology applies no more to the wealthy than to anyone else, but, of course, the rich have more freedom to act on their instinctual desires than other folk, and it's a lot more fun to go do sociological research in Aspen than it is in Ouagadougou (though to be fair, Conniff, a correspondent for *National Geographic,* has done both).

His theory: that Veblen's "conspicuous consumption" is really a form of "wasteful display," which for many decades was a puzzle to evolutionary biologists. The classic example is a peacock's tail. It's easy enough to surmise that a male peacock's tail serves to attract a female peacock, and thus helps to perpetuate the male's genome. But it gets trickier if you apply elementary Darwinism, which surmises that any adaptation, to survive through the generations, must bestow a survival advantage on the organism. Peacock's tails are enormous, ungainly, require a huge amount of energy to grow and carry around, and help keep the bird from effectively fleeing predators, or curious children, or me, once, at a Hawaiian luau, where I had one too many mai tais. Or three too many. Perhaps I too was engaged in wasteful display.

The question is, then: How could evolution, "the survival of the fittest," allow such a ridiculously inefficient animal to live? Wouldn't a bird with a large, ungainly tail be dragged down and immobilized, like Dr. Seuss's bird Gertrude McFuzz, and eaten? (If I were Dr. Seuss, that's how I would have ended it, which is why it's a good thing I'm not Dr. Seuss. Also: Sylvester Mc-Monkey McBean would give the Sneetches guns.) How could any attribute so seemingly detrimental to an organism's physical survival flourish throughout a population? The answer—in both cases—lies in the theory of *sexual selection,* which arose when a clever biologist realized that it wasn't enough for an organism merely to survive to reproduce; it also had to convince a member of the opposite sex to reproduce with it. I assume this insight came in a bar, late on a Saturday night, when the biologist once again found himself sitting by himself with his notebook. At any rate, certain kinds of attributes, such as the peacock's tail, might levy a significant cost in terms of the animal's overall speed, efficiency, and hardiness. But the same attribute might make up for that loss by making the creature more sexually desirable.

Thus: One day—and forgive me, evolutionary biologists, for the caricature of how mutation actually works—a bird is born with a fantastically heavy and colorful tail. Other birds laugh at it, mock it, run circles around it, predict the bird's early demise when the coyotes arrive. But: the chicks dig it. (And here, of course, I mean chicks in the vernacular, not avian, sense.) Chicks mate with it, and more big-tailed birds are born. As long as the big tail maintains its appeal, the added attractiveness (and thus matings) outweighs the survival disadvantages, and the genes for the big tail will persevere and spread through succeeding generations.

Ah, but the more perspicacious will ask: But why would a big tail—or a yellow beak, or magnificent horns, or a Lamborghini—attract a female in the first place? Female organisms, like any other, want to propagate their own genes, and aren't going to fall for any flashy young cock just because he provides his own sunshade. There must be an advantage for them, as well, in picking mates who are so clearly wasting precious bodily resources on pointless displays. And the answer to that seems to be: *the waste itself.* A female is looking to mate with the strongest, most hardy male around. She has limited time, and limited input, to choose from among the potential mates. Thus, in thousands of different species, males (and it's almost always the males) have evolved body parts, behavior, or other kinds of displays to show they have energy to burn: peacock feathers, reindeer antlers, hummingbird mating displays, a room in a hundred-thousand-square-foot mansion reserved solely for gift wrapping. The males sometimes exhaust or immobilize themselves, wasting their precious resources on the most gaudy displays possible, just to show females that they've got it to burn. A mature elk says to a female: "What, these eighteen-point antlers? Just picked 'em up on a lark, baby. Woulda gone for twenty, but you don't want to seem too nouveau, ya know?"

Which brings us, fairly directly, to eating gold.

They serve it at the Lodge at Pebble Beach: gold-foil-flecked abalone, foie gras, and truffles. Not in Jell-O, not yet, but that would be fun. There are bars, such as Libation in New York, where you can drink gold; chocolatiers where the gold wrapper is never meant to come off the bar; and at least one company, Easy Leaf Products, which sells edible precious metals for the

home chef.[2] The eating of gold might be the purest form of conspicuous consumption ever. For one thing, it's actual consumption—down your gullet it goes. For another thing, unlike other forms of extravagance, it has *no* utility to justify even a fraction of its cost. A $600,000 BiTourbillion BiFuseau watch by de la Cour may be a tremendous waste of money, but at least it tells time, and, as an extra, the phases of the moon, which increases the justified fraction of its price up to at least forty bucks. Gold-plated food is the closest polite society comes to actually lighting cigars with $100 bills. It has no utility, other than the exceptionally valuable utility of showing you can afford it. Once you have successfully demonstrated your excess resources to your potential mate, you straddle her thorax, and grasp her with your pedipalps, and then—oh, wait. Wrong species. But not by much.

Thus, the first principle of buying luxury items: No matter what they tell you at the Maybach dealership/jewelry store/spa, there is very little material benefit to any high-end item. Anybody who starts explaining to you, at length, why his $8,000 custom-fitted Serotta Ottrott bicycle frame with carbon fiber components, just like John Kerry's, is actually worth the money because of the way the handmade frame geometry provides the

2 You might ask, Why is this not mentioned in the chapter on eating? Because you're not eating gold or silver. You're merely borrowing it, as some ancient wag once said of beer. Gold foil is chemically inert in the human body; you can't, and wouldn't want to, digest it. In other words, diners of gold are paying a premium merely to forge a link in a chain that carries a precious metal, its chemical composition unchanged, from a deep seam in the earth to a local sewage-treatment plant. Which, if this particular trend continues, might see hordes of prospectors descend upon them, with shallow dishes for panning and thick rubber gloves.

perfectly calibrated balance between stiffness and ride, with optimum motion damping for an efficient power train, really wants you to know only one thing: *he spent $8,000 on a bicycle*. Or, that he is John Kerry, in which case my advice to you is back away slowly, nodding, without making any sudden movements.

Some men grasp this principle but little else. Years ago, I happened to be talking to a group of attractive young women in L.A. It was one of the those rare occasions when the ratio of women to men was so lopsided that I became statistically insignificant, a rounding error, and the women began talking to one another as if I weren't there. The subject of their disdain was, of course, men, and their pathetic attempts to impress women. Some of the men they met in bars led with nothing less than a personal inventory: "I've got a Benz outside, a two-point-two-mil condo in Brentwood." One man, said a particularly incredulous girl, actually introduced himself to her by flipping open his wallet and showing off his collection of credit cards.

I should say here that I met these women through a wealthy doctor who had invited them for a ride on his forty-foot yacht. So it wasn't that the men they disdained were wrong; it was that they were unskilled. Then again, so was the Russian oligarch who recently called up a professional concierge in Aspen and demanded reservations for dinner at an eating establishment at which he could spend, minimum, $1,000 per person for his family of ten—exclusive of beverages. That was his only criterion, and as such, he ended up both disappointed—even Aspen has no $1,000-a-plate restaurant—and looking, to the experienced wealth watchers of Aspen, like a pure arriviste. These pursuits take more than money. They take finesse.

🐦 🐦 🐦

My own experience with purchasing luxury items has been limited both by interest and by budget. Some years ago, my wife was in need of a new handbag, so I ventured into a shop on Fifty-seventh Street in New York City that seemed to have a nice selection. On one shelf, I saw a small simple bag with two shoulder straps, which looked much like the bag Beth had recently lost. "That looks nice," I said. "How much?"

"That *is* a lovely bag," said the clerk. "Let me check . . . five fifty."

For a wild moment, I entertained the notion that he would sell me a brand-name bag for $5.50. Then I quickly put that thought out of my head and trained my focus on getting out of the shop without tipping my hand, by choking or laughing. "Uh-huh," I said. "And how about that one next to it?"

"A little larger," he said. "Seven hundred eighty."

"Can I see it?" I said. He handed it down to me, and I gave it a cursory examination. I handed it back to him. And then we considered each other with, as the economists say, perfect in-formation. He knew that I would never, ever consider buying a bag for more than a hundred bucks. I knew that he knew. We smiled at each other.

"Okay, thanks," I said. "I'll run some more errands and will come back later."

"Sure thing," he said. "See you then."

He waved; I left, and bought a bag for Beth at a basement luggage shop on Lexington Avenue.

Imagine, if you will, a wealthy man: single, about forty, somebody whose business and personal interests require him

not only to have massive capital but to appear like he has capital. Somebody who has become, by necessity, an expert in the art of the most exquisitely conspicuous consumption. Let's call him Ramon. He would critique my approach this way:

"You asked for the price."

"How was I supposed to know how much it cost?"

"You're not supposed to care."

Ramon, as said, is wealthy, and more important, looks wealthy, but even more important, looks wealthy only to those whom he cares to impress. "Appearing wealthy is like shooting," he says. "People say they're going shooting. Shooting what? Grouse? Rats? Fish in a barrel? It's a question of what you're aiming at. You want to be a big hit down at the trailer park? Buy yourself one of those Excalibur custom car kits, and get yourself a jumpsuit with gold-plated grommets, which you should wear with patent leather shoes. That'll do it."

Hunting a better class of quarry himself, Ramon drives a Mercedes-Benz SLK55 AMG, a $70,000 hardtop convertible that has a specially tuned eight-cylinder engine from the performance division of Mercedes-Benz. Driving it is a bit like slipping into a leather seat attached to a space-shuttle engine, and I don't mean that in a good way. Ramon doesn't enjoy driving it—it's practically useless in the city where he lives, where its massive engine serves pretty much only to scare pedestrians when he revs it, although that can be fun. But it is—or has been—the perfect car for him. It's a slick-looking hardtop convertible, with those horizontal metal striations in the design that give it that pleasing engorged, venous look. Plus, the AMG nameplate is a kind of additional code, signifying the Mercedes-Benz racing and performance shop. It also indicates a premium of anywhere from $10,000 to $30,000. The AMG nameplate

next to the model number on the hood is, to put it crudely, like wearing a small medallion around your neck that says, "Four extra inches."

But Ramon is growing dissatisfied with his car. A rising tide lifts all boats, which is frustrating to those who are determined to be somebody who enjoys flicking his cigar ash onto the other boats, moored far below. "Just about anybody and his poor brother-in-law has a Mercedes these days," he says. "I met a guy who drove a Chrysler referring to his 'Daimler.'" For his next car, Ramon has three choices, all of which would indicate a particular image.

The Lexus. Despite Toyota's best efforts, the Lexus brand will never have the cachet of indulgence and luxury that Cadillac once had, that Mercedes had for a long time, and that now seems to be diffused among BMW, Mercedes, and the giant SUVs of Range Rover and Lincoln. Everybody knows it's just a Toyota dressed for a prom. But driving a $70,000 top-of-the-line LS 430 indicates that all you care about is *quality, image be damned*. As Alan Mulally, a profoundly wealthy, immensely influential senior executive of Boeing (2005 salary: ca. $10 million), said, he researched all the cars, and the LS 430 is "the finest car in the world." The fact that Mulally said this after being named the new chairman of Ford Motors also made choosing a Lexus seem *ballsy*, for the first time in the history of the brand. Despite his apostasy, Ford paid Mulally $28 million in salary for 2006, a year in which (a) Ford lost $12.7 billion dollars and (b) Mulally worked only four months, because he was hired in September. With those resources, Mulally can now get out of bed, buy a new Ford Focus, drive it to work, and then, upon arriving home, slow the car down to walking speed, climb carefully out, and then let it cruise off, self-guided, into the

distance. The next day, he'd purchase another, increasing his own company's bottom line, and taking away the sting of having to cancel the order he had already placed for a new '07 Lexus.[3]

🌂 🌂 🌂

Ramon is also considering the exotic car. One has to be careful: nothing screams recent lottery winner, soon to be bankrupt and in rehab, louder than a bright red Ferrari or, God forbid, a Lotus. Plus, as anyone who has actually driven one knows, they are terrible, loud, uncomfortable cars. The trick to spending a lot of money on an exotic car is to find one so exotic—quietly so—that again, almost nobody knows what it is. For example: the Panoz Esperante GTLM, a curvilinear sports car built by hand in an artisanal factory in Georgia. The Panoz company also owns a chateau with a winery and golf courses near its factory, so prospective buyers can tour the factory, sip vintages, and play a round while contemplating their purchase. If you agree to order a $128,000 customized car within thirty days, the visit is free. This seems a bit mercantile to some wealthy people, who expect, because they have lots of money, that *everything* should be free.

3 And nothing, but nothing, did more for the reputation of Lexuses than Mel Gibson getting pulled over for driving drunk in his LS 430 in the summer of 2006. Many people, of course, were appalled by his anti-Semitic drunken "sugar tits" ranting. But more were thinking, *Mel Gibson drives a Lexus? Whoa.* I don't know if there will ever be an investigation, but I wouldn't be surprised if the person buying Mel all those drinks at the bar at Moonshadows in Malibu was Bob Carter, group vice president and general manager of Lexus North America. Hard to prove, but Carter did get a promotion shortly thereafter.

The problem with exotic cars is that while they shout "Money!" to a knowledgeable observer, they also indicate a certain unseemly obsession with toys. It's only a few short steps from driving a Panoz or even a 2007 Pagani Zonda (base price: $1.5 million) down to slowly driving your precious reconditioned 1968 Corvair in a small town parade or, God forbid, putting your mint stock 1985 Porsche Carerra on a flatbed so it doesn't get nicked while driving to the next Concours d'Elegance. "Huh," people will say, "he sure must have a lot of free time." The best place for a truly expensive exotic car is in the remodeled barn at your country home. You can point it out to weekend guests while giving the tour, saying, "I still take it out for a spin sometimes, but mostly it just sits there. I really should sell it, but it's like parting with my youth. [Pause for guilty yet wistful smile.] Come on, let me show you the composting area I've been working on with the gardeners."

<p style="text-align:center">⚜ ⚜ ⚜</p>

Last, Ramon is considering an increasingly popular choice among the wealthy: the surprisingly mundane car. The patron saint of this movement is Warren Buffett, the multibillionaire who drove a 2001 Lincoln Town Car around Omaha for years. He recently auctioned off the car for charity, and replaced it with a Cadillac DTS, spending about $45,000 of his $52 billion net worth, the equivalent of you or I purchasing a single Tootsie roll. The message here, of course, is that you simply don't care about such mundane things as cars, and, as Buffett's car says explicitly—the license plate reads THRIFTY—you're someone who knows the value of a dollar, presumably because you have

counted every single one of the hundred million or so in your possession. A far more common exhibition of this impulse is the Starkly Utilitarian Vehicle: the (usually) American-made truck or SUV, mud on the fenders, that indicates you need a car not to show off, but to do necessary work around your many estates. Back in the midnineties, I spent some time at a movie star's home in Hollywood, and he proudly showed me his latest acquisition: a brand-new Dodge Ram truck, which, he said, he'd be using to pick up new trees at the nursery. Which he would plant himself.

Those who aren't quite confident enough can always choose the BMW, Range Rover, or Lexus SUVs, cars which try to straddle practicality and bling. If you don't actually have a country home yet, you can always pick up a bottle of Spray on Mud, genuine dirty water—filtered to remove potentially abrasive matter—harvested from the muck of central England.

Ramon is thinking about all these options, and in the meantime, contemplating striking out on his own, trendwise . . . purchasing a brand-new Vespa GTS 250 scooter, and showing up at the next charity ball with a scarf flapping in the wind, his date of the moment clutching him tightly around his waist. Since the rich are different from you or me, if you want to appear rich, then the best thing to do is appear different. One night I hosted an award ceremony, at which the awards were named after the incredibly wealthy philanthropist who had funded them. At the ceremony, I saw a man walking around, smiling at everyone, wearing a light brown three-piece corduroy suit and a carefully shaped White Guy Afro. He looked like an accountant who had been struck on the head and awoken with the delusion that it was 1975 and he was a pimp. It was

the philanthropist, of course; it may well be that the most suc-
cessful way to impress is pointedly not to try.

The truly wealthy, as they move about in public, are careful
not to flash their wealth . . . it's unseemly, and vulgar. Richard
Conniff tells the story of entertainment lawyer Alan Grubman,
who, upon first hitting it rich in 1981, went out and bought a
Rolls-Royce. In 1990, though, Grubman got a call from his
friend, the billionaire David Geffen: "You know, Alan, it's not
necessary for you to drive in a Rolls-Royce anymore. Will you
please get rid of it?" Grubman describes his moment of self-
realization this way: "It was like I had a blinking neon sign on
my forehead: NOUVEAU RICHE. The NOU went on, then the VEAU
went off."

Note, though, that Geffen said "it's not necessary *anymore*,"
implying, correctly, that at one time it was. The exception to
the general rule of not trying to impress the hoi polloi with your
wealth occurs when maintaining your own upward wealth vec-
tor relies on impressing them. In 1991, I went to Laughlin, Ne-
vada, to interview Don Laughlin, the Owatonna, Minnesota,
native who spotted the overbaked desert spot at the southern
tip of Nevada from a plane in 1966 and decided it was the per-
fect place to set up a gambling operation. The founder of the
town of Laughlin, now the third-largest gambling destination
in the United States, after Las Vegas and Reno (Laughlin says
he wanted to name the town Casino, but the postmaster re-
fused), has become a multimillionaire catering primarily to
low-rollers . . . RV-driving snowbirds, lower-middle-class slots
players from Kingman and the Inland Empire of California.
"We cater to what the Strip drives off," he told me.

Now, Steve Wynn is selling one kind of image, and provides
luxury restaurants and a collection of priceless European art

masterpieces, which he occasionally pokes holes in with his elbow, just to show he can. Don Laughlin is selling another kind of dream—he has to act rich in the way his customers aspire to be, and thus parks his Lamborghinis at the front of his casino, with signs pointing to the rest of his collection at Don Laughlin's Classic Car Museum a few blocks away. Other placards describe the extent of his holdings: the ranch, the private forest, the housing developments. A picture of him at the casino's entrance showed him wearing a white three-piece suit, like Tony in *Saturday Night Fever*. In person, Laughlin didn't seem particularly louche, and he says he's far more interested in expanding his business than in actually enjoying the fruits of his labors. Although, judging from his appearance, he also believes that his clientele hope to one day afford some high-end plastic surgery.

Similarly, Willie E. Gary, a trial lawyer based in Florida, flashes more bling than the Van Cleef & Arpels trunk show. A man who literally grew up in a shack in the cotton fields of the Florida Panhandle, he has become one of the most flamboyant and successful trial lawyers in the country, a winner of a $500 million judgment against the funeral home industry among many other victories, a figure who haunts the fevered nightmares of the U.S. Chamber of Commerce. He now greets potential clients with an image of himself, on his website, standing with his wife next to their his-and-her Bentleys, his a convertible, hers a sedan. (The Lexus SUV is off camera, in the garage.) You can also see a gallery of pictures of *Wings of Justice*, a customized Gulfstream, and his latest addition to the fleet, the *Wings of Justice II*, a custom-designed Boeing 737 with a large G emblazoned on the tail. According to his website, *Wings of Justice II* "sports an interior renovation that cost

more than $11 million, includes an 18-karat gold sink, plush leather seats, carpet, a $1.2 million sound system and a full service kitchen." *An eighteen-karat gold sink.* The accompanying photo gallery shows that the decor is, indeed, something along the lines of what a twelve-year-old would sketch out while drawing his Superhero Team Airplane while ignoring his geometry teacher.

Gary says, "This aircraft allows us to better serve our clients. We can meet with people in Atlanta, Chicago, and Carolina the same day and still be home for dinner."[4] Yeah, because we're concerned he and his lawyers are working too hard. Gary is not interested in attracting wealthy people, who would either—like David Geffen—be put off by this vulgar display of wealth, or quietly simmer with jealousy.

He's interested in attracting people who were *wronged* by the wealthy, people who want to be wealthy themselves, people who want a "high-flying," gilt-bedecked eight-hundred-pound gorilla in their corner. For example, the *Wings of Justice* must have appealed to the poor folks at SPS Technologies, a company that says it was driven out of business when tech giant Motorola stole its technology. Gary flew to its defense—we need not ask how—filed a suit for $10 billion in damages, and . . . lost, or at least didn't win: the November 2006 trial ended in a hung jury. But then it came out that one of Motorola's witnesses had improperly looked at a transcript of prior testimony. Gary immediately filed suit, and demanded—simply as recompense for that slight—$93 million *for himself,* a rate

4 Another wonderful feature of Gary's website: some elementary animation creates the image of a beam of light flashing from Gary's hand, as in benediction. He is, literally, the Bringer of the Light.

which works out to $11,000 an hour. His logic? "Look," he told the *Wall Street Journal*, "had we won the case, we would have gotten $4 billion in fees." Well, if you put it *that* way . . . it seems kind of . . . *reasonable*. A judge eventually awarded Gary $22.9 million in fees. Whether SPS, the supposedly wronged party, got anything is lost in the smoke from the departing jet, as Gary seeks out more injustice.[5]

The one area where all wealthy people indulge to the limit of their resources and beyond is entertainment. Throwing a party, or hosting a group of friends at your country home or yacht, is an excuse to throw all restraint to the wind. By definition, nothing you do for friends is an indulgence, so you can indulge all you like.

For example: the latest party accessory among the wealthy is Name Entertainment. They don't want you to know it, but major acts—folks from KC and the Sunshine Band to Paul McCartney—will play your private affair if you pay them an extremely large amount of money, transport them and their entourage to the locale, and promise never, ever to tell anyone. In November 2005, the *New York Times* wrote up the entertainment event of the Miami Beach fall season—the bat mitzvah of Amber Ridinger, whose parents arranged to have her and her 251 closest friends entertained by A-list rapper Ja Rule, with a special appearance by Ashanti. Her parents, who made their money on the Internet, proudly boasted of their ability to

5 Or, as the occasion may be, causes it. Apparently, on one of those trips on the *Wings of Justice,* before he could "get home for dinner," he impregnated a woman Not His Wife with twins. After originally agreeing to pay $28,000 a month in child support to the mother, he decided this was unjust, and successfully sued to have the amount lowered to $5,000 a month. Or, as he might put it, one gold sink.

celebrate their daughter's entry into womanhood, according to Jewish law, with A-list talent.

But even as that article ran, it was being topped by an affair in New York City, now as legendary in certain circles as Truman Capote's Black and White Ball was back in the 1960s: The Brooks bat mitzvah. David Brooks, a Long Island defense contractor (he made his millions on bulletproof vests for police and military applications), decided that his daughter's bat mitzvah needed not one, not two, not three, but at least nine major musical stars, ten if you include Kenny G, who was hired merely to provide background music as the guests walked into the hall. "Hey, that looks like Kenny G," one guest said, walking into the hall.

Steve Tyler and Joe Perry from Aerosmith were the headliners—or maybe that honor belonged to Joe Walsh and Don Henley from the Eagles, who also played. Tom Petty apparently wowed the crowd, singing his heart out, regardless of the venue, or, we presume, the raucous games of spin the bottle happening just offstage. The rapper 50 Cent, though, who was allegedly paid $500,000 for his time, did only four or five songs, including a variation on his "Birthday" hit, "Shorty, It's Your Bat Mitzvah." One wonders what Steve Tyler, just to pick on him for a moment, is thinking when he takes on this sort of gig—certainly, he can't really need any more money. He's a man who rose to the very top of his profession, and lived it largely . . . and now he's singing his anthems to an insanely spoiled (how could she not be?) thirteen-year-old girl from Long Island. "Janey's Got a Platinum Card?" "Janey's Got a Freakishly Oversized Id?" What does he say to himself? Presumably, something like, "The million dollars will come in handy, and no one will ever know." Or maybe he's thinking about how much

it's going to cost to hire U2 to play his granddaughter's christening, and he'd better start stockpiling the cash now.

And we assume that Mr. David Brooks was thinking: I can tell Steve Tyler to let my teenage nephew sit in on drums. And he's going to have to let me. Which, in and of itself, may have justified the $10 million price tag on the party.

It was a party that ultimately brought down Dennis Kozlowski, the chairman of Tyco, who was convicted of looting his company's coffers to shower himself with luxuries like his infamous $6,000 shower curtain, and his $15,000 dog-shaped umbrella stand, and his $2,200 gold-plated wastebasket. And then, of course, the birthday party in Sardinia, featuring entertainment by Jimmy Buffett, waiters dressed as Greek gods, and a replica of Michelangelo's *David* with a particular function. Here's the description from the memo sent by the party planner: "Two gladiators are standing next to the door, one opens the door, the other helps the guests. . . . We have gladiators standing guard every couple of feet and they are lining the way. Big ice sculpture of David, lots of shellfish and caviar at his feet. A waiter is pouring Stoli vodka into his back so it comes out his penis into a crystal glass."

The party ended with the revelation of a huge cake, in the anatomically correct shape of a woman. And then, at the climax of the evening, according to that party planning memo: "The tits explode."

It was those purchases, all or partly on the company dime (the Sardinia party was listed as a shareholders meeting), that made Kozlowski a villain in the public eye, up there with early-aughts financial warlocks like Richard Scrushy and Ken Lay. But Kozlowski's first trial for embezzlement ended with a mistrial, and in interviewing the released jurors, prosecutors found

that their focus on Kozlowski's wild lifestyle did not have the desired effect. Kozlowski was genuinely a self-made man, who had grown up in the Newark tenements, joined Tyco as a $28,000-a-year accountant, and single-handedly built it into a massive conglomerate, becoming known, along the way, as "Deal a Day Dennis." The jurors probably sympathized with him—if they had the wherewithal to make $100 million a year in salary and stock options, they'd probably blow a lot of it on vodka-pissing ice sculptures and exploding-tit cakes, too. I mean, what the hell?

In the second trial, prosecutors focused more closely on the mechanics of the financial malfeasance—the undocumented loans, the self-authorized payments—and Kozlowski was duly sentenced to eight to twenty-five years in jail. *60 Minutes* interviewed him at his new home in jail in central New York, and he expressed the same kind of wide-eyed innocence he had at his trial. He did not express significant regret for his wrongdoings. His defense at the trial was that he never tried to *hide* any of his expenses, or his habit of charging them to the firm, so what's the problem? Nobody complained, especially not the board of the company, although that may have been because they were soz-zled by drinking vodka from David's penis. Throughout the interview, he referred again and again to his riches, and the things he purchased with them, as merely a way of "keeping score," and it's easy to believe him. He thinks he's in jail for the crime of running up the score. It would be like imprisoning the New York Yankees.

And he said he never used, or even saw, or knew about, the $6,000 shower curtain. It was just arranged by somebody else—some professionally tasteful person who was hired to go out and make the Kozlowskis appear to be high class—and

Kozlowski signed off on it without bothering with the details, because why not? Because it may be that the true point of life is not to own a $6,000 shower curtain; the ultimate high scoring play is to be able to not notice you've purchased one.

<center>༄ ༄ ༄</center>

I have not met Mr. Gary, or flown on the *Wings of Justice I* or *II,* or been invited to a bat mitzvah with 50 Cent, or to (the former) Mrs. Kozlowski's birthday party. But I have met Madonna's accountant, and that, believe me, is just as good.

In 1996, I was just starting to get work as a screenwriter, and my agent suggested I meet with money managers. One of the names on the list she gave me was Bert Padell. I called the number, and a woman answered—I remember her name as Sylvia, but that may just be an embellishment. She spoke in a classic Brooklyn Jewish accent.

"Bert Padell's office."

"Yes, hello, my name is Peter Sagal, I'm with [my agency], they suggested I speak to Mr. Padell about managing my finances."

"One second, please."

It probably was one second, literally, before Bert came on the phone. He too sounded like a quintessential New York Jew.

"Hello, Peter! Delighted to hear from you. Sure, come down. When's good for you? Tomorrow?"

Tomorrow happened to be my birthday, but sure. I was a little put off, in that Groucho Marx "I wouldn't want to belong to any club that wanted me as a member" way, that he seemed so eager to meet me, and his schedule was so open. But I agreed to come down to his office, which, he said, was in the

building housing Carnegie Hall, on the fourth floor. I expected a small, old-school office, with a pebbled-glass window with his name stenciled on it, a dingy anteroom for Sylvia, a small office with a window looking out on the airshaft for Bert. Maybe an old, unused adding machine in the corner, which belonged to his dad, and he didn't have the heart to get rid of it. I expected a bad toupee.

I got off the elevator, and instead of that Raymond Chandleresque hallway of office doors, the transom windows open above, I saw: a vitrine. That is, a museum-quality, six-foot-high display box. Inside, a headless mannequin. The mannequin was wearing an elaborate rhinestone bustier. I stepped closer. The bustier was inscribed. By Madonna. "To Bert."

I looked left. The only doorway in the hallway led into a foyer about the size of my entire Upper East Side apartment. The three walls were lined, literally floor to ceiling, with gold records and other memorabilia. It was a riot of frames, gilt, awards. An attractive young woman greeted me. I said I had an appointment with Bert. "Of course," she said, and pressed a button, whispered into her headset. I walked over to the wall, looked at a smaller frame, in which I saw a sheet of White House official letterhead stationery. It was Richard Nixon's resignation letter. It seemed to be the original. How could this be?

Bert appeared. He seemed to be in his midfifties (he was actually just past sixty). The suit was expensive. The toupee, excellent. He said he was delighted to meet me. He led me to into the office. It wasn't on the fourth floor, it *was* the fourth floor. And the fifth. His own office suite was astonishing, a vast cavern filled not with luxurious furniture or art but with memorabilia . . . piles of it. Huge piles of bats and balls and signed shirts and gloves and framed letters and gold records and

mounted microphones and custom-made boxes of stuff I couldn't recognize. Bert had started to narrate the room, but there was too much to take in. He had been a batboy for the New York Yankees in the 1940s. Knew DiMaggio. That was his bat. Here's the ring from the 1949 World Series Championship. He showed me a robin's-egg-sized ring on his finger. I goggled.

In the corner of the room sat an older woman, with Gary Larson pointy-frame glasses, at a tiny desk with a computer and phone on it. She had large hair. This was Sylvia. That much, at least, I had got right.

Bert and I discussed my future. "We take care of everything," he said. "We pay your bills, we get you loans, we buy your real estate. You want to buy something? You call me up, we have it delivered, or we deliver you to it. For all this, we take ten percent of your income."

"Ten percent?" I said.

"Yeah," he said. "How much did you make this year?"

I mentioned the number. It was not much, and 10 percent of it was only one-tenth of not much. "So it's a bargain!" he said. "Later on, you start to make serious money, well. . . ." He smiled at me. "Then, it starts to get expensive."

He led me on a tour of the rest of the offices. Each wall was lined with more memorabilia, more gold records, more clothing behind vitrines. Each and every item, it seemed, was signed to him by the former owner: Luther Vandross, Elvis Costello, dozens of other major stars. It was like walking through the attic of the most wealthy, powerful obsessive celebrity stalker who ever lived. I kept waiting to see the framed restraining orders.

At the end of the tour, we arrived back at the door. I had seen the endless cubicles of hardworking CPAs, paying the bills of people vastly more famous than I would ever be. I had

seen the piles of signed footballs from every Super Bowl ever played. I had seen wonders that would make Ozymandias glower with jealousy. And I had an idea.

"You know," I said, "today's my birthday."

"It is!" he shouted.

"Yes," I said. "Really."

"I have a present for you," said Bert Padell.

"Wow," I said.

"I'm going to sing for you. I've been learning to sing. But I can't do it if I'm looking at anybody. So I'm going to turn my back."

Standing in the foyer of his two-story office complex, surrounded by riches and toys and the quiet hum of celebrity money burning through wires, Bert Padell, accountant to the stars, turned his back to me, and sang, in a tremulous baritone, "Happy Birthday to You." I smiled at his toupee, politely.

The next day, I visited another such firm. They had a pleasant if standard suite of offices on Park Avenue, with a few signed posters of movies starring their more prominent clients. "Where's all your stuff?" I asked one of their accountants.

"Oh, you met with *him*," he said. "We like to allow the clients to think we're not spending *all* their money."

7

PORNOGRAPHY

or

YOU CAN LOOK,
BUT YOU CAN'T ADMIT IT

I

Back in the 1970s, I went to school with a girl named Stephanie LeBow. Her father, Bennett LeBow (the "-owitz" was silent), was known as one of the richest men in our suburb, and went on, shortly after Stephanie and I began high school, to become notorious as a wealthy arbitrageur and the beleaguered owner of Liggett Tobacco Company. But on this particular Passover seder evening in 1978, his private jet and his grand yacht (the *Stefaren*, one of the largest ever built) were dim visions of the future; what we were all slipping into his den to behold, before we were enlisted to go find the *afikoman*, was the large metal-and-faux-wood box on his shelf: a VCR, the first anybody in my town had ever seen. It was both conspicuously consumptive, as it were, and naughty: because the only thing anybody would

want a VCR for, of course, was watching filmed records of an act that Stephanie called, in the midst of a particularly heated gossip session about some eighth-grade classmates, "Making Her Pregnant."

We stared at the silent, gleaming box. I wondered where the tapes were kept. In a locked, satin-lined ark, no doubt. I imagined Bennett LeBow dimming the lights, reclining in his Eames chair, perhaps sipping from one of those roundish glasses swirling with a brown liquid I had seen in movies. I didn't know the word "decadent"—okay, I was a geek, I probably did—but the imagined scene provided a sense of illicit and privileged sinning. What would be depicted on that tape was somewhat unclear to me. . . . There would be naked people, certainly. Perhaps an exotic plot of some kind. And Mysterious and Thrilling Actions.

I certainly knew about sex. In fact, in the fifth grade, I had become chief reader of the Mature Club, a group of boys that gathered at recess to listen to me read aloud from a purloined book, *How to Talk About Sex with Your Children*. "The penis is shaped like a thumb," it said. We all looked at our thumbs, and then glanced downward. Eventually we broke the club up, for fear that the Authorities would discover us, and prevent us from attending the Ivy League college of our choice. (Little did I know that years later, worldly women at Harvard would reject my advances because I kept provocatively wagging my thumb at them.) As to whether any of us would ever wish to actually commit such an act as described in the book remained an open question. Certainly, we knew that someday the option would arrive, and we would have to choose wisely. But despite my lingering skepticism about whether anyone should want to *do* it, I was convinced that given the chance, of course you would want to *watch* it.

In the adolescent years that followed, I had developed the typical appetite for glossy magazines with pictures of naked ladies, but, still, porn films were a distant grail, hinted at by the ads in the back of said magazines. *Debbie Does Dallas . . . Georgia Peach . . . The Opening of Misty Beethoven . . . Candy Stripers . . .* all available delivered to your home in a brown paper package, for only $100 each. That seems insane now, when free member previews display things unseen in the fever dreams of Al Goldstein himself, but it struck me as a just price, back then . . . perhaps because, as I unconsciously echoed the Talmudic tradition of my forefathers, it seemed that a revelation of the Great Mystery of the Universe should come at some cost.

But I certainly wasn't going to swipe my dad's credit card and order up one of those tapes, and we were still a few years away from the ubiquitous neighborhood Video Huts with their swinging plywood door in the back. So I came late, as it were, to seeing my first pornographic film.[1] It wasn't, in fact, until shortly after I started college. And given all the preliminary musing and theoretical research, I was woefully unprepared for the midnight showing of *Café Flesh* at the Harvard Square Theater, September 1983.

Café Flesh, one of the very few hard-core films with a credible case to be made for being Art, concerns a future society in which a plague has rendered most of society incapable of having sex. Instead, they gather at the Café Flesh, where the few

1 One of the frustrating things about writing or talking about pornography is that almost everything you say sounds like a cheap double entendre. You can stay on top of the subject, you can get the thrust of it as a thought comes over you, despite its being a hard topic to get around. See the problem? We've got a whole chapter to get through, so the only thing to do is just lie back and enjoy it.

remaining "Sex Positives" are required to perform for the view-
ing pleasure of the impotent masses. The scenarios are not
randy pizza guys making deliveries, but strange pastiches of
late-seventies-era surrealist downtown performance art: A
housewife at home, with three grown men dressed as babies
sitting in high chairs. A large man dressed in a furry rat cos-
tume enters the scene, sniffing with his whiskers. The housewife
does not notice him at first. But it turns out that the rat costume
has strategically placed flaps.

The Act, presented on the forty-foot screen in middle to
extreme close-up, seemed more biological than erotic. My in-
evitable, reflexive arousal was rather distressing, surrounded as
I was on all sides by male college roommates of recent acquain-
tance. I also remember being discomfited by the very loud
squishing sounds.

But the inserted shots of insertion, the odd sub–Wooster
Group performance art, these were not the ultimate reason for
my unease.[2] It was the reaction of the in-film audience at the
Café Flesh, and their implied doppelgängers in the audience at
the theater watching *Café Flesh*. They/we were impotent, alone,
desperate, staring at far more attractive people doing things
they/we couldn't themselves/ourselves hope to do. The film was
both the culmination of the whole "Porn Chic" movement that

2 The slam-bang transition from weird basement theater performance art to
hard-core sex—which I remember actually making me flinch, there, in my
damp seat at the Harvard Square—wasn't just a comment on the lack of fore-
play in the mechanistic sex shows of the future, or the porn films of the
present—it was an artifact of the filmmakers' financial planning. They had
hoped to raise financing by making a hard-core porn, and then cut out the
X-rated footage for mainstream release. One of the writers, Jerry Stahl, went
on to have a successful career as a writer, heroin addict, and bon vivant.

had begun with *Deep Throat* (and this movie made *Deep Throat* look like the awful, turgid, step-above-a-hard-core loop that it was), and the ultimate and final comment on it. *Café Flesh,* like its unpleasant, Joel Grey in *Cabaret*–ish emcee character, named Max Melodramatic, gave its audience what they wanted while at the same time telling them they could never really have it. "I get off on your need," hoots Max. As the scholar Hillel once said, about something entirely different: when it comes to porn, the rest is commentary.

<center>⚜ ⚜ ⚜</center>

Our earliest evidence of humans' predilection for erotic images comes, of course, from archaeology. There are numerous examples of stone figures of females, usually emphasizing the breasts and buttocks, such as the famous Venus of Willendorf,[3] but relatively few images of sexualized males. This has led archaeologists to believe that the figures are fertility figures, rather than sexual objects. This theory, though, was challenged by a recent discovery in Germany of a pair of clay figurines depicting a sexual act between a man and a woman. This seems to indicate that the figures were used to, say, invoke a bounteous crop of lentils exactly as much as *Penthouse* gets read for the articles. But we have no idea, of course, where in the social order those figurines fit. Did those Stone Age connoisseurs of the female form decorate their homes with little clay figurines to set the mood? Did they invite similarly primitive females up to see their erotic etchings? Or was it similar to what has devel-

3 To any young woman out there about to embark on a career in porn: if you take the stage name Venus Willendorf, I myself will pay you $100.

oped in our modern world . . . were the collectors of such things Pleistocene trench coaters, stuffing their little clay treasures in the Stone Age equivalent of a sock drawer?

In mid-2005, excited archaeologists discovered a very rare stone phallus in the German site which had been the source of many other Stone Age artifacts. It had been smashed to pieces, and reassembling it was a task akin to doing a jigsaw puzzle. When the archaeologists finished it, they discovered that the thirty-centimeter-long object was deeply scarred, apparently from being used as a tool to shape flints. The implications of this will keep anthropologists guessing for years: Was it part of some arcane ritual, in which the mana of the erection was used to pass off its endowment to other tools? Or did some unknown female just break her usual mallet and grab the nearest object to hand? Because you know how it is: he thinks you've had it easy while he's out hunting mammoths with the boys, and he doesn't understand that flaking chert all day doesn't quite put you in the mood. I particularly enjoy this scenario: a cavewoman, smiling wickedly to herself, whacking away with That Which Usually Is Whacked.

The Roman Empire remains the high-water mark of pre-modern porn. The famous frescoes at Pompeii, depicting various sexual acts not known again to humankind until the rise of Super 8 film, have titillated and offended tourists for years. Some of them were plastered over, in fact, by grand-touring Europeans of the eighteenth century, believing that their own morals were a sign of advancement since the Roman times. Instead, of course, this Bowdler-era bowdlerization was merely proof that Enlightenment Europe hadn't yet returned to the classical level of achievement. If, say, Cicero had been resur-

rected to walk the streets of Victorian London, he would have been astonished by the smell and disappointed by the food. But bring him to today's O'Farrell Theater in San Francisco on any Saturday night, and he would grin in familiar delight and try to order a bowl of candied lark's tongues from the concession stand.

People in the porn industry like to say that as soon as any image-making technology is invented, it's used to make porn, from cave paintings down to DVDs. That may be an exaggeration, but not by much. According to the abstruse lit-crit scholar of porn, Linda Williams, it was Eadweard Muybridge himself, the famous inventor of stop-motion photography, who created the first proto-porn loop. Schoolchildren are taught that Muybridge was commissioned to make the first photographic studies of motion by railroad tycoon Leland Stanford, who wanted to settle a bet as to whether the four feet of a galloping horse ever all left the ground at the same moment. What schoolchildren are not told is that once Muybridge created the necessary fast-shutter technology, he quickly moved on from horses galloping to a naked woman writhing on the floor. Perhaps Leland Stanford had made a bet concerning where, at any given moment, all *her* limbs would be.

One of Thomas Edison's first films, made shortly after the invention of movies, was 1896's *The Kiss,* which preceded *Snakes on a Plane*'s stark truth-in-titling by more than century. *The Kiss* was followed by a competitor's *The Gay Shoe Clerk,* which wasn't what it sounds like but did include a lascivious shot of a female customer's ankle.

But when did the first movie camera get pointed at the world's oldest act? Luke Ford, a weirdly obsessive historian of

porn (imagine James Boswell, if Boswell were a conflicted religious Jew who followed around porn stars rather than Samuel Johnson), says the first porn film—meaning, the first film made solely to arouse erotic feelings—was the 1896 French short film *Le Bain*. It featured the actress Alex Willy disrobing. Whether the filmmaker, like Leda in the Yeats poem, glimpsed a vision of the future he launched with his film loop, a strange hallucination of high-def gonzo DPs and cream pies,[4] is lost to history.

For a long time afterward, of course, pornographic films occupied a weird place in culture: they were utterly ubiquitous but completely unknown. Nobody talked about porn. Nobody knew anybody who had anything to do with it. Throughout the 1930s, 1940s, and 1950s, it was financed by disreputable elements and made by secretive filmmakers who filmed fleshy women and men with dark socks, their product showed in "smokers" and back rooms to men who never spoke of it, not even to the men who sat next to them.

Retro Raunch is a website which sells access to thousands of vintage photographs of naked people. The working definition of "retro" is quite broad, and the more recent material, from the 1970s, doesn't count a lot as anthropological documentation but is amusing and fun in its own way: how do you know if a scene was shot in 1975, say, if wide ties and white disco suits are nowhere to be seen? Farrah Fawcett haircuts, that's how. Brown nubbly slipcovers. Pre-op breasts, and nonironic handlebar mustaches.

But it's the early stuff, the chiaroscuro photos of hard-core

4 Don't ask.

sex from the 1910s and earlier, that really arrest attention. They look so old that you surmise the models were held still by iron apparatuses holding their heads, like Abraham Lincoln being rotogravured by Mathew Brady. (In this context, even "rotogravured" sounds dirty.) But what they're doing, these models, is exactly the same as what you might find today on ten thousand full-color websites. Girl on girl. Boy on girl on girl. Legs flung into the air, backs arched, sex of every persuasion, except that no persuasion seems to have been necessary. It's *Gibson Girls Gone Wild*. We knew, of course, that the act of sexual intercourse was as old as life itself. It's still a little shocking to discover that tastes in porn go back about that far as well. You know what you've read about the cultural determination of the erotic? You know how, say, Eskimos finding rubbing noses really sexy? I'll believe it when somebody turns up a black-and-white tape loop of some bored-looking Inuit rubbing noses with the whale blubber delivery guy. Apparently, humans are as hardwired as to what we want to watch as we are to what we want to do.

And thus we proceed throughout the twentieth century, what we might call now the Chemical Photo Age: in public, as far as anyone knew from the available evidence, men and women had underwear stitched to their skins, never to be removed. The only thing that changed was the shape of the bra. But in secret, men looked at Super 8 films and black-and-white photos, purchased from . . . where, exactly? I asked Heather Nash, the proprietor of Retro Raunch, about the distribution system for premodern porn. She had no idea. It just *was,* and if you wanted it bad enough, you knew where to find it. Porn was an eschatological puzzle: it didn't exist, the people pictured didn't exist, yet there it was.

It all changed in the odd sociological moment known as Porn Chic, in the 1970s, with the bizarre mainstream success of two famous but terrible porn movies: *Behind the Green Door* and, later and more iconographically, *Deep Throat.* Anybody who's ever seen the latter—by some calculations, the most profitable movie ever filmed—has probably wondered how in the world this tacky, poorly and cheaply made hard-core sex comedy became the Breakthrough Porn Movie, the one that bestowed a veneer of cool on what used to be known as the "raincoat crowd." It may be that by being lousy—the plot stupid, the performers unattractive, the sex ranging from dull to vaguely disquieting to utterly gross—it provided those early-seventies hipsters a kind of ironic distance, which allowed them to cover up their prurient interest with smirks. If the movie had been at all good—like *Café Flesh* or *The Opening of Misty Beethoven,* the *Citizen Kane* of porn movies—the eyebrow-cocked disdain toward convention, squares, etc., might have been short-circuited by a more genuine, and very proletarian, response.

But if there had been no *Deep Throat,* the transformation would have happened anyway, with some other film. Sex and free love were cool and worthy, and thus filmed depictions of sex had to be the same. Porn would be the signature art form of the time. Where the French impressionists had Manet's *Le déjeuner sur l'herbe,* the American demimonde of the seventies had *Candy Stripers.* By the end of the seventies, the very first "porn stars" had emerged: Marilyn Chambers, Seka, Carol Connors, Vanessa del Rio. It was to be another decade or more before they could be openly seen in public, escorted by musicians or even sports stars, but they achieved a real celebrity nonetheless, which has increased logarithmically since then.

People wondered: What were they like, these ultimate sexual outlaws? The movies themselves depicted the most extraordinarily wanton behavior—and although it was clearly fake . . . how fake was it? I mean, she looks like she's having some fun with those six guys, doesn't she? Just a bit?

Meanwhile, the faceless naked men in dark socks of the fifties loops had transmuted into John Holmes and Harry Reems, new heroes—they had no costumes, but possessed the only superpowers that mattered. In the 1970s, the newly legitimatized porn industry was based in San Francisco, a city well known as the center for the burgeoning new hedonism. Which all made it less pathetic, in a way . . . this wasn't masturbation, this was sociological research. This was a Tour of the Star's Beds. And cars, and pool tables, and flat rocks. Once we admitted the existence of the films themselves, we admitted, also, the existence of the people who made them. And we—and decades later, eventually I—began to wonder: What in the world were they like?

�™ ☙ ☙

"We've signed a contract with Gail Palmer," said my friend Tim, an editor at a New York publishing house. "She's the foremost female director of adult films. She's had a disagreement with her ghostwriter, and we're looking for someone new. Are you interested?"

Well, yes.

I was twenty-eight, a struggling playwright living in the attic of a duplex of a house in a rotten section of Minneapolis—and yes, Minneapolis has rotten sections. I needed the work. And while I never saw myself as a ghostwriter, if I was going do it, why not for a fabulously glamorous erotic transgressive?

Because, naturally, that's what I thought. That's what every-body thought. Here was the pitch: Gail Palmer grew up in Michigan,[5] and made her first porn film, *Hot Summer in the City,* as a student at Michigan State University in Kalamazoo, using equipment borrowed from the college's film department. Happy but not quite satisfied with the scandal she caused, she headed out to the West Coast, where she took the nascent *Boogie Nights*–era porn industry by storm, creating such porn classics as *The Erotic Adventures of Candy, Candy Goes to Hollywood,* and, well, other movies with naked people having sex! She was no diamond-pinkie-ringed, hairy-chested, mob-connected pornographer—she was beautiful, feminine, sexy, entrepreneurial.

"Gail Palmer is a breath of fresh air," wrote *Adam Film World,* a pre–*Adult Video News* sex film trade newspaper, in 1978:

> As the producer, writer and director of Hot Summer
> in the City *and* The Erotic Adventures of Candy, *two
> of the highest grossing erotic films, she demonstrates a
> remarkable feel for people and what makes them get
> off. Not only has she brought some of the highest pro-
> duction values the erotic film industry has ever had,
> but she has also been one of the prime movers in the
> movement to have erotic films understood—even if
> not totally accepted—by the mass of American adults.*

5 An awful lot of people in porn, and serial killers, come from the upper Midwest. Somebody should do a study on why this is. I once tried it myself, with inconclusive results: see chapter 3, on strip clubs.

> *That she wields a big stick—despite being a*
> *woman in a man's industry—and has an entrepre-*
> *neur's knack for good business at the age of 23, makes*
> *her a phenomenon. She is a tall, statuesque country*
> *girl whose raw beauty and sensuousness is matched*
> *by her warm personality.*

You can feel the desperation in that breathless copy. "Please," muttered the people whose job it was to polish up pornography press releases into something that resembled journalism if you squinted at it. "Please, Gail, be someone we can talk about that doesn't make us want to obsessively wash our hands."

Even though I was reading these articles fifteen years after the fact, I imagined Gail as slender, sexy, and provocative in leather pants, with polyamorous perversities and a volume of Henry Miller sticking out of the faux-leopard bag she carried her bondage equipment around in. Research sessions would mean late long nights in some demimonde haunt, surrounded by her many lovers of all sexes, as I took down her thoughts, like, "I thought Simone Signoret had it down, but where's the pussy, man? *Where's the pussy?*"

As I began my correspondence with Gail, and arranged our first meeting, I became the envy of just about everybody in my starving-artist set. For example: I went to a master class with a grizzled, lionized playwright of the Old School, a writer whose work was done only in the hippest of garages, who was famous for the scorn he heaped on Broadway and Hollywood and any-thing that stank of commercialization or selling out. I told him about what would soon be my money gig. He grinned, showing more interest and enthusiasm for this project than for any of

the heartfelt works of dramatic art we'd been discussing for the past two hours.

"Wow, ghostwriting a porn memoir? Cool!"

Because, you see, unlike the shibboleths of Broadway and Hollywood, porn made money without compromising with bourgeois convention. Capitalism was cool only if you sold people what they *really* wanted, not what you fooled them into wanting. Porn was an act of rebellion you could get rich off of without losing your veneer of proletarian solidarity. . . . By bringing this woman's memoirs to the public, I'd be part of that rebellion, without myself risking violating applicable obscenity laws. I'd be Carlos Castaneda with a Riot Girrl for my Don Juan, and instead of psychedelic transformation, I'd be writing about *getting it on*.

Sweet.

<center>☙ ☙ ☙</center>

If Gail Palmer owned leather pants, she chose not to wear them on her flight from Florida, choosing instead—maybe for comfort reasons, as she had to fly coach—a velourish sweatsuit in pinkish tones. She emerged into the gate area moving tentatively, as if afraid of generating any speed would cause a crack in her stiff hair. And if she had ever posed naked herself, it was either many years and pounds before, or for someone with particular, and not widely shared, tastes.

No matter: the years pass, and they grind away on all of us. I escorted her to my home, where I opened my notebook and we began to talk. Almost instantly, it became distressingly clear that, like Bogie going to Casablanca for the waters, I had been misinformed. It was true, certainly, that Gail was not a

diamond-pinkie-ring-wearing, hairy-chested, mob-connected pornographer.

She had been his girlfriend.

And, of course, as it all turned out, his front. Because the D.P.R.W.H.C.M.C.P. in question, Harry Mohney, wasn't an idiot.[6] He knew that people would react to an attractive young woman making porn movies, back in the late seventies, exactly the way my friends and I did in the midnineties: as if it gave us *permission*.

Despite my misgivings, I went ahead with the project. I visited her at her condo in Florida, and I walked up and down the beach with her, listening to alternating stories of her own moxie and her own powerlessness, sometimes simultaneously. She had really directed the movies. Harry had forced her to do it. She had kept trying to get out from under his thumb. He had threatened to throw her out if she didn't do what he wanted. Our evenings were spent eating the surf-and-turf early-bird specials at the local restaurants. Then we'd retire to her condominium—paid for her by her current, Michigan-based doctor husband, who was never around—and she'd drink gallons of powdered Crystal Light and we'd talk some more and go to bed. Separately, I should add. With my door locked.

I returned home to Minneapolis, transcribed the tapes, and started digging through boxes of her archives, dozens of videotapes, magazines, letters, trial transcripts. I decided to begin by

6 Harry, unlike Gail, remains a player in the adult industry, primarily via his Déjà Vu chain of strip clubs. I never met or talked to Harry, so of course my opinion of him was heavily influenced by Gail. As time went on, though, I began to have, shall we say, some sympathy for him. I've met people who know him, who think the world of him—sure, he's a low-down pornographer, but then again, so were the people I was talking to. So that was a wash.

screening "her" first "film," *Hot Summer in the City,* the movie
that garnered her all sorts of shocked but titillated news cover-
age in midseventies Michigan, and started her career. Accord-
ing to the AP story written about it, which made the national
wires, she had borrowed film, cameras, and lighting equipment
from her college, not telling them what she was really doing,
and then gotten some of her hot 'n' sexy friends together to
make a movie that kids like her really wanted to see.

If that was true, as I discovered with widened, and then
averted, eyes, then midwestern college kids in the 1970s were
into vicious, grimy rape scenarios, as erotic, feminine, and
transgressive as a prostate exam. The dank little film would have
vanished, unremarked upon, into the bowels of the adult the-
aters of Michigan (owned by Harry, of course) if it hadn't been
for the fact that the name and face above the title were those of
the nineteen-year-old dark-haired beauty Gail Palmer. It made
money. It probably got a little blip of that post–*Deep Throat* Porn
Chic appeal, bringing more people into the theaters. And when
they ran out, repulsed by its misogynistic racist grainy horrible-
ness, well, they were often too much in a hurry to ask for their
money back. So what's not to like?

Reading over the clippings again, after seeing the film, I was
struck by the constant and continuing divide between what
porn really is, and how it gets talked about. Apparently, none of
the authors of the contemporary news accounts of spunky
Ms. Palmer's guerrilla filmmaking ever actually saw the movie,
or they would have asked questions like how a Michigan State
student would know a bunch of really scary-looking thuggish
guys and women who looked, and acted, like prostitutes; and
why said spunky Ms. Palmer would want to create a racist rape
scenario that was calculated to appeal to the worst instincts of

the sticky-raincoat crowd; etc. It's hard to discuss porn honestly when one of the rules of writing about it is that you can't admit to having looked at it.

Floating on the publicity earned by *Hot Summer*, Gail moved out to California with Harry and started her career. She became the credited director and public face for movies like *The Erotic Adventures of Candy* and its sequel, *Candy Goes to Hollywood*, each introduced, on-screen, by a younger, slimmer, definitely attractive Gail, her voice pushed low to sound sexy. She gave numerous interviews at the time about her career as a porn director, talking avidly about casting, about talent, about writing and directing. And, in fact, these movies are actually not bad. *The Erotic Adventures of Candy* is actually a much more faithful adaptation of Terry Southern and Mason Hoffenberg's subversively dirty novel *Candy* than the psychedelic, star-studded 1968 Hollywood version. That might have made up for the fact that Gail and her backers never paid the authors a dime for it.

All during that period, nobody ever asked whether this young, attractive pornographer actually was who she said she was, even as she was saying it on *The Mike Douglas Show*, in a debate about pornography with entertainer John Davidson and William F. Buckley. Davidson admitted that he and his wife enjoyed the occasional erotic film because, let's face it, "We're animals and sex is part of our nature." Buckley responded by noting that the Nazi death camps were also "part of our nature," and that as civilized human beings we had an obligation to rise above our natures. Gail just looked around and seemed happy to be there.

In 1984, she ended her personal relationship with Harry, and anybody who cared to speculate on how much a role he

played in her success would have noted her precipitous decline. None of her "collaborators" on the films she had "directed" would take her calls . . . because, she told me, Harry had black-balled her. Strangely, though, those men—Bob Chinn, Bud Lee—went on to make movies much like the ones Gail had purportedly directed, this time under their own names. Gail's only post-Harry video project was something called *Shape Up for Sensational Sex,* in which a leotard-clad Gail leads the viewer in various Fondaesque aerobic exercises, followed by lifeless sex scenes which supposedly make use of the toning provided by the exercises just demonstrated. She ended up being sued by some of the models in the exercise scenes, who said that they were misled into appearing in a sex video, and the only distributor who would agree to take on the film insisted on erasing her own voice and dubbing in somebody who sounded better. Eventually, she told me, she had to sell the film to someone who chopped her out entirely and just used the sex scenes as peep-show loops.

Perhaps her lowest point—maybe anybody's lowest point, really, maybe the lowest point of our species—was when she appeared on a pilot TV game show, made in the early eighties. The premise of the show was that various people would come onto the set and explain a problem, and then receive help or advice from a group of B-list celebrities. The host, or hosts, was/were Jay Johnson and Bob, a ventriloquist and his dummy made famous back on the seventies TV series *Soap.*

There she was, my Sexual Adventurer, on grainy videotape with eighties hair saying to a man and his wooden dummy, "I made all these pornographic videos and now I can't get a real job."

"Sounds tough, Bob."

"Sure does, Jay!"

"Panel, anything we can do for her?"

So much for *transgression*.

🌿 🌿 🌿

I remember the moment when I confirmed, after a long period of steadily increasing incredulity, that Gail Palmer's whole career, the whole premise for the book, was a lie. In the mid-1980s, Harry Mohney went on trial for tax evasion. One of the significant witnesses against him was his longtime companion, Gail Palmer, who haltingly told of the various shell games and deceptions Harry had played to hide his personal involvement in his various businesses. Here's a prosecutor, trying to establish how deeply Gail was involved in Harry's various scams and shell games.

Q: So, in fact, you didn't actually direct any of these movies?
MS. PALMER: Uh, no.

Uh, no.

It had long become obvious why Harry and his associates would want to put "A Film by Gail Palmer," with her still-attractive figure, on the cover. But what was Gail's motivation for participating in the scam? Whatever Harry paid her for fronting the films was no more, we presume, than what he would have given her for simply being his girlfriend. (One friend of Harry's from those days assured me that Harry gave Gail anything she wanted.) Gail's sexuality, as it turns out, was more or less mainstream . . . in all our conversations about her films she never seemed particularly excited by the sexual acts she

was depicting; in fact, her favorite bits of her own movies were the lame nonsexual jokes. So why in the world would she want to *pretend* to be the director of porno films?

Porn was and is filled with people who got into it to make money, which is understandable; or to explore their own outré sexuality, which is cool and titillating. My subject, my muse, the woman whose story I had agreed to tell, had gotten into porn for this reason: to become famous.

Which is *stupid*.

As the ghostwriter, I was faced with a dilemma. Everyone, including Gail's agent, the publishers, and me, had signed on to the project believing, on the basis of very little evidence, other than our own wishful thinking, that Gail was somebody other than who she was. The only solution, it seemed to me, was to maintain the delusion. So I invented a new Gail, a fictional character who had Gail's name, lived her life, made her mistakes, but did so with a good deal more intelligence, self-awareness, and irony than the real thing. My Gail was funny, literate, acerbic, rueful, sexy, and—in the spirit of the eighteenth-century novels I had studied at Harvard—able to look back at her youthful naïveté with the wisdom of age. The publishers loved it. My editor loved it Her agent loved it. We presumed that a decent fraction of the book-buying public, too, would love it.

Gail didn't get it.

She didn't like how forward she was in the book, how complicit. She didn't like some of the things that she—rather, I—had to say about sex and porn, not realizing that I was forced to say them for her only after she'd had the poor taste not to think of them herself. Sadly, she waited until the manuscript was finished and ready to be sent to the compositor to announce this.

Everyone pleaded with her to allow the book to be published. She wouldn't do it. She broke her contract with the publishers, and me, and vanished. I never received half the money I was promised. As far as I know, she never published any version of her memoirs. The only record of her career is a real trail of pornographic films with her name on them, and a fictional version of how those films came to be made residing in a box in my closet.[7]

But at the same time, I had been the recipient of a forced education in the pornography business. I had read serious scholarly appreciations of the topic, both from the perspective of academic criticism—for example, Linda Williams, who posited that a porn film is like a classic Broadway musical, with sex instead of singing—and the psychological surveys of the late, much-lamented Robert Stoller. I had read about women who were far closer to what I had imagined Gail to be: women like Nina Hartley and Candida Royalle, who were genuinely empowered, intelligent, creative, sex-positive, and slightly dangerous. And I had read about the thousands of women who were none of those things, who daily delivered themselves up unto the meat market of porn, in which young women agree to be photographed having sex for money, for reasons that sometimes

7 One more thing about Gail Palmer. Do you remember the sad incident in the life of Hunter Thompson, in which he was charged with sexual assault, and the ensuing investigation turned up drugs at his house in Woody Creek, Colorado? Well, the woman he was supposed to have assaulted? Gail Palmer. Gail was vacationing in Aspen, and tried to get in to see the famous writer, with a note stressing her career in porn. Of course, he invited her over. She said he made advances, which I believe; she said she refused him, which I also believe—Gail's life is marked by a pattern of simultaneously using and denying her porno image—and then she said he hit her. Which I don't believe. Gail also had a habit of, well, lying.

had to do with trauma, sometimes with self-expression, but mostly to do with paying the rent.

I felt a little like an explorer who had been allowed to poke his head through a cave opening and see, for just a moment, a bizarre other world, which existed next to ours, and had a parasitical relationship with it. There was communication between our world and it, but it happened at night, in the dark, and we weren't supposed to speak of it.

But, then, in the ensuing decade since my misadventure with Gail, came the Porn Explosion. It's as if the Interdimensional Portal between our two worlds exploded, and the twin worlds began intermingling. For example: Ten years ago I had regular business in a building near Times Square in New York City, with what is euphemistically called an "adult bookstore" on its ground level. After walking past it a dozen or more times, I finally decided to stick my head in, to see what there was to see. What there was, on a video box cover just five feet inside the door, was an image so disgusting, so profoundly disturbing to my heretofore firm ideas about sexual behavior and the limits of the human body, that I emitted a short, sharp squeal and scurried from the store, to look for a wire brush I could stick in my ear to scrape the image from my mind.

Six months ago, I opened my e-mail box to discover that someone had sent me, out of the kindness of his heart, a spam e-mail with an image depicting the same act. Of course, by that time, I, like everybody else, had become used to it.

Traci Lords, the famously underage star who Gail claimed to have met, has become a mainstream actress. Jenna Jameson, who was just starting her career when I met Gail, is a legitimate cross-cultural superstar. And everybody seems to know

who Ron Jeremy is. This once alien, distant species now Walks Among Us.

So the time had come, in the pursuit of this book, to go back and explore that world again . . . but this time, to visit it directly. All my time with Gail had been merely vicarious. . . . I heard her stories, read other people's descriptions of what it was like. But I had never personally seen what it was like. The only "porn star" I had ever talked to was a complete fake.

So I got on a plane to Los Angeles.

II

Somewhere out by the Glendale Freeway, miles away from the louche hillsides and corrugated flats of Porn Valley, there is a particular eruption of cinder block, with asphalt and chain-link moat, generic even by L.A. standards. I checked the street number written on the plywood board pinned to the gate. I checked the number on the paper in my hand. I did this a few times. It was hard to imagine this place as the setting of my first porn set; it looked sterile, so unromantic even an amoeba would refuse to divide because it was not in the mood.

I parked the rental car and approached the door, where a young man sat on a chair. "I'm here for *Spice Live*?" I said. "I'm Peter Sagal?" He assured me that it was, and I was, and I was ushered in.

The cinder blocks turned out to enclose a production facility like a thousand others throughout L.A., the sort of efficient soundstage where you might do a local access cable show or even a small-market newscast. The stage itself, about the size of a two-car garage, was separated from a narrow control room

by a fifteen-foot-long thick glass window. On the control-room side, where I was, were six or seven people, most of them seeming within five years of thirty, in one direction or another, manned various bits of electronic equipment. On the other side of the glass, a woman named Dee was having sex with Bob, who—and here was the genius part—was in Chicago.

Dee was an attractive woman of apparently Latina heritage, judging by her creamy brownish skin, and at that moment, just about all of it was exposed to view except for the gluteal postage stamps covered by the Daisy Dukes pushed down to the top of her hamstrings. From what I could tell, Dee did seem to be having a good time, but not nearly as good a time as Bob in Chicago, whose grunts were emanating from the speakers in the control room and, also I presumed, from the heavy woofers hung above Dee's bed.

Judging from his sudden silence, Bob got to where he wanted to go, or maybe he just became shy; whichever, his time was up. Then Dee, surprisingly sanguine for a woman who, a moment ago, was in the throes of vocally orgasmic pleasure, said, "It's time for another clip." The light on the robot camera pointed at her pudendum went out. The lascivious expression on Dee's face vanished, so quickly that it might have given pause to Bob, had he been allowed to see it. But Bob, and the rest of viewing America, was now watching a hard-core sex clip, which I could see playing on the monitors in the control room. Dee's attention became focused on the careful removal of Bob's local stand-in, a colored glass sex toy provided by the manufacturer for promotional consideration. Because, as I was about to find out, that's what it's all about on the set of *Spice Live*, America's only live pay-per-view hard-core sex show: consideration.

A man who looked like a prosperous, aging hippie ap-

proached me with a wide smile and an outstretched hand. This was Bud Lee, the director of *Spice Live,* and the man who would serve as an aloha-shirted Dante for my visit to the set. Bud is a twenty-five-year veteran of porn, an old-timer in an industry that normally chews up and spits out talent at the rate of a World War I infantry platoon. In fact, Bud had been in the skin trade so long that not only did he know all the people involved in Gail Palmer's life and career—his opinion of Gail, having seen many confused young women go through the business, was much less cynical than mine—but as it turns out, I had actually seen him naked, performing with his then-wife, porn star Hypatia Lee, in a "Gail Palmer Production." Fortunately for our rapport that evening on the set, I had absolutely no memory of this.

Bud was immediately friendly and outgoing, which at first I took simply as an eagerness to get his name in print, but came to understand as more genuine than that. Nobody who spends his career making porn can afford to let the slightest trickle of shame through his mental dikes, and Bud, like some other veterans of the industry, tends to overcompensate in the other direction. He answered all my questions, sometimes relying on some clearly practiced lines, but certainly trying to project genuine pride in his work. Not that I could figure out exactly what his work was: during the entire time I was on the set, he never touched a switch, and made only one specific direction to his staff. In fact, at one point, as if only for my benefit, he shouted out, "Get a great shot on every camera!" and everybody laughed, and went back to doing what they were doing, the way they were doing it before he said anything.

For example: now that the red ON-AIR light was off, Josan, a twenty-something guy with a preemptively shaved head, left his

post in the control room and went onto the set to chat with Dee for a moment. Since the mikes were off, it was impossible to hear what they were talking about, but Josan told me later that he just likes to check in with "the talent," to see if she needs anything—a towel? more lube? motivation?—and just to keep her company. That done, Josan wandered back into the control room, where everybody was ignoring the hard-core sex clip unspooling on the monitor, and instead enjoying the only amusement they were to get this evening: me.

Everybody working behind the scenes in porn, it turns out, embraces and accepts the cliché that the sex itself, the hot hot hot girl-on-girl or boy-on-girl or dildo-standing-in-for-Bob-in-Chicago action, becomes completely boring after a while. The sight, to take a random example, of a beautiful woman of indeterminate ethnicity loudly pleasuring herself with a glass sculpture becomes, indeed, just another night at the office, no more interesting than if she were flexing her arm or scratching her butt, which, by the way, she was now doing. However, like those aliens on *Star Trek* who can't experience emotion themselves but are endlessly interested in we humans who can, porn people love it when someone comes onto a set for the first time. On my very first visit to a real porn shoot, I was startled to discover that I was the center of attention.

So Josan came back into the control room and asked me what I thought of it all. I said it was pretty impressive, and he nodded happily. Then he started talking to me about the effect of his job in porn on his own social/sex life. This effect was not a positive one. At that moment, back on the naked-people side of the glass, Dee realized that she needed something she had forgotten to ask for. She had never done this particular gig before, so it's possible she didn't know what was to come next.

When the clip ended, would she be required to have more virtual sex with another caller? Or was her shift over? In the control room, on my side of the soundproof glass, Josan was saying to me, "I don't know. . . . The women think I'm dealing all day with porn star sex goddesses. They figure they can't measure up."

Behind him, Dee was waving, trying to get his attention. Her very full artificial breasts pressed against the glass. No one looked.

"Or maybe," Josan said, "it's just me."

Spice TV is wholly owned by Playboy Inc. which is something it doesn't particularly want you to know. I'm telling you about it, in fact stressing it (Spice TV is owned by Playboy Inc.!), because that ownership and denial of same is a perfect synecdoche for the hypocrisy of *Playboy,* which bothered me even as a teenager: that is, it presents photos of beautiful young naked women as a masturbation aid while pretending that it's part of some sort of hip lifestyle in which you never have time to masturbate because you're too busy with sports cars and stereo equipment. *Playboy,* for all its celebration of sex, rarely admits what sex really is: penises, vaginas, fluids. But, having found that selling glossy airbrushed photos of nubile young women is a losing proposition in the age of Bestiality on Demand, the company's executives have come to grips with the fact that the real Act Itself is all that they're selling, and on their wholly owned subsidiary *Spice Live,* they're selling it, at least on my satellite provider, for $12.95 per segment.[8]

8 Some years ago, I was given a tour of the *Playboy* editorial offices, near my home in Chicago, by a friend who worked there as an editor. For the most part, it looked exactly as you might think: a luxurious two-story suite of offices with expensive art on the walls, not all of it by LeRoy Neiman. But deep

In fact, what they're selling, as I was about to see, is unique in the industry, and it was the primary reason I had come to the set. Most of us, of course, will never work in pornography, but many of us will make use of it. What in the world do They, who Do, think of Us, who Watch? Only on *Spice Live* do the two sides meet, as the transaction itself unfolds in real time, through the magical media of live satellite TV and the telephone.

The blazing tungsten floodlights on the set went dark for a moment, and Dee, her work done for the night, vanished into the dressing room. The *Spice Live* crew looked at the minute hand of the clock, approaching the top of the hour, with the focus of a crowd awaiting a hanging. Because *Spice Live*'s pay-per-view system works on half-hour increments, every half hour means a brand-new show, and a new metaphorical crash of coin into Playboy Inc.'s virtual cash register. The segment they'd just wrapped was called "Spice Clips," a sort of porno takeoff on MTV, with hard-core porn scenes rather than music videos, and a lubricious near-naked woman rather than a tousle-haired Gen X VJ. But coming up at 10 P.M. PDT was "Spice Hotel," which everyone, audience and producers alike, think of as the main event.

Fittingly, then, at about ten minutes to the hour, the door to the control room opened, and Evan Stone, a very muscular,

in the back of one of the floors, far from the offices where the fiction editors and lifestyle editors smoked their pipes and chatted with Halberstam and Wolfe, or whatever, was a compositing room centered around a huge light table. On the table, and on the walls, was a riot of soft-core porn: all grist for the mill that produces *Playboy*'s down-market knockoffs: Playboy's Perfect 10, Playboy All Naturals, Playboy Lingerie. I was told these were the real moneymakers for the company, and the company's recent purchase of *Spice Live* and other hard-core providers shows that it knows what really pays for the flamingos at the mansion.

very tan man with Fabio-style long hair, swaggered in, wearing a bathrobe and carrying Everlast brand boxing headgear and two sets of boxing gloves.

I reached out to shake his hand, and Jennifer, the petite, boyish producer whose job was to speak to the talent via PA during the broadcast, shrieked with laughter: "Never shake hands with a porn star!" she yelled. And in fact, Evan's hand was disturbingly slick. "Moisturizing lotion," he said reassuringly.

Then he turned to Bud: "Can I get somebody to come in and arrest me?"

🕊 🕊 🕊

"He's been doing a lot of different things," Bud explained to me, once Evan had gone onto the set. "Last week he was the evil Dr. Von Bubbly, and also his alter ego, Captain Spice, who saved the innocent maiden. He's . . . whacked. He's really interesting, and he has a lot of entertainment value, other than just the sex. He makes it fun and interesting, especially for us."

The door swung open again, and in walked a woman with dark hair, about five four, also in a terry cloth robe: Kelly Kline, who would be "working" with Evan on tonight's shoot. She offered a quiet hello; her hand was dry. Unlike Evan's style of sideline bounce, her preshow vibe had a quiet air of fearful concentration, like someone about to go into combat. Kelly's website calls her the "Girl No One Would Suspect," which seems to be a play on her unusual-for-porn looks. Her slightly Jewish-looking features clearly haven't been dulled to stereotype by surgery, nor has her figure, at least not yet. Female porn performers almost always turn to surgery to increase their appeal and extend their careers. Jenna Jameson, for example, the

World's Most Famous Porn Star, has had so much surgery over her long career that she doesn't even appear to be closely related to the woman depicted in her early films. Distant cousins, maybe, with the same tattoo on their buttock.

Nobody has done a statistical study of the length of porn careers, as far as I know, but given the appetite for fresh faces in the industry, and the tournament-style rewards system—the chosen few at the top get rich, the crowds below get very little—my guess is that for most women, a porn career lasts three years or less: within two years you've either hit the big time, with a contract at one of the major production companies, your own website, bookings in strip clubs, etc., or you're falling quickly down the ladder, to cut-rate productions and grotty clips on pay websites. Part of the problem is the production schedule. A premium porn "feature" can be shot in two days or less; a "scene" can be done in an hour. If you're young and attractive and newly discovered, you could be fielding offers to do fifty or seventy-five or a hundred scenes in a single year, and, since porn "actresses" work under a model contract, they typically get no residuals or royalties on top of their appearance fees. The system creates an incentive for young women to make as much money as they can when demand for their services is high, but by saturating the market with images of themselves they have no control over—images which migrate to compilation videos, websites, peep shows, and on and on— they rapidly diminish that demand. You know what they say: Teach a man to fish, and he'll eat for life, but give everybody thousands of fish, and pretty soon they'll develop an appetite for a different entrée.

According to Kelly's website, for example, her rise in the industry was typically rapid. She and her husband filmed them-

selves having sex to celebrate their first wedding anniversary, and then sent the film to porn producers. Job offers soon followed, and they both went to work in the industry, she as a performer, and he as an agent for performers. She had worked incessantly in the year since moving out to California, making dozens of films, and had created a website on which she positioned herself as the next breakout star. But I noted, when I checked the website after the shoot, that it hadn't been updated in many months. It was possible that soon after her debut, Kelly's moment had already passed.[9]

However, at least as of that evening, she and her husband were still married, despite the routine adulteries of the workday. "This was explained to me by my ex-wife," said Bud, and we remember here that Bud could have been referring to either of two porn star ex-wives. "That's *business*, they're not going to have sex, they're pursuing their career path. . . . They're going from Point A to Point B on that path." Apparently, this distinction is as flimsy and useless as the costumes regularly worn on his sets. Few marriages survive the vocational infidelities of porn; those unfortunate husbands of porn stars who are not themselves in the industry, who show up on sets carrying the costume changes and bitching about the working conditions, are known disparagingly as "suitcase pimps." Like the traditional pimp, they make their living from their women having

9 I didn't have the chance to speak at length to Kelly that night. Unlike everybody else on the set, she did not eye my tape recorder and notebook the way a crow looks at a shiny object. She refused repeated requests for a follow-up interview via the publicist at her agency. A porn star who does not want any publicity does not fit into my (or anybody else's) theories of why they do what they do, so I found her refusal troubling. But, to paraphrase Josan, maybe it's just me.

sex with other men for money; unlike the traditional pimp, nobody thinks they're cool.

At the same time, though, those couples who both perform are the subject of some respect and envy: Evan Stone and his wife, porn star Jessica Drake, were for a while sort of the Jen and Brad of the sexvid world, featured approvingly in a 2005 HBO documentary on the industry. But some months after I met him on this April night, they broke up; in fact, some friends in the business told me that Evan's wife had really "screwed him over." I wondered how this could possibly be. How do porn stars cheat on each other? If you were to come home early from work and find your wife in bed with another man, couldn't she plausibly claim she was just rehearsing?

Back on the set: the minute hand was only a few ticks away from the top of the hour. The production crew turned the cameras around to point at the "Spice Hotel" set, which consisted of a bed on a dais, and a couch below and in front of it. Evan was on the set, explaining his idea for the scene to Kelly. She seemed interested, but I couldn't hear what they were saying, because the control-room speakers were still broadcasting the sound of the last hard-core clip filling the airtime till the start of the segment. Everybody working the shoot ignored those clips, from long association, and I began to do the same. But later, when I reviewed my tapes of the evening, I found that many of the conversations were underscored by constant moaning and obscenities issued in the imperative mood.

Twenty seconds to air. Matt, the segment producer, had set his lights and positioned the cameras. Evan had run some yellow tape around the bed and sofa set, trying to make it look like a boxing ring. Evan and Kelly had dropped their robes, and

both were wearing boxing gloves and headgear. In addition, Kelly wore a negligee, Evan a padded midriff protector over his boxing shorts. The digital clock ticked to 10:00, the red camera light went on, and Evan spoke directly into it:

"Hi, I'm Evan Stone, and I'm here with Kelly Kline, and right now we've got the Battle of the Sexes."

Thusly, he revealed his theme for the evening.

"Right here on 'Spice Hotel,' that's why we've got the whole place ringed off . . . we're going to have some fun, you're going to have some fun with us, and you can get off. . . . Call 1-800-Spice TV, that's 1-800-Spice TV. . . ."

The two performers began a comically fake boxing match. Kelly bounced on her bare feet and swung at Evan, who collapsed, theatrically. I held my tape recorder up to the speakers in the control room to document what happened next:

"You knocked the crap out of me! I'm so turned on right now. . . . Man, you're tough. . . . See, I got a nut cup on just in case you kick me in the balls or something. . . . What? You could have worn one. . . . Let me see what you've got. . . . Well, since you won, I guess I should reward you, right?"

Silence. Then: the squishing sounds.

Bud Lee spoke, in the proud manner of Willy Wonka revealing the Chocolate Room:

"This is the only, and the first, live sex show on television."

🌾 🌾 🌾

After a very brief while—this is a business, after all—Jen the producer flicked a microphone switch and announced the first caller, Ed from Annapolis. Evan removed his face from Kelly's

crotch and, as Kelly obliviously continued to writhe in pleasure, shouted to the caller: "Ed! What do you want us to do!"

Ed expressed his viewing pleasure in a voice so growly and guttural and private that I suddenly felt as if I had opened the door into the wrong bedroom.

Kelly and Evan instantly switched positions so Kelly could minister to Evan, as Ed has requested. Evan's hands reached around to massage Kelly's buttocks, and for the first time there was some consternation in the control room. Josan, who was manning the camera with his joystick, asked Bud for a judgment. Bud said, "It's okay, he's only grasping her ass," and the scene continued.

Bud then explained, in a distressingly matter-of-fact way, that the X, XX, or XXX after a porn film's title isn't—as I had always thought—merely a pathetic attempt to gin up attention, no more meaningful than the AAAAAAA that an auto-glass company might put in front of its name to get first mention in the yellow pages. No: according to Bud, they are carefully constructed guides to content. Viz: A single X indicates full frontal nudity of both sexes, with lots of grinding and bobbing and moaning but little "hard-core"; it is the sort of thing you'd see on the Playboy channel—that is, the Playboy channels Playboy admits to. XX is featured, visible penetration, Bud said, "but no anal, or ejaculation. XX and a half is everything that XX is, plus ejaculation."

XXX, of course, is the whole shebang. "A lot of the girls doing anal would be surprised to find it only earns them half an X," Bud said wryly.

I asked Bud who came up with this elaborate system, and he said he wasn't sure . . . "maybe the FCC." The mind boggles at the thought of Washington bureaucrats, particularly in a Republican administration, sitting in an office with their Power-

Point charts explaining all this. By this system, Bud said, *Spice Live* is XX, and therefore: no touching the bum. Fortunately, as Bud was able to determine, Evan was merely being kind, rather than pressing his advantage, so nobody had to worry about the FCC for the immediate future.

I had been watching a real live porn shoot for no more than fifteen minutes, and true to the cliché, found myself strangely unaffected by the rather intimate nature of what I was watching: as with the traditional kind, porn-set virginity is something that ends rather quickly. Instead, I began to appreciate how very well Evan and Kelly did their work. They both seemed to know where the camera was without obviously checking, and would "cheat out," as they say in the theater, to give the viewer unobstructed vistas. In fact, during the course of the evening's entertainment, both Kelly and Evan showed an astonishing ability to enthusiastically insert Part X into Orifice B or C (but never A, of course) with all the requisite facial expressions and exclamations often associated with such acts, while at the same time preserving the camera angles, talking with a viewer, and occasionally yelling out the 800 number the next viewer needed to call.

After a while, at Ed from Annapolis's request, Evan and Kelly moved on to the full-on Act itself, with Kelly lolling back on the sofa, her left leg thrown back and hooked over it, her right leg touching the floor and still. As per usual in porn's Kabuki version of copulation, both Kelly and Evan were angling back as much as possible from the point of contact, as if the rest of their bodies heartily disapproved of what their genitals had gotten up to. It occurred to me, there, as I made a note about how Kelly managed to keep her leg tensed in that lovely, wearing-a-high-heel shape without the benefit of actual heels, that for the first time in my life, I was watching somebody else

220 THE BOOK OF VICE

have sex. . . . Or to be more precise, I was watching somebody else have sex with somebody who wasn't me. Even inured as I've become to film of the act, I always assumed that in the presence of it, Itself, I would feel something different . . . if not awe, or titillation, then at least some form of embarrassment. But even in their most vocally exuberant, squinched-eye, tensed-neck poses, Evan and Kelly radiated a contagious professional detachment. They were not engaged in the ancient combat of love; they were merely reenactors. Whatever was going on here, it wasn't "sex," any more than what Cathy Rigby does on the set of *Peter Pan* is "flying."

Suddenly, Bud, for the first and only time during my evening on the set, issued an order: "Go to a clip." The monitors showing the broadcast feed suddenly cut to a snippet of hardcore, leaving poor Ed in Annapolis to amuse himself otherwise, and Josan and the other producers rushed onto the set. What happened? Had Evan or Kelly crossed the line from XX to XXX or some perverse forbidden kingdom beyond? Had someone sneezed or coughed or otherwise revealed him- or herself to be just poor, poor flesh?

No: the performers had, perhaps through momentary unprofessional overenthusiasm, fallen into a position which blocked all the available cameras. If two porn stars are having sex and nobody can see it, they become as useless to you as any of the millions of people around the world having sex right now when you're not.

Strangely, Evan and Kelly didn't stop what they were doing. I asked Josan if they knew the cameras were off; he said, gently and patiently, that the people on the set moving them around from place to place might have been a clue. Maybe Evan knew that a sudden withdrawal would ruin Kelly's composure, or

even, God help us, hurt her feelings. After the shoot, I asked Evan if emotion ever came into his work, and he said, "Absolutely. Every time I'm working with a girl, I'm madly in love with her." Certainly, whatever was happening between the two of them, for a certain single moment, it wasn't for anyone else's benefit, not Ed in Annapolis's, and not mine, and for the first and only time that night, I felt nosy.

Evan and Kelly finally broke it off, and the crew repositioned the cameras, and everybody was getting ready to go back on air. Evan grabbed the crotch protector he had tossed away at the start of their first segment and helped Kelly get into it, a funny and endearingly nonsexy sight. The crew quickly cleared the set, took their positions back in the control room, and threw the switches that sent Evan and Kelly live back to America. Evan grabbed Kelly's wrist, and as she laughed, he raised her arm in the air: "Ladies and gentlemen, the winner of tonight's First Bout in the Battle of the Sexes . . ." He paused, uncertain. Dead air.

He'd been having sex with her for twenty minutes. He had forgotten her name.

". . . Kelly Kline!" He pulled it out. As it were.

Evan welcomed another caller, who asked if Kelly could put on "those shoes, I love those sexy shoes." Evan grabbed his own discarded pair of big white sneakers and knelt to put them on Kelly's feet, a porn prince anointing his Cinderella. Kelly laughed like a girl.

🐾 🐾 🐾

Early on during the shoot, a tall woman entered the control room, wearing the classic Porn Star Leisure Suit: circulation-restricting low-rider jeans, a top which was no more than a

rhinestoned bra, and stiletto pumps, which, added to her five feet nine inches, made her look like the Leaning Tower of Flesh. She introduced herself as "Jordan Styles," and said that she was a performer but there tonight only to support her room-mate, who'd be performing in the last segment of the evening. And although "Jordan"'s name was no more or less fake than Evan's or Kelly's or anybody else's in porn, she seemed so wholly and crudely prefabricated that I can't help thinking of her in quotes.

"I love sex," "Jordan" crooned into my tape recorder. "I abso-lutely *love* sex. I love the attention I get. I'm going to a conven-tion, where we interact with our fans. I'm on a billboard. I love being a symbol. It's not like I have low self-esteem or any-thing."

Much like Daniel Burnham, "Jordan" had made no small plans. She said she was going to be big, really big, world fa-mous.

"Like Jenna Jameson?" I asked, invoking the greatest cross-over star in the history of porn, the only porn star to have her memoirs top the bestseller list, to be invited to genuine Holly-wood premieres, to be featured in massive billboards hanging above Times Square, the Gypsy Rose Lee of our time, as ad-justed for obscenity inflation.

"No," says "Jordan." "*Really* big."

I found this unlikely. "Jordan"'s looks, though impressive by normal human standards, were too mundanely beautiful for her to fight her way out of the vast crowds of aspirants in porn; and, seemingly in her midtwenties, she was probably already too old to be the next Big Discovery. But if her dreams of vast success and fortune and fame in her chosen field were perhaps unrealis-tic, or uninformed, well, then she was no worse than the thou-

sands of aspirants who descend in vast flocks every year to the Southern California Air Quality Management Basin, determined that with enough grit, ambition, and attitude—what prior generations called *moxie*—they can Change Their Life. In the mainstream world, they flicker across our lives as Girl in Bikini #3, or Girl in Office, or the Hot 104 FM Party Team Captain. They say to you, while screening their reels, "I'm the one behind Mel Gibson when he's giving mouth to mouth to Rene Russo. . . . There, you can see my head." They dream that somebody will catch that glimpse, that the break will come, as it did for the people they envy. For these people, hallucinatory optimism isn't just common, it's required to survive.

So, I asked myself, is "Jordan" so unusual, or strange, or worthy of scorn? Isn't she just a twenty-first-century Eve Harrington, working in the au courant form of performance? So what if she takes off her clothes and has sex on camera? That's what her audience wants, and if so, why is it any weirder than the thousands of starlets who take off their clothes and *pretend* to have sex on camera? Isn't the difference between "Jordan" and, say, Sharon Stone only that Sharon Stone fakes it? Is "Jordan" really any worse, or better, than all the women and men who get up every day to take another step toward that distant day when they slip into the seat next to Jay or Dave or Conan, and laugh about a clip from their latest film?

I did a good job of convincing myself of all this. Then, when I got home, I looked her up in an online database of porn films. "Jordan"'s filmography includes such titles as *Assault That Ass 4, Assfensive 2, Jungle Love 2: Blonde Gone Black,* and *Deep Throat This 19.* She also appears on a website called Meat Holes and Piss Mops.

So, yeah, in the end, it's a little different.

✤ ✤ ✤

But: on the set, the caller, he with the interest in the "sexy shoes," was getting very excited, and events were speeding toward their natural fruition. Kelly and Evan were going right along with him, and as the moment arrived, Evan grunted and groaned, Kelly moaned encouragements, and . . . nothing happened. It was the porn equivalent of one of those Wild West Village Gun Shows: lots of noise, but nothing got shot. Orgasm mime. It had to be, of course. The rules of the broadcast prevented the Real Thing. Plus, there was Evan's endurance to consider. It would be disappointing, to say the least, for a viewer to pay his $12.95 for a segment of "Spice Hotel" only to see Evan Stone smoking a cigarette and turning on the TV to check the scores.

The clock was ticking toward the end of the hour, and right on cue, Matt, the segment producer, wearing a ridiculous wig and policeman's hat, entered the set to "arrest" Evan. This would presumably lead to next week's scenario: a quickie porno *Law & Order*? Nobody on the set had any idea, including, I think, Evan. The monitors switched to another clip, and "Spice Hotel" was over for the night. Evan, feeling justifiably pleased with his performance, gave a high five to the crew and vanished through a back way into the dressing room. Kelly, her robe back on, entered the control room, to enthusiastic applause, and Bud escorted her back to her dressing room. When he came back a few minutes later, he said he talked to her about her experience—which she enjoyed—and inquired as to whether she'd like to come back. She would. He also told me they talked about a mutual interest: show horses.

On set, the second iteration of "Spice Clips" was about to

begin, this time "hosted" by Trina Michaels, a newcomer to the Spice set. She was a fill-in for the immensely popular Stephanie Swift, and either it was a substitute-teacher vibe, or just the lateness of the hour, but nobody in the control room seemed to care much about what was going on. This apathy extended to the callers: about a half hour into Trina's performance, the producer manning the phones decided to patch Alvin through to the set. Alvin, a regular caller, was kind of a weird mascot of the show, with a high-pitched, lispy voice, who liked to chat with the hostesses about odd topics in his own life, and had a frustrating unwillingness to just talk dirty. When the *Spice Live* crew let Alvin on the air, it's a clear sign they're bored.

Evan reentered the control room, showered and dressed in impeccably neat casual clothes, his hair pulled back into a ponytail under a baseball cap. He had the rare ability to preen when standing absolutely still. I asked him how he got into the business.

"I was in high school, and I auditioned for this college play, and I got the part, it was like *Man of La Mancha* or something, up at Western Michigan University.[10] And the people I met there, in the theater, were the most interesting people I've met in my life. And I said, this is the place I want to call home . . . and here they are. The makeup artists, the people working on the props . . . It's the modern theater. We have everything but a live studio audience."

"Oh no." Bud laughed. "He's going to bring bleachers in, I can see it."

"After I got out of school," Evan continued, "I went down to

10 Again with the Michigan!

Texas and I started male stripping, and started making a lot of money. And after the show, we'd all go back to somebody's hotel and have an orgy. So making the transition to this"—i.e., performing sex acts live on cable TV—"was easy."

Evan told me he planned to be in the business about two more years, and then he would move on to another career he had planned out, a career he was both very secretive and, incongruously, very serious about. But for now, he said, he was enjoying himself.

"I'm beginning my sixth year in the business, about thirteen hundred movies. I do maybe five a week. I go to the set, I eat great food, drink gourmet coffee. I wait around two hours, until they get it all set up. Then I meet some gorgeous girl I could never get on my *best* day. I get to have sex with her, and then they pay me money. But do I ever get a pat on the back? Does anybody ever say, 'Nice job'?"

I realized he was doing part of a stand-up routine. I also realized it was pretty good. Evan was, in the words of fellow porn star Nina Hartley, "very rare: a heterosexual male exhibitionist." He was certainly comfortable with the idea of what his audience was doing at home while watching him perform, and he further showed no sign of discomfort working in close proximity to other, sexually aroused men. "Here's something funny," he said to me, when I asked him about it. "I've done so many DPs with other guys"—that would be double penetration, in which the woman "enjoys" the ministrations of two men, simultaneously, separated only by the perineum—"that I can tell when they're going to come based on the change in their breathing pattern. Funny, huh?" Then he grabbed another mouthful of M&M's from the bowl on the table next to him.

All of a sudden, everybody in the control room stood up to peer through the window. Something was happening on the set. I had been in the control room for three hours, and this was the first time that any of the crew had showed any excitement, or surprise, about anything going on around them.

While the cameras were off, "Jordan Styles" had slipped through the door onto the set and climbed onto the bed with the performer, Trina Michaels. She was now enthusiastically nuzzling Trina's breasts, an unscheduled and unpaid act of sexual exhibition, performed in the hope that the director and crew would reward her with her own opportunity to perform on the world's only live hard-core sex broadcast, and thereby climb another rung in her quest to be Bigger than Jenna Jameson.

The producers quickly lost interest and got back to browsing the snacks.

"Attention whore," sniffed Matt.[11]

11 As this book went to press, I Googled the performers to see how they were doing. Evan Stone, in the time since I met him (April 2005), has continued his affable rise, appearing in many more films, among them *Pirates,* reputedly the most expensive porn movie ever made, which was given a gala premiere on Hollywood Boulevard. He seems happily positioned for mainstream fame, if he wants it. Kelly Kline also continues in the industry, at least through 2006. Her website has been extensively revised, into a more typical adult website, with very little personal information, just lots of invitations to pay to watch videos of her. The bio is gone, as is any mention of her husband, though that could be the standard starlet ruse of pretending to be sexually available. She still advertises herself as the "Girl No One Would Suspect," and among the things you would not expect her to do is partner with a website called Iamyourwhore.com and another that specializes in foot fetishes. Oh, and ride a motorcycle. "Jordan Styles" also continues to work in the industry, and has her own website, much like Kelly's, with even less information. She had a supporting role in *Corruption,* the most honored film at the 2007 Adult Video News Awards. Maybe I underestimated her.

III

Stormy Daniels is reenacting the experience of being recognized in public.

"First, they give me *the Look*," she says, raising one plucked eyebrow, enacting a naughty knowing smirk. "Then, they kind of shift their weight."

She sits up in her chair and leans toward me.

"Then, they realize they're standing next to their wife."

She slumps back, looks sheepish.

"Then, they wait until their wives go away"—*the Look* comes back—"and then lean over, and whisper, 'I love your work.' Never 'porn.' It's always 'your work.'"

Stormy, the third-most famous woman in this Chicago restaurant, doesn't much like being recognized as a porn star. Porn is the only multibillion-dollar industry in the world with no customers, at least no customers who like to admit it, but when they do, Stormy says, they can get pushy. Shane, sitting on my right, the second-most famous woman in the restaurant, doesn't agree. She *loves* her fans. She seems to genuinely love *everybody*. In fact, she became the second-most famous woman in the restaurant because of a successful series of videos in which she filmed herself doing just that.

Nina Hartley, the most famous woman in the restaurant . . . well, I don't know right now what she thinks of her fans. The only "adult" star to make the cover of *Newsweek* is engaged in an animated conversation with my wife, Beth. They both laugh about some shared insight, and give each other a high five.

✤ ✤ ✤

It was some months after my visit to the *Spice Live* set, and I had found myself profoundly regretting my failure to talk to Kelly Kline. For all of Evan Stone's openness and good humor, let's face it: he didn't present much of a puzzle. A male porn star's motivations seem obvious and widely shared. The only question Evan Stone raised, philosophically speaking, was: *Where do I sign up?*[12]

Women are obviously the center of the (straight) porn world; their willingness to do what they do is what fuels the industry and also is the heart of its mystery. Now, most people have evolved beyond any surprise or disapproval of a woman with strong sexual appetites[13]—certainly, many women equal or surpass the average man's enthusiasm for sex. But, even given current liberal mores, you would think that even the most sexually adventurous woman would be hesitant before creating filmed records of her indulgences which might outlive the performer herself. A man who performs sex on camera—a group that includes, among others, the actor Rob Lowe—is just somebody Living the Dream. He can laugh it off with a self-deprecating joke on *Leno,* maybe going on *Letterman* to read a list of "Top

12 Everybody involved in the porn industry, even in the most marginal ways, is constantly harassed by guys who want to be porn stars. Amazingly, and generously, many of these men are willing to *perform for free*. By the way, in case you're wondering: I can't help you either.

13 With the important exception that men will always disapprove of a woman's sexual urges if they don't happen to be directed at the man doing the disapproving.

Ten Titles for a Porn Movie Starring Me." A woman who does the same is Hester Prynne, but stripped naked, with her scarlet letter tattooed on her inflated breasts.

Gail Palmer was a woman who deluded herself into thinking that a career in pornography would reward her with something more than her onetime payoffs and many decades spent figuring out how to live down a career in pornography. Maybe every woman in porn is just as misguided, but that seems unlikely. Hundreds, if not thousands, of young women go into porn every year, and even granting the standard naiveté of eighteen- to twenty-year-olds, they can't all be fools. If they were, it would mean an evolutionary crisis for humankind.

In addition to still wondering about the answer to porn's persistent question—*Why would a nice girl do anything like that?*—I will admit a growing desperation. The more I learned about porn, the more alarmed and concerned I became for the people involved in it. In one conversation after another, I heard about how porn people had succumbed to drugs, or alcohol, or depression, or their own native instabilities. Bud Lee, for example, told me that his first wife, the eighties-era superstar Hypatia Lee, had descended after her retirement into a kind of bitter paranoia. Other men and women I asked after turned out to be coke addicts, wife abusers, helpless depressives, unstable folks spinning out of control. It could be, I suppose, that I was just unlucky in the anecdotes that came my way. Or maybe, since I was asking about people who were by definition well known, what I was hearing about was the end result of too much exposure and success. But still, I found myself wanting to meet somebody normal within this very abnormal industry. I didn't need to buy into the fantasy of the porn world being an endless bacchanal of frictionless, consequenceless copulation. I just

wanted to meet somebody who did the job and went home at the end of day, kissed his or her mate on the cheek, and watched some cable TV. Not Cinemax, either: something with clothed people. I needed to meet some porn success stories, which, in this context, I defined as people who ended up being relatively normal.

One such person might be Carly Milne, who arranged this particular dinner party. Carly is a former porn industry publicist I met through her gossipy blog, the late, much missed Pornblography; she was the woman who had arranged for my visit to the *Spice Live* set. Now she was in Chicago, promoting a new book she'd edited called *Naked Ambition,* a collection of essays by "women who are changing pornography," including, of course, our three dinner partners. Carly's thesis: After many years of merely being exploited as "talent," women are now taking charge of their own careers, using the Internet and inexpensive film-making technology to amass their own money and power, and challenge the male pornographer cabal. It's sort of a Marxist seizure of the means of production, but with more eyeliner and discarded lingerie.

Despite my no longer being a "set virgin," the prospect of this dinner had made me nervous. These were three of the most famous women, past and present, in porn. Nina had appeared in some Gail Palmer–era projects, but I had never seen any of Stormy's or Shane's oeuvre, and I didn't know whether that was a bad thing, in that I wouldn't be able to knowledgeably discuss their work, or a good thing, in that I wouldn't be constantly averting my eyes and blushing.

I did know, though, that I would insist on my wife, Beth, coming along. If you have a dinner date with three beautiful stars of adult films, it's a no-brainer that you bring your wife.

First: because if your wife is my wife, she'll get a kick out of it. Second, because bringing your wife will be a clear signal to the ladies that your intentions are friendly and aboveboard. And last, so your wife will let you go.

Beth and I had no idea what to expect. Would they be creepy? Sleazy? Embarrassing? Would we stare at each other in silence, realizing that the gap was just too wide between our staid midwestern suburban life and their exotic 24/7 bacchanal of sexual excess? But just a short while after we all sat down, everybody was chatting happily, Nina Hartley was ordering all kinds of food for everybody at the table—she's sort of a mother figure, it turns out—and Beth was sneaking off to the bar with Shane to smoke cigarettes and talk about raising kids. Stormy was staring off into space, which she does a lot.

"Anything strike your fancy as an appetizer?" I asked Stormy.

"Oh, no," she says. "I'm easy."

<p style="text-align:center">🌹 🌹 🌹</p>

Let us meet our dinner companions:

<p style="text-align:center">🌹 🌹 🌹</p>

Born in 1959, Nina Hartley is an icon, an institution who's been around since before some of her colleagues were born: the Strom Thurmond of the sex trade.[14] Her career began in the 1980s, and

14 Nina has objected to this comparison, on the grounds that Mr. Thurmond is politically inappropriate. She suggests instead, as a metaphor for her surprising longevity in a young person's game, Mick Jagger. I agree Jagger would be a better fit, but still, Thurmond is funnier.

within ten years she had appeared in hundreds of videos and was already a legend. Then, in the early nineties, she launched a series of "educational" videos, in which she guides the viewer through explanations of various sexual techniques and situations, and then, of course, demonstrates them. For example: in 1992's *Nina Hartley's Guide to Alternative Sex,* viewers can watch her, in the piled-on hair and tight dress of the period, explain the anatomy of the male prostate with flip chart and pointer. She has a degree in nursing, as she'll be the first to tell you, and she does tell you. She's the daughter of Jewish intellectuals from Berkeley, and she acts like one; talking—well, talking a blue streak about her own life, her career, the choices she's made—Willingly!—the mistakes she's made—out of Ignorance and Repression!—the wisdom she's gained—through Honest Sexual Expression!—and all the puritans and antiporn feminists and Forces of Sexual Repression she's dedicated her life to fighting.

I had met Nina before. In fact, I had interviewed her in her apartment, in a renovated office building near downtown Los Angeles which she shared with her second husband (and third spouse), a nice, Jewish, hyperarticulate S&M pornographer named Ira Levine. The loft is divided neatly into two parts: one on end, a pleasant, tastefully decorated living space, which, if it weren't for the pornographic art on the walls, might be the home of an art dealer or graphic designer; and on the other, an S&M dungeon and film studio, which looks, with its black leather and chrome apparatuses, like hell's own Pilates studio. Nina, giving me the tour, pointed out the sleeping quarters: "Funny," she said, "the bed is the one place we've never had sex."

Oh.

"All happy families are alike, of course," she said, starting to tell me about her upbringing in Berkeley.

234 THE BOOK OF VICE

"I'm sorry," I said, interrupting. "Did you just quote Tolstoy?"

"Yes," she said, puzzled as to why I had stopped her to ask. Perhaps most porn stars preferred Dostoyevsky.

She proceeded to give me the Full Nina, sitting at her kitchen table, talking rapidly and at length mostly about her own life, her own emotional experiences, her own needs, and how living and working in the sex trade ultimately fulfilled those needs. She presented herself as somebody who'd be doing this anyway, even if no one was watching, but, of course, she's even happier to know you're out there watching. For a long while, she said, she had lived in a "triad," with both a wife and a husband, but then she realized, she told me with much detail, that this arrangement was repressive and inhibiting, so she broke up with those spouses and was now married to the lucky and talented Mr. Levine (score one for the Jewish guys), although of course she and Ira invite all kinds of people over to play in their dungeon, and often broadcast what ensues on her website. Once you spend a little time with Nina, you find it unremarkable that she left a permanent, polyamorous ménage a trois because it was too restrictive.

When we met again, at the restaurant in Chicago, she had no memory of me at all. I must have looked a little hurt, because she said, "Come now. There's a lot of you, and only one of me."

🕆 🕆 🕆

Stormy Daniels, next down the table, is twenty-six, and the only one of the three who's dressed like a porn star . . . spike heels, a flimsy top barely covering her surgically augmented figure. In addition to being a contract star with one of the main porn companies, and starring in some big-budget video fea-

tures, she's already begun to achieve that rare crossover status, appearing as—natch—a porn star in *The 40 Year Old Virgin,* as well as in music videos and the like. And now, she's begun writing and directing her own porn features.

For her, in contrast to Nina, porn wasn't about expressing herself, sexually or otherwise, but getting the hell out of Baton Rouge, and getting rich in the process. She also said, somewhat astonishingly, that she was incredibly homely as a kid: "I had to pay a guy $250 to take me to the prom and have sex with me," she said.

"You're kidding me," I said.

"Really," she assured me. "I looked like Nicholas from *Eight Is Enough.*"

For her, being first a dancer in strip clubs, and then an actress in adult films, and now a writer and director of same, was a way of making herself beautiful and powerful. Her tenth high school reunion was coming up, and she was really looking forward to it.

"I'm going to do it up, I'm going to show up in a limo, with a fur coat down to here, two huge bodyguards, the works."

"Why?" I asked.

"Hah!" she said.

🜚 🜚 🜚

Shane, thirty-five, seems to have stumbled into situations so frequently that it's amazing she didn't trip walking into the restaurant. She started stripping at the age of seventeen when her drug-dealer boyfriend brought her to a strip club and abandoned her there. The owners threatened to beat her if she didn't get up and perform—one of the many cruelties done to

her she now easily forgives—but, hey, she said, it turned out she *loved* stripping. She loved the customers. She became close with a number of them. . . . One regular, she said, paid her $800 over the course of an evening of private lap dances. When she found out it was from his kids' college fund, she forced him to take it back, berated him—gently, I assume!—and sent him back to his wife. Whom she also knew, she said. And liked.

(I believed this story, as well as everything else she said. This was a woman with very little left to hide, and absolutely no inclination to do so.)

Later on, she met a nice guy named Adam, and had actually moved into his house, she said, before she figured out he was a notorious pornographer, known as Seymour Butts. Well, in *that* case . . . Shane became both Adam's fiancée and star, and the "Seymour and Shane" series became among the most popular in "reality porn," a burgeoning subgenre in which performers film themselves as themselves, purportedly doing what, and whom, they normally do. Her many fans say that what made that series so special was Shane herself . . . her personality, her innocent (yes!) charm, her sense of humor. She remains the world's only porn star you'd want to take home to your mother.

When Shane broke up with Seymour in 1997, he contemptuously asked her what she'd do now, and she reflexively shot back, "I'll just make my own movies!" And, without much experience or skills behind the camera, she created *Shane's World*, which still is one of the most popular reality porn video series out there. That's Shane—proof that good things happen to good people, despite, or in her case because of, their willingness to have sex with just about anybody they meet.

❦ ❦ ❦

Soon we were all eating noodles and talking about family.

"My mother had a hard time with my career," admitted Shane.

"I wish I could say that," said Stormy. "Nothing is more disturbing than to be on stage and bend over and look between your legs, and see your mom with a dollar in her mouth."

Shane shrieked with laughter. "My mom has never been in a strip club!"

"My mom has never been allowed to stay in one," replied Stormy. "I give them Polaroids of her, tell them to keep her the hell out."

This brings up a more delicate question for Shane. With her brown hair pulled back in a bun, she looks like what she now is: an extremely attractive suburban mom. A short while ago, she and her husband, a former rock musician, moved from L.A. to Northern California to raise their two kids, aged five and three. She's been retired from performing for many years now, but she's afraid her neighbors will find out about her past. Her plan, such as it is, is to get so involved with her kids' school and community that if one of the neighbors does sneak down to the basement and pop in a video and recognize that enthusiastic performer of ten years ago, she'll be too well established to shun. "I'll be like, 'Yes, it's me! Your library lady!'"

But someday, she knows, she's going to have to talk with her own children, before they learn about their mother's career from someone else. For the first and only time in a long night of

talking about her life and career, she showed something akin to regret.

"Who knows," I suggested, trying to be comforting. "The way porn is becoming mainstream, it's possible that ten years from now, or whenever you have that conversation, they'll just think it's way cool."

"Come on," she replied. "Imagine yourself, getting a call from *your* mother, and she tells you—"

I was laughing too hard for Shane to finish the thought.

<center>🌾 🌾 🌾</center>

I repeated a story told by another performer, Heather Hunter, in an HBO documentary about the porn industry. One night after her retirement from the business, Heather said, she met a man, struck a spark. She went home with him and slept with him. Immediately afterward, he asked her for an autograph. Ms. Hunter found this somewhat humiliating.

Stormy stopped staring into space. "I've got a better story than *that*," she said.

"I've just broken up with Brad Armstrong"—her long-term boyfriend, director, and costar. "We are at this party, it's two weeks later, and I walk around this corner and there's Brad, making out with this girl. And I'm just heartbroken, and I start crying. This guy comes up, he's like, 'What's wrong, are you okay?' And he asks me my name, and I say Stephanie—that's my real name—and I tell him what I do, I say, I do video production. And he's says he's a TV writer—I looked him up later, he really was who he said he was—and we just talk for like, *three hours*. We just talk. And it's just great. . . . I'm not *at-*

tracted to him, but he's just so kind, and interesting, and he's interested in me, just to talk to me. . . ."

Everybody at the table was hanging on her next words, rapt, waiting for the inevitable doom. I realized why Stormy was so often staring into space. She was polishing her anecdotes.

"We go back to his place, and it's just beautiful . . . expensive furniture, art on the walls. . . . I'm thinking, *ka-ching!* This is just great. And he gets me a drink, and we're talking, and he says, 'Hey, do you want to watch a movie?' I say, 'Whatever you like.' And I turn around . . . and there I am on the screen, having sex with Brad. And he throws open the doors of the entertainment center, and it's the Stormy Daniels Film Library. He says, 'This is a dream come true. . . . I'm such a big fan . . .' and he starts *touching* himself. . . . I got out of there *so* fast."

Groans of disbelief. Nina shook her head in sympathy.

"He called me a day later, he was so sorry, he just got 'excited.' But it's okay. I'm so going to use it for a movie. And he'll get *his.* My first script, it was a murder mystery, I killed off all the girls who were mean to me in high school."

<p style="text-align:center">❧ ❧ ❧</p>

Sometimes the attention they get from their fans isn't funny, and it isn't welcome. Stormy told the story of getting recognized in a mall, and how a crowd of men surrounded her, some of them trying to touch her. "I'm not a *prostitute!*" she yelled at them, and had to run into a store and have the clerk call security. And on at least one occasion, a fan has gone from being annoying to threatening. "I was home, in my husband's house—now my ex-husband—and

it was all glass walls and windows. A rainy night. I'm all alone, and I'm upset. The phone rings. This voice says, 'You look too pretty to be crying.'

"I called the police, but they didn't find him," said Stormy. "I was so mad at my ex-husband. He wouldn't let me buy a gun. He said, 'You're going to kill someone.' I said, 'That's the *point*.'"

All this brings up a central question: How do they feel about the nature of their work, and the reason for their celebrity? Why would they put up with the public gropings and leerings and even more alarming aspects of porn fandom? I tried to get some confession out of them that they'd rather be doing something else but that doing porn provided them with advantages which justified the sacrifice.

"Come on," I said to Stormy, "you're twenty-six, and you're writing and directing your own movies. You couldn't do that outside of porn, right?"

"I am an *excellent* writer and director," she shot back, "and it has nothing to do with my vagina!"

I was alarmed that I might have insulted her. "No, no," I said, "I don't *care* about your vagina!"

Everybody cracked up.

<p align="center">🦅 🦅 🦅</p>

Over coffee and dessert, I asked the women to respond to the latest iteration of the antiporn argument, as put forth in books like the recent *Pornified*, by Pamela Paul: namely, that the current ubiquity of porn is hurting real relationships. Men prefer porn fantasies to their wives and girlfriends; women feel they

have to act like porn stars to please men. This made Nina mad:

"Utterly ridiculous. Ridiculous. It's porn. It's a fantasy. Everybody knows that. If you can't tell it apart from reality, you've got a serious problem. And if some girl is asked to do something she doesn't want to do, she should say, 'No, thank you.' But our stupid puritanical society and abstinence-only education have not prepared people to take responsibility for their own lives and their own bodies!"

Stormy, staring into space, shrugged. "I'm really of two minds about it. Sometimes that stuff bothers me."

Shane just laughed and shook her head. She agreed with Nina, but for a much simpler reason. Confusing porn with real life wasn't an issue for her, because for her, porn was her real life.

🐦 🐦 🐦

Carly, the woman who had brought us all together, looked at her watch and ordered everyone out of the restaurant so that they could go back to their hotel to prepare for the next part of the evening: a theme party at the nightclub Transit, where Nina, Stormy, and Shane would be the special celebrity "hosts." Just as we all got up, a man with an angular chin approached Nina from a nearby table. Angular Chin was giving Nina . . . *the Look*. "My friend says he recognizes you from the movies. . . . Can you come say hello?"

Nina happily marched over and introduced herself to the two couples sitting there. "Hi! I'm Nina Hartley. I do sex-education videos." The two women at the table looked at the other man,

heavyset with rimless glasses. Was that where he had seen her? Sex-ed videos? "I thought I recognized you from that movie, *Boogie Nights,*" said Rimless.

"Sure," replied Nina. In the 1997 film about the porn industry, she had a cameo role as William Macy's promiscuous wife. Nina gaily chatted about how Macy proposed to his wife on the set, while everybody at the table thought . . . *That's not it, either.* Rimless whispered, "You do adult videos, don't you?"

"You bet," said Nina, and she shifted quickly into a new mode, from sexual healer to porn evangelist. She gestured at Rimless and his wife: "I like to say that if I don't turn her on, you don't get laid, right?"

"Right!" said Rimless. Now it was all out in the open, and everybody was a fan. "You keep it up, girl!" said Mrs. Angular Chin.

If anybody else in the restaurant recognized anybody in our group, he wasn't telling. As Nina and I walked to the door, I asked her what she expected from the party that night.

"I'm there for the fans," she said. "I'll talk to them, and dance with them. But I've got very strict rules. They can touch, but nothing in an area that would be covered by a bathing suit. If their hand strays, I will slap it away."

She puts on her jacket.

"Of course, they can touch my rear all they want. I'm so used to that; it's practically public property. I can have a hundred people pat my butt, and I could still discuss Nietzsche."

☙ ☙ ☙

Several hours later, Transit's Fifth Annual "Pimp and Ho Party" was in full swing. I was, sadly, stag for this part of the evening.

Our babysitter had a curfew, and our agreement had been that Beth would stay with the sleeping kids while I ventured back out to finish the story. Beth was surprisingly regretful she couldn't see her new friends again. "They were the opposite of what I expected," she said as I drove her home. "They seemed utterly genuine, and completely aware of who they are, and very happy about it."

In the middle of the crowded, pulsingly loud dance floor, Nina Hartley was hard at work, representing the Porn Queen for her many fans. She had changed into high-heeled black boots, fishnets, and a thongish bottom that revealed, in all its glory, what is known justifiably as the Finest Rear End in Adult Entertainment. I was struck by the urge to place my hand on her bare buttocks and ask her about *Thus Spake Zarathustra,* but I resisted.

Carly was there too, also dressed in a way that made me concentrate on looking her directly in the eye, and we left Nina to the throng of goggle-eyed fans around her and headed to the VIP area at the back of the stage, where the other two "hosts" of the party reclined, sipping free drinks, insulated from their "guests" by two rows of bouncers.

Shane and Stormy were dressed . . . no. They were wearing some clothes, true. But "dressed" usually implies that at least 50 percent of the body area below the neck is covered by fabric. Stormy was now wearing a ruby red bustier, tiny shorts, and a dog collar around her neck. She was staring into space. Shane was wearing tight black pants and a black bra. She was grabbing my crotch.

This is not quite true; at least, it was not true for more than, say, two seconds, but those two seconds were pretty vivid, and they tend to linger. Let me back up a bit:

I sat down next to Shane and she was delighted to see me again, as if the four hours since our dinner had been years, and I was an old dear friend rather than someone she'd met that day. She was particularly disappointed not to see Beth. We started talking about her kids, and my kids, and kids in general, and the way in which kids are exactly who they are from the very moment they are born, and how becoming a parent makes you want to forgive your own parents for whatever slights, real and imagined, they might have committed against you (and the slights against Shane were far more real than imagined), and in general we were having perhaps the most homey and friendly chat I have ever had while shouting at the top of my lungs so as to be heard by the half-naked porn star I was having it with.

Then I happened to mention that some friends of mine were really big fans of hers. And she said, "Whenever anybody says 'I'm a big fan!' I always say 'How big?' and do this!" and she grabbed my crotch. I believe I made a girlish noise. She laughed and released her grip and kept chatting. She didn't mean to shock me, and she certainly didn't mean to come on to me. It was just what she did. Strike that: it was a tiny fraction of what she did, a kazoo toot next to the baroque orchestra of her sexual persona.

I looked up: Stormy was giving Carly a lap dance. Carly had the drink tickets, and Stormy wanted them, and this was the suggested price. The transformation of Stormy was rather stunning; despite her clothing, she had seemed sexually inanimate the entire evening, excited only by the prospect of telling a good story. Now she switched something on, and transformed from Stormy, née Stephanie of Baton Rouge, to *Stormy Daniels*™: she gyrated, she swiveled, she unbuttoned her top and pressed Carly's face between her breasts, as her perfect rear described perfect circles in the air.

Lucky me: I was, for maybe the first time ever, in kind of a sexual sanctum sanctorum. I had the attention—maybe even the affection—of three of the world's most sexually desirable women. Other men—literally held back by a velvet rope—looked at me with envy and wonder, because I had been Allowed into the Presence, while they must merely watch. And I felt nothing but a sense of loss. I wanted Stormy to quit it. I wanted Shane to put her clothes back on. In the course of the evening, I had become quite fond of these women. But now they had, easily and professionally and even enthusiastically, slipped on their sexual selves, which functioned in the manner of a carnival mask, vivid but obscuring. It was like getting to know, say, Leonard Nimoy—talking to him about his poetry, his music, his tasteful photographs of nude women—and then accompanying him to a *Star Trek* convention where he had to put on the gold tunic and make the "Live Long and Prosper" salute all day for the fan-boys. I mean, sure, he's Spock—*but he's so much more!* So sitting there, surrounded by gorgeous porn stars who were finally, after a long evening of noodles and chat and snuck cigarettes, acting like goddamn porn stars, I found myself unexpectedly feeling prissy. I didn't want Shane to grab my crotch, or Stormy to grind her butt into somebody's face. I wanted to order more noodles and hear them tell more stories. While fully clothed.

Stormy finished the lap dance. Carly handed her the drink tickets. Stormy, folding herself back up like a sexual Transformer, ordered a drink. And then stared into space.

Nina, exhausted from the unrelenting and unchanging attentions of her fans, scurried into the safe area of the velvet ropes and sat next to Stormy. The two women exchanged a confidential word, and then Nina reached into her bag and pulled out two

small plastic ampoules. She handed one to Stormy, and I thought, *Okay, this is it, finally here's where the drug-induced porn star bacchanal begins*. Nina and Stormy pricked open their ampoules with their fingernails, leaned their heads back, and carefully put the drops in their eyes.

"I hate these kinds of places," said Nina. "So smoky."

"Given your druthers," I said to the owner of the Finest Rear in Porn, "where would you rather be right now?"

"Right now?" she said, incredulously. "Home in bed!"

And I had no problem picturing exactly what she'd be doing.

AFTERWORD

or

WAKING UP BACK IN KANSAS, AND HAVING TO MUCK OUT THE BARN

Curiosity may not ultimately kill the cat. If the cat is anything like me, it'll end up sitting on the back of its ratty old boring couch, a little wiser, and not particularly interested in looking under the curtains again, at least for a while, thank you very much.

I am profoundly aware that my tour of Lands Unknown and Pleasures Undreamed was the Apple Vacations version, a quickie skim through some of the more well-known attractions, my understanding of them limited to a glimpse out of the motor coach. My reading and research, plus the conversations I had with those denizens of these realms of gold whom I did meet, convinced me that somewhere out there, right now, there are bacchanals of sex and consumption and sinning that still, even after all I've seen, would leave me pale and stammering with shock. Gambling? There are $100,000-a-hand cash poker games happening nightly in the luxury suites of Las Vegas, and games of golf on which tens of thousands of dollars are bet on each round. Sex? Somewhere, bobbing in a warm-weather port, there are yachts, right now, where the guests know it's going to be just a quiet night because the elaborate group copulations involve only humans.

Nonetheless, I feel like I've seen enough for one trip. I am now a believer in Nina Hartley's expansive definition of sexual orientation, namely, that you are born a swinger or a fetishist just as much as you are born straight or gay. Further, I believe it extends into most every other area of indulgence. If it's not the way you are, then no matter what lengths you go to explore it, it'll never seem right, and you'll be as frustrated and unhappy at an orgy as a pansexual satyr would be stuck at home doing the once-a-month missionary with the wife. That seems to the case with me; much as I enjoyed meeting the people I describe in this book, I have no particular desire to be them. Or have sex with them, with all due apologies to the fine people at the Swingers' Shack.

This is not to say I didn't feel envy—I'd love to be as free and confident in my own skin as Nina Hartley is, and I can only dream of being possessed by the same vision and dedication and discipline that illuminates Grant Achatz. Even Ross and Rachel, proprietors of the Swingers' Shack, have decided what they wanted in life and pursued it heroically, in a way that could be the subject of a Hollywood movie, had they just chosen something slightly more wholesome. To decide what makes one happy in life, and to relentlessly pursue it—responsibly, mindful of one's obligations and limits, careful to do no harm to others—is certainly as much an act of courage as we assume abstinence to be, and I admire those who commit themselves to it.

But at the same time, during these travels, it occurred to me that I might be a subject of envy myself. The crew of *Spice Live,* who enjoyed watching me lose my "porn-set virginity," may also have wished that they could, once again, be someone who watched two other people make love with awe, or curiosity, or at least some small measure of embarrassment; the urge to look

away means that you haven't yet seen it all. In fact, they probably wish they could still think of the term "make love" without rolling their eyes. And then there was Shane, the former porn star, who talked to me about her current attempt to make a life with her husband and her kids, and hinted that the life she was trying to create would always be haunted by the one she used to have. Not that someone of her nature could live within my vanilla confines for a moment, but I wouldn't be surprised if while talking to me—or more to the point, while talking to Beth—she wished she could.

Everybody is a tourist outside the bounds of his own life: wondering how the natives manage, trying to get a taste of it while knowing he'll never know what it's like to live there. We all stand in our circles of light, and what's around us is familiar and visible. Sometimes we travel, so our light can be cast on things far away. Some people—like the strippers I met in Vegas, like Evan Stone, who went from a college production of *Man of La Mancha* to starring in *The Da Vinci Load,* relocate permanently, becoming expatriates from their old lives. But you can't ever really expand your circle to encompass everything. You can only move the center. There will always be something just outside your light, and what you've left behind will also fade into darkness, becoming as shadowy and mysterious and alluring as what you think might lie ahead.

God knows there are people who are having more fun than you, who are having more and better and frequent and more gymnastic sex than you are, who are enjoying adrenaline thrills and indulgences you can't even imagine. But you have one thing in common with those people: they, too, are wondering if there's something that they're missing. Gamblers look for bigger and bigger games; foodies look for more and more exotic dishes; and

sexual hedonists are constantly looking for more varied play-
mates, weirder positions, stranger rites. Even Ross and Rachel,
of the Swingers' Shack, are dissatisfied with the life they have
right now; otherwise, why would they work so hard to bring in
fresh bodies for the next party? And hell, if everybody's going to
be vaguely dissatisfied with what they've already got, you might
as well stay at home, where at least you know the snacks are
things you like and you get to control the remote.

And there's this: sometimes it's good not to know exactly
how the castles in the air, way up in the distance ahead of you,
all beautiful and shiny and seemingly made of candy, are actu-
ally built. Once you've been on a porn set, sex videos lose any of
the erotic allure they might once have had. The "amateurs" are
well paid, the positions painful, the excitement feigned. Casino
games, once you know the odds and have chatted with the ex-
ecutives who happily spreadsheet your inevitable losses, seem a
little less exciting, and a little more like ratholes. Even food:
while visiting the kitchen of Alinea, I hung out for a while with
a photographer who was documenting some of the entrées. Af-
ter she had photographed the lamb dish—the very same entrée
that had sent Beth and me spinning off into despair—she of-
fered it to me. In that basement room, under fluorescent lights,
eaten not with rosewood chopsticks but with my fingers, it was
just a couple of chunks of lamb. Maybe, when you turn up the
work lights, that's all any of these vices are: just ways of gussy-
ing up meat. Sometimes, the meat is us.

<p style="text-align:center">🐾 🐾 🐾</p>

At the end of my night at the Power Exchange (see the intro-
duction) I was picked up by a friend and taken straight to a

party held by a San Francisco collection of "Burners," veterans of the famous Burning Man art festival/neoprimitive party/happening held every year in the Nevada desert. The party filled a huge industrial loft somewhere down near the China Basin waterfront, maybe five hundred people, ranging in age from teenagers on up to people in their fifties. Everybody glowed with joy, and/or alcohol, and/or maybe some other chemical enhancements. Some of the women were so beautiful they would immediately have caused a riot had they walked into the deli display case that is the Power Exchange, or at least they would have commanded a hushed, churchlike silence. Some of the men, too.

House music filled the warehouse, and people danced, some with each other, some by themselves. I have never much liked large parties, because, being a nervous fellow, I have always felt as if the expectations were too unclear—was I supposed to be trying to pick people up? Impress them? Ignore them? But having been to the Power Exchange, and the Swingers' Shack, and numerous strip clubs and casinos, where the exact nature of the expected transaction is explicit—sometimes written out on the felt—all of a sudden, the ambiguity seemed marvelous. People were there to do whatever they wanted to do, but unlike all those other places I had been, here I had no real clue what it was. The swingers I had met talked of the pleasure in everybody's agenda being absolutely clear, but there are advantages to ambiguity. Any one of the most beautiful women, dancing there in the middle of the crowd, could be a virgin, or a lesbian, or a man—there was no way of knowing. They were just dancing, and their casually kept secrets added to their allure.

After a short while, two women, wearing fluorescent body paint and thongs and bras and glitter, came to the center of the

room, and people cleared out of the way. They produced rhine-
stoned hula hoops, and proceeded to do the most joyous, erotic,
and goofy routine with them that I could ever hope to see.
People clapped and applauded, and then they went back to
dancing themselves, with their lovers or by themselves, stoned
or sober, sad or happy. I looked at them all, and drank my beer
with a strange contentment, and thought of the son of a friend
of mine, an actor named Steve.

Steve has a teenage son with autism, and has suffered
through the usual difficulties of raising such a child. But his
son made great strides, and once, at the age of twelve or so, was
taken to see a production at a children's theater.

He just loved it, and came home with boundless energy and
excitement, talking a blue streak, which in and of itself was a
victory for Steve. He talked about all the magical effects he had
seen—the actors flying through space, the disappearances and
illusions. "I wonder how they did that!" he said.

Steve, being a veteran of the theater, began to explain. "Well,
the actor is wearing a special kind of clothing, called a harness,
which—"

"No, Dad," said his son, silencing him. "I don't want to
know. I want to *wonder*."

ACKNOWLEDGMENTS

First, thanks to Ken Jennings, who, like me, always looks here first.

Thanks to the many people who responded to a call from an obscure public radio host with generous offers of aid, including Flo Rogers of KNPR, Anthony Curtis, Alan Feldman, Dave Schwartz, Jack Sheehan, Mark Brandenberg, Gary Smith, Kate Hausbeck, Barb Brents, James Reza and Staci Linklater in Las Vegas, "Delilah," Carly Milne, Craig Peterson, Bud Lee, Evan Stone and the cast and crew of *Spice Live,* Nina Hartley, Shane, Stormy Daniels, "Ross," "Rachel," "Joey," "Monica," and the other patrons of the Swingers' Shack (who spoke without knowing to whom they were speaking), Penn Jillette, Jennifer Galdes, Grant Achatz, Kenneth Goldman, Suzanne Lipson, Mike Powers, Josh Powers, and Gina Powers.

Thanks to Ted Anderson, my intrepid researcher, who enjoyed this more than his term papers; and to K. C. Davis, who escorted me through Las Vegas, which was almost as valuable as introducing me to my wife.

I am lucky to be surrounded by gifted writers and humorists who inspired and encouraged me: Jess Bravin, John Hodgman, Nicole Galland, Roy Blount Jr., Charlie Pierce, P. J. O'Rourke, Kyrie O'Connor, Sue Ellicott, Amy Dickinson, Mo Rocca, Paula

Poundstone, Tom Bodett, Chris Ware, Roxanne Roberts, and Adam Felber.

Thanks to Tim Bannon of the *Chicago Tribune* and Paul Tough of the *New York Times Sunday Magazine,* who published some of the material in this book in an earlier form.

Most grateful thanks to my colleagues and friends at *Wait Wait . . . Don't Tell Me!,* without whom (a) nobody would be interested in a book by me, anyway, and (b) I would never have been able to take the time to write it: Carl Kasell, Lorna White, Robert Neuhaus, Mike Danforth, Emily Ecton, Amanda Gibson, Doug Berman, and especially Rod Abid. Thanks as well to Luke Burbank, Chad Campbell, Margaret Low Smith, Jen Pearl, Anna Christopher, Jay Kernis, and everyone at NPR.

Many thanks to Don Epstein, Alec Melman, Jessica Fee, and everyone at Greater Talent Agency; to my agent Luke Janklow and his aide de camp, Claire Dippel, and to Mauro Di-Prieta, my editor, as well as Jennifer Schulkind and Ben Bruton at HarperCollins. I'm grateful for your support, confidence, enthusiasm, and most important, in my case, patience.

I thank my in-laws, Marilyn and Arlin Albrecht, for unknowingly providing me with anecdotes, and my parents, Matt and Reeva Sagal, for allowing me to wait until this moment to tell them what this book is about. Sorry.

And to my own family: thanks to my daughters, Willa, Grace, and Rosie, for waiting so many hours, on so many days, for me to "finish the book" . . . with special props to Rosie, for coming up with the word "naughty" for the title. I promise that the next one, you'll be allowed to read. And lastly, endless gratitude and love to my wife, Beth, my ideal reader and my smartest critic, to whom this book is dedicated. Without her, I'd have no good stories to tell, and worse, no one to tell them to.